The Metropolis and its Iı

Constructing Identities for London,
c. 1750–1950

The Metropolis and its Image

Constructing Identities for London, c. 1750–1950

Edited by
Dana Arnold

BLACKWELL
Publishers

Copyright © The Association of Art Historians 1999

First published in 1999

This title is also published as Vol. 22 No. 4 of *Art History* ISSN 0141 6790

Blackwell Publishers
108 Cowley Road, Oxford OX4 1JF, UK

and
350 Main Street
Malden, MA 02148, USA

British Library Cataloguing in Publication Data
A CIP catalogue record for this book is available from the British Library

Library of Congress Cataloging-in-Publication Data applied for

ISBN 0 631 21667 7

Cover illustrations:
J.B.C. Chatelain: *A view of St Mary's Church, Islington* (1759), John Roque: *An Exact Survey of the City of London* (1746), and Telford: *Design for a cast for London Bridge* (c. 1800), courtesy of the Guildhall Library, Corporation of London.
J. Baily after Thomas Girtin, *St Martins Le Grand* (1795), courtesy of the Museum of London.
Extract from *Plan of streets and roads between Black Fryars Bridge and London Bridge* (anon., 1769) and Henry Roberts: Design for the approaches to London Bridge (undated), courtesy of the Yale Center for British Art, Paul Mellon Collection.
Extract from George Bickham Jnr: *The Charms of Dishabille* (1933), courtesy of the British Museum.
J.M. Brydon, Public Offices, George St and W. Young, War Office, Whitehall, courtesy of Michael Port.
Interior of National Provincial Bank, Princes Street, courtesy of Natwest Group plc.
Bank of England, Threadneedle Street, courtesy of the Governor and Company of the Bank of England, London.

Printed and bound in Great Britain by MPG Books, Bodmin, Cornwall

CONTENTS

Editor's Introduction

Dana Arnold

> The most glorious sight without exception, that the whole world as present can show, or perhaps ever cou'd since the sacking of Rome in the European and the burning of the Temple of Jerusalem in the Asian part of the World
> (Daniel Defoe)

But what was this sight? What kind of image did London present? Defoe's avoidance of metaphor infers the immeasurability of the metropolis and that there was and remains no single identity for London. Instead, the city is a means of giving coherence to diversity. It is at once an imagined community and an interaction of histories and place which present the experience of a metropolis. These different systems for representing a city's identity are not necessarily counterpoints but rather they form a complex and initially inexplicable set of social, economic and cultural relationships. London's infrastructure, architecture and geography remained in a state of flux in the period c.1750–1950. And this unknowable metropolitan totality of the metropolis has to be brought to scale in order that it may be interpreted and understood. Objects and commodities take on a system of meanings relating to the religious, aesthetic and social values relevant to their time – and so do cities. But in this case these meanings are not static as cities continually change and develop over time without entirely shedding their past. Historical sequences cannot then be expressed in spatial terms; space, or indeed a city, cannot have two different contents simultaneously, instead histories of the same geographical location must be juxtaposed. In this way any images of London, whether relating to the real, the virtual or the subconscious are not at variance, rather they reinforce the city's unfathomable diversity. London's different identities show how they can signify moments in the city's histories but they remain fragments of the unchartable macrocosm which goes beyond the anthropomorphic scale of proportion, scale and beauty. If the city is of human making, humankind has created a monster.

> London the Metropolis of Great Britain, has been complained of, for Ages past, as a kind of Monster, with a Head enormously large, and out of all proportion to its Body. (Josiah Tucker)

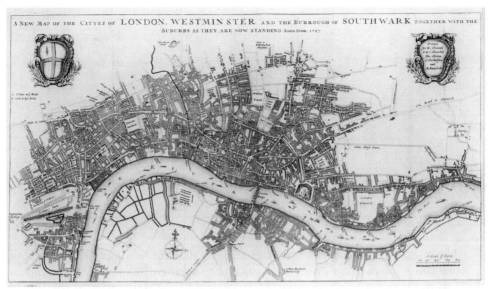

i *A New Map of the Cityes of London, Westminster and the Borrough of Southwark together with the suburbs as they are now standing, Anno dom. 1707.* Department of Prints and Maps. By kind permission of the Guildhall Library, Corporation of London.

The essays in this book examine moments in the emergence of London as a metropolis and consider different ways in which its image has been formulated and presented. The complexity of the different identities of London are revealed in the tensions and interactions between manifestations of civic and national pride, the relationship between private and governmental institutions and issues of urban planning. The chapters present a range of material from specific questions of architectural style to an examination of the relationship between the City of London and London as a metropolis. Alongside this different self-conscious methods of constructing urban identities are explored whether this be the work of architects and planners, representations of London in the visual arts, or approaches adopted by historians to give the city different meanings and identities.

This volume is intended to complement the existing body of writing on London's image. Indeed, London has become a popular subject for inter-disciplinary and thematic studies. The rich visual compendium found in the exhibition catalogue *London World City 1800–1840* (1992) has its verbal counterpoint in Rick Allen's more wide-ranging and useful literary anthology *The Moving Pageant; A Literary sourcebook on London street-life, 1700–1914* (1998). The literary image of London is engagingly examined in Julian Wolfreys *Writing London* (1998) which focuses on the nineteenth century. And it is this century which has received most attention, due not lease to the vivid writings of Dickens, Mayhew and Engels. But there are also important visual records of the city and these are discussed in Alex Pott's article 'Picturing the Modern Metropolis', in *History Workshop Journal*, 1988, and Griselda Pollock's analysis of late-nineteenth-century images of London in 'Vicarious Excitements; London; A pilgrimage by Gustave Doré and Blanchard Jerrold', in *New Formations*, 1988.

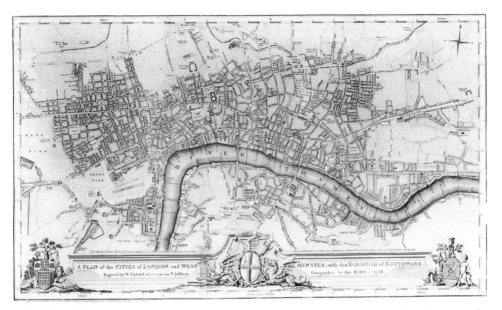

ii *A Plan of the Cities of London and Westminster, with the Borough of Southwark, Engrav'd by W. Faden, Succr. to the late T: Jefferys, Geographer to the King, 1781.* Department of Prints and Maps. By kind permission of the Guildhall Library, Corporation of London.

It is perhaps, however, Stephen Daniels's opening chapter of *Fields of Vision*, (1986) 'The Prince of Wales and the Shadow of St Paul's' which relates most strongly to the odd juxtaposition of space and history that this volumes seeks to explore.

The rapid growth of London in terms of its size, infrastructure and population is a fundamental part of its image and a common thread in the chapters. Here it is mapped visually in the illustrations to this introduction (plates i–iv). And the visual repertoire of the whole volume serves at once as an essential part of the argument of each of the chapters and as an essay in its own right presenting a rich and varied synopsis of the different visual images of London. The resonance between the verbal and the visual, whether it be a two-dimensional image or the built environment, is an important theme of the volume: in Lucy Peltz's essay the changing representation of London from an antiquarian subject where ruins are rebuilt and presented in isolation to a contextualizing of the sights of the metropolis in response to modern systems of viewing. The idea of ways of viewing is taken up in Elizabeth McKellar's consideration of the suburbs. These are shown to be sites of interchange between rural and urban activities – both polite and raucous – which did not find expression in the polite *all'antica* architectural style of building so dominant in the city itself. The image of the metropolis as a place of augustan splendour and sophistication is squarely challenged by Diana Donald, who shows that metropolitan progress in terms of the increase in commodification and luxury was paid for by the increased inhumanity and deprivation to animals. Here again we return to the contrast between the country and the city where the innocence of the natural world of the suburbs and beyond is juxtaposed with the rapacious consumption and morally degenerate urban environment.

3

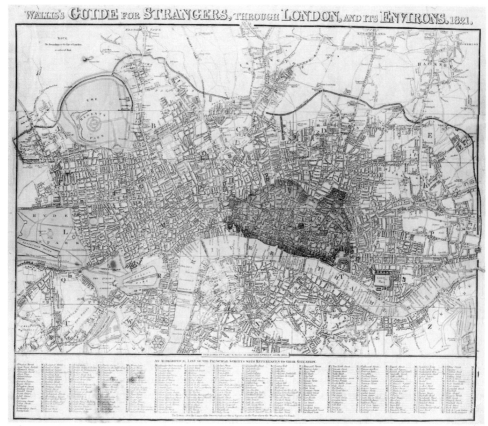

iii *Wallis's Guide for Strangers, through London, and its Environs. 1821.* Department of Prints and Maps. By kind permission of the Guildhall Library, Corporation of London.

The ideas of modernity and progress in the development of the metropolis rupture the relationship between the past and the present as feelings of nostalgia for the mother city run contrary to the processes of improvement. The removal of the physical remains of the old city – whether it be street plans or monuments like London Bridge – signify the removal of markers of different social and political systems and demonstrate the complex relationship between space and history. But the modern image of the metropolis has an on-going relationship to its past. Here the augustan theme of London as the new Rome re-occurs at different points in the city's evolution. The polite architecture of the eighteenth-century city together with writings on London present a version of Rome. But this re-imaging of London along the lines of Imperial Rome takes hold more strongly in the nineteenth century when Michael Port's Roman Aediles, charged with making a metropolis appropriate for the first city of empire, attempted to use Roman models for public buildings and the overall image of the London. This notion of a classical past surviving and influencing the present and its relation to a capitalistic, consumer-driven metropolitan society is seen further in Iain Black's consideration of the City of London – especially the large banks which were the financial heart of the imperial economy. Their headquarters, built in the early twentieth century,

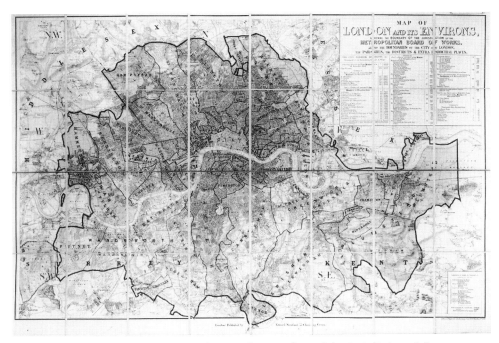

iv *Map of London and its Environs, shewing the Boundary of the Jurisdiction of the Metropolitan Board of Works. Also the Boundaries of the City of London. The Parishes, the Districts & Extra Parochial Places*. 1878. Department of Prints and Maps. By kind permission of the Guildhall Library, Corporation of London.

presented a potent image of their economic strength and London as the heart of the empire.

The resonance between the chapters is rich and rewarding; it is for the reader to explore their diversity and interaction and for the editor to thank the authors for their thoughtful and insightful contributions and commitment to this special issue of *Art History*. But of the many common themes in the book St Paul's cathedral stands out as a constant indicator of London. It serves as a locator for views of the city which might otherwise be understood as an anonymous cityscape so that images of Islington, Smithfield or St Martin's le Grand all include St Paul's. In this way it dominates the real and the virtual city. And it is here in the city of the mind that the volume ends: where Lacan meets the Lavender Hill Mob and the silhouette of the dome of St Paul's eclipses its hollow counterpoint – the Millennium Dome. This self-consciously constructed image of space and time cannot overtake London. It will be subsumed into the identity of the metropolis to become part of its histories.

Dana Arnold
September 1999

My thanks to Mr Jeremy Smith at the Guildhall Library for his help with the illustrations in this introduction.

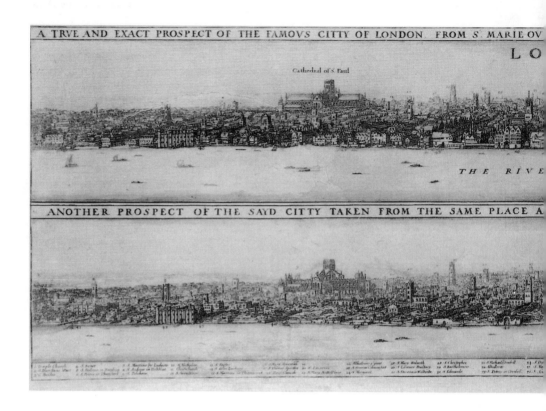

A TRVE AND EXACT PROSPECT OF THE FAMOVS CITTY OF LONDON FROM S. MARIE OV
L O

Cathedral of S. Paul

THE RIVE

ANOTHER PROSPECT OF THE SAYD CITTY TAKEN FROM THE SAME PLACE A

Aestheticizing the Ancestral City: antiquarianism, topography and the representation of London in the long eighteenth century

Lucy Peltz

Samuel Johnson's *Dictionary* (1755) defined 'Metropolis' as the 'mother city'. Forged from the Greek *mētēr*, the use of maternal metaphors for London had a long tradition in literature which reached its emotive peak in the poetic responses to the Great Fire of 1666. A notable case in point is Roger l'Estrange's *Vox Civitatis: or, London's Call to her Natural and Adopted Children; Exciting them to her speedy Reedification* (1666). L'Estrange, a Royalist pamphleteer turned Restoration Censor, made the poignant comment that London was a 'sad Mother ... Burnt by the raging Fire almost to th' ground'.[1] John Stow's *Survay of London* (1598), the first attempt to recount the successive phases of London's development, was also framed by his affection for 'my native mother and Countrey'.[2] Following Stow's example, antiquarian accounts of London were

6

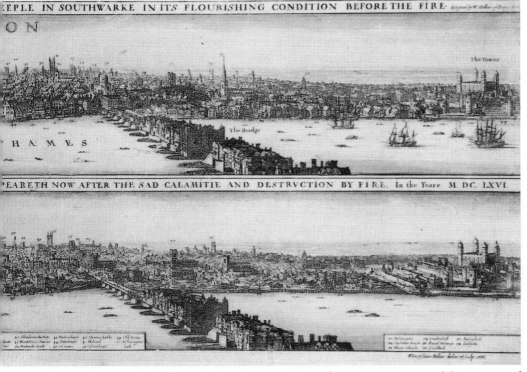

Wenceslaus Hollar, *London Before and After the Great Fire*, etching, 1666. Courtesy of the Museum of London.

published almost annually throughout the eighteenth century but these generally eschewed the use of metaphor. Representations of London as the nation's mother would, nevertheless, have had implicit cultural reverberations for eighteenth-century readers who had a remarkable appetite for antiquarian subject matter.[3]

Mother is part of us all, our progenitrix and a figure with which we can identify as home-maker – in myth and ideology, if not practice. Her symbolic function in relation to London was that of a common ancestor for the whole nation and a locus of collective identity. This evocative, maternal root highlights the importance of London, or, more exactly, London's myriad pasts as the birth place of national and cultural identity. In the words of Henry Hunter, an antiquarian author writing in 1811:

> The History of London and its Environs, though peculiarly appropriate to the inhabitants of those places, is important to readers in general, inasmuch as London is the centre to which every person, from the remotest parts of the island, is attracted at some period of life ... for the purpose of business or pleasure.[4]

While this statement brings out the universal allure of London, it also confirms that the concept of London's past was of national importance. This past was conceived, born and fed by antiquarian prints and literary accounts. Such

7

publications were widely disseminated and were enjoyed by a geographically diffuse audience and were not, therefore, predicated upon a presence in the metropolis. This fact was recognized and reinforced by Richard Gough who insisted that 'it was not till ... the invention of printing ... that we began to be acquainted with the face of our own country.'[5] Indeed, as a catalogue of all that had 'been done for illustrating the topographical antiquities of Great Britain and Ireland', Gough's extensive *Anecdotes of British Topography* (1768) demonstrates the great quantity of topographical representations that were in circulation by the mid-eighteenth century and, at the same time, the importance of this material in the study of mapping, history and chronology. These topics had been a seminal part of the ideal humanist education of young aristocrats since the seventeenth century and were additionally directed to young gentlemen by the start of the eighteenth century.[6] Such knowledge was viewed in patriotic terms as having 'immense political advantage' and enhancing the 'publick spirit'.[7] Thus young gentlemen were advised that 'It will be singularly beneficial for you ... to travel over most parts of this Kingdom.'[8] During such trips they were not only encouraged to observe scenes of trade and industry but also 'to take notice of monuments of Antiquity'.[9] Otherwise, it was feared, by pedagogues and parents alike, that England would be undervalued and that youths would be targets of foreign derision when making their Grand Tour.[10] In these circumstances, a specific knowledge of London was considered the *sine qua non*. This was made plain in Sir John Fielding's caution that it would be 'strangely preposterous ... for any person to embark in hazardous and expensive peregrinations' if he should 'appear at the same time to be deficient in his acquaintance with the beauties even of his own metropolis.'[11] Such words of advice were taken to heart by England's gentry. When, in 1787, the celebrated antiquarian and natural historian Thomas Pennant prepared his teenage son for a trip to the continent he accompanied him to London from their home in Wales, to help him form 'a comparison of the naval strength and commercial advantages ... of our island, with those of her two powerful rivals'.[12] Equally, from Pennant's manuscript reflection 'I was very unwilling that foreigners should find him ... *In urbe sua hospes* [In his own city a stranger] but was ambitious that he should support the honour of our name', he shows that topographical knowledge – the knowledge of one's own metropolis – remained the very basis of national and personal identity.[13]

Pennant's concerns and ambitions for his son appear to have been much informed by topographical and antiquarian literature such as John Strype's *A Survey of the Cities of London and Westminster and the Borough of Southwark* (1720) and William Maitland's *The History of London from its Foundations by the Romans to the Present Time* (1739). We know from the footnotes in Pennant's own *Some Account of London* (1791) that he was familiar with such texts and these volumes are just three of the plethora of antiquarian accounts which rehearsed a set-piece trajectory of London's history that invariably concluded with hyperbolic disquisitions on the contemporary 'Grandeur and Opulence of this vast City'.[14] But while these texts culminated in heroic celebrations of urban progress, their audience was sensitive to the fact that the anatomy of London was being violently reworked and that many of the visible remains of London's past were being completely erased. The rebuilding of London was of 'prodigious extent' and

the 'rage of building everywhere' was thought to be so ubiquitous that ardent antiquarians like John Britton reacted painfully to the 'many fine ... Buildings ... entirely obliterated, and others ... *daily* falling a prey to the slow but sure dilapidations of time, and the reprehensible neglect, or destructive hand of man'.[15]

Given London's position as the 'mother city', the disorientation caused by these transformations threatened a crisis in national and cultural identity, a crisis which was partially addressed by antiquarian engravings of texts, views of monuments and scenes of urban life which helped keep the past in sight. Just as exiles might hoard souvenirs and remnants of their original home in order to retain a sense of self, we could well interpret the antiquarians' often indiscriminate tendency to publish and collect representations of the past as an effort to come to terms with the perceived separation from the emotional motherland of London. The purpose of this essay, therefore, is to chart the responses to the city as documented by antiquarian prints in the long eighteenth century. Our aim is not to provide an architectural history of London; rather, it is to investigate what antiquarian prints tell us about the conflicting discourses of preservation and modernization and to question whether such disseminated representations could provide an effective alternative to actual engagement with the urban fabric.

Publish and Perish: the antiquarian dilemma in metropolitan representation

From the earliest activities of the Elizabethan College of Antiquaries, in the 1580s, the disparate interests of antiquarians were at least coherent in one shared objective: that antiquarianism should determine and confirm 'by historical or archaeological precedent the institutions of ... contemporary England'.[16] Consequently, a spirit of historical disclosure informed John Stow's survey which, though published without the help of illustrations, sought to uncover 'what London hath been of auncient time ... as what it is now every man doth beholde'.[17] Despite his promise of objectivity, Stow's account was underpinned by a patriotism, at once stalwart and parochial, that betrayed his deep conservatism towards urban growth and the changing appearance of London. He not only remembered physical details such as 'Fagges Well, neare unto Smithfield ... now lately dammed up ... [and] hardly now discerned', he also related his own childhood experience of fishing in the clear and open 'Towne ditch'.[18] No doubt it was this intimate quality, along with his observations of a Reformation and pre-Fire London, that ensured the enduring influence of Stow's *Survay* on many eighteenth-century accounts of the city, many of which show a clear debt to his taxonomic and thematic treatment of the subject.[19] Not surprisingly, the outdated character of Stow's portrayal of London was soon noticed by Edward Hatton, for example, who opined that 'the devouring Flames made such vast Alterations, what was in Mr Stow's time is now like another city.'[20] That was in 1708. But by the century's end Stow was no longer taken as a benchmark for the antiquarian survey, London but was an historical testament in its own right – one that evoked a particularly sentimental reading. His eventual resting place in the canon of antiquarian worthies is shown by John Thomas Smith's rhetorical question 'Can

we read . . . industrious Stowe [sic], or laborious Hollar, without emotion?'[21] John Thomas Smith was a major figure in the popularization of antiquarian London.[22] His etchings of London's ancient topography mark the rise of an antiquarian printmaking which implicitly critiqued old London and thus welcomed the onset of urban reforms and improvements (plates 8 and 9). But before turning to Smith in detail, we need to examine the traditions of antiquarian topography on which he drew, which serve to signal the ambiguous relationship between antiquarian prints and the depiction of sites of metropolitan antiquity.

The fashion for collecting English prints became increasingly popular in the early eighteenth century. And Wenceslaus Hollar (1607–77) was seen as the father of domestic printmaking.[23] This is evident, for instance, in George Vertue's hierarchical taxonomy of fourteen artistic categories, into which a collection of Hollar's work could be distributed. It was more for his numerous plates of English topography, however, that Hollar was granted a near-heroic status in the minds of later antiquarians.[24] This was evidently Horace Walpole's opinion when he proclaimed that 'till the arrival of Hollar the art of engraving was in England almost all confined to portraits.'[25] Nathaniel Hillier's judgement on 'the excellence of his execution' helps to explain Hollar's celebrity, but the currency of his prints, at least among eighteenth-century antiquarians, was largely due to the artist's own involvement with seventeenth-century antiquarians such as Elias Ashmole, along with the evocative charge of certain of his etchings of London.[26] Most emotive of all was surely his parallel long-view *London Before and After the Great Fire* (1666) (plate 1). Sketched from the spire of Southwark Cathedral, this comparative design was essentially a narrative composition, one where the first stage of its temporal dynamic was the commemoration of a lost vista – the 'Before' – and the second the devastations of the fire – the 'After'. By juxtaposing a thriving London, crowded with reductionistic signs of houses and church spires, against the relative ruin of the post-fire vision, this plate was an effective record of the trauma and loss generated by that conflagration. It is often argued that people experience nostalgia only after the 'internal relation between past and present' is made impossible by 'absolute disruption'.[27] Several twentieth-century commentators further agree that a 'requirement of nostalgia is that objects, buildings, and images from the past should be available' as the 'material objects from which nostalgia is constructed'.[28] Just such a reaction could be attributed to Hollar's etching, which, through its comparative strategy, reminds us of Jean Starobinski's premise of the 'memorative sign' which helps to kindle nostalgia.[29] Reinforcing this point is John Bowles's *A Plan of London in Q. Elizabeth's Days* (c. 1750) (plate 2) which – in medley format – collated miniature versions of Ralph Agas's map of 1560, one half of *London Before and After the Great Fire* and several of Hollar's vignettes of buildings destroyed in the fire. Bowles's print indicates that Hollar's various designs remained the archetypal way of envisaging the depredations of the Great Fire. But beyond this, its medley format, which emulates the antiquarian tradition of amassing fragments of information in cabinets of curiosity which could then provide a world- or over-view, also suggests the imaginative potential of such combined vignettes in presenting a gloss of past experience.[30] In the eighteenth century many of Hollar's original prints were already considered rare, but Bowles's antiquarian production reflects that, even at

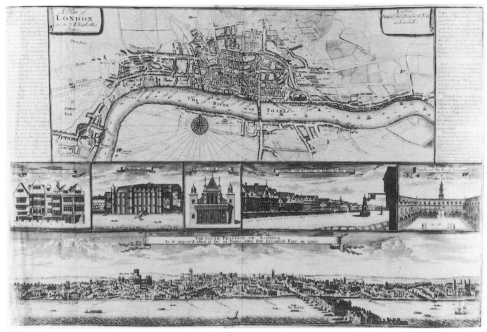

2 [John Bowles], *A Plan of London in Q. Elizabeth's Days*, engraving, *c.* 1750. © The British Museum.

the cheaper end of the print market, purchasers enjoyed the manifold possibilities of contrasting early images of London with references to its 'present magnitude'.

Hollar's *London Before and After the Great Fire* was an unique document which could never be imitated, although it was occasionally copied. By contrast, Hollar's series of illustrations for William Dugdale's *The History of St Paul's Cathedral in London* (1658) had a more enduring impact upon subsequent antiquarian representations of London. Dugdale's *St Paul's* was a work of rigorous archival research which was concerned to record 'by Inke and paper, the Shadows of them ... might be preserved for posteritie, forasmuch as the things themselves were so neer unto ruine.'[31] It was also one of the first coherently illustrated works of London topography. The appearance of a second edition in 1716 indicates that it remained of interest to antiquarians for several decades after its publication. From Walpole's complaint that 'extracts from Dugdale ... swell and crowd most of our histories', we know that his circle of antiquarian friends clearly took Dugdale's work for granted.[32] The inclusion of Hollar's west view of old St Paul's among the vignettes of Bowles's medley plate (plate 3) suggests that for ensuing generations of antiquarians Hollar's illustrations did, indeed, constitute the definitive visual record of a monument which burnt down six years after the volume's publication. The success of Dugdale's work and, tentatively, the style adopted for many eighteenth-century antiquarian representations of London both had their point of origin in Hollar's designs. The etching *Ecclesiæ Cathedralis Sti Paulis Ab Occidente Prospectus* (plate 3) characterizes the format of all his exterior views in which the size, monumental qualities and, by inference, the cultural importance of the structure were accentuated by the raised viewpoint.

11

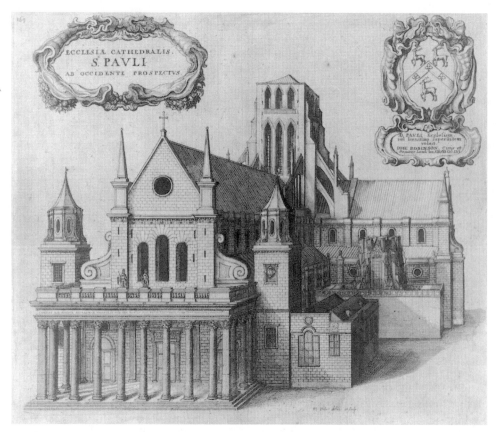

3 Wenceslaus Hollar, *Ecclesiæ Sti Paulis Ab Occidente Prospectus*, etching, *c.* 1658, published in William Dugdale, *The History of St Paul's Cathedral in London* (1658), p. 164. Courtesy of the Museum of London, Neg. no. 10971.

Further, setting the cathedral apart, removing it from the topographical clutter of its surrounding streets, ensured a clarity of visual information which could never be matched *in situ*. In Hollar's time the actual situation of old St Paul's, planted in the middle of a chaotic, medieval city 'deformed' by the 'congestion of Houses' and the narrowness of the streets, was deemed hugely unsatisfactory.[33] Even after London was restored and Sir Christopher Wren's St Paul's had risen from the ashes, such frustrations did not abate. Without the benefit of any coherent urban planning, vociferous objections abounded about London's 'endless labyrinth of streets', its 'tumultuous crowds' and its 'fine cathedral' 'coop'd up' in 'monstrous thraldom'.[34] For eighteenth-century viewers encouraged to value topographical prints because of their notional ability to 'represent absent Things to us, as if they were present … [and] convey us instantly, without Hazard or Expence, into the most distant Countries', Hollar's records of the past would, no doubt, have had a considerable resonance.[35] If topographical representations could, indeed, be enjoyed in such imaginative ways then, we can make sense of the later antiquarian usage of Hollar's graphic formula for illustrating London, where prints had the capacity to triumph over primary fieldwork.

The study of artefacts was absolutely fundamental to the antiquarian project and, as Arnaldo Momigliano put it, the literary text was generally 'subordinated' in favour of visual evidence.[36] Though many Fellows of the Society of Antiquaries did actively conduct fieldwork, the earliest entries in their minutes demonstrate the importance placed upon the collecting of representations of metropolitan antiquities – a comparatively passive mode of antiquarian inquiry. In 1720, the Secretary:

> W. Stukeley proposed ... that the Society should take Drawings of all
> the Old Edifices in London that have not yet been or not well done, and
> have them inserted from time to time in Mr. Stripe's [sic] Stows Annalls
> belonging to the Society which was agreed to: It was likewise added that
> Every Member be desired to buy all good prints of Such public Buildings,
> Monuments and the like that happen in his way at as reasonable a price as
> he can, which shall be repayd by the Treasurer out of the Societys money.[37]

By suggesting such a thematic collection of visual data to serve as a common fund of antiquarian information, this entry formalized Stukeley's earlier statement that 'Without drawing or designing the Study of Antiquities ... is lame and imperfect.'[38] By contrasting these two statements it becomes clear that antiquarians viewed their project as a rational science which, like natural history, elevated sight to primary importance and thus relied on visual representation as the very foundation of its researches. Consequently, they could not long rely on the vagaries of the individual Fellows' print collecting and Stukeley's proposal heralds their entry into the publication of metropolitan plates which eventually formed part of *Vetusta Monumenta* (1747–1906), their ongoing series of folio engravings.

Vetusta Monumenta was not principally concerned with London and its environs. But the importance of metropolitan topography is apparent in the forty plates, around one fifth of the Society's total publication, issued before 1815. Several of these plates are particularly indicative of the methods and expectations of antiquarian inquiry, the physical status of the monument and the way it triggered the historical imagination. These issues are all apparent in *Waltham Cross* (1721) and *King Street Gate Westminster* (1725) (plates 4 and 5), examples of the style George Vertue, the Society's engraver, espoused to promote the ideal that prints could act as identical transcriptions of antique prototypes.[39] To achieve this gloss of exact representation and overcome the two-dimensionality of the medium, Vertue attempted to resist charges of artistic capriciousness by asserting his own antiquarian credentials. He did so by invoking a hierarchy of printmaking, previously articulated by John Evelyn in his *Sculptura* (1662), where 'Burination' (i.e., engraving) was aligned with the manual labour of 'plowing' which was akin to the digging of archaeological excavation.[40] Privately, Vertue expounded this in numerous unpublished manuscripts, including his extensive Notebooks.[41] Publicly, he asserted this principle in many of his works and (despite some etched detail) this can be observed in these plates' basic formulation and execution. Like Hollar's plates of old St Paul's, *Waltham Cross* and *King Street Gate* are stereographic, front-lit views which placed the notional spectator just above street level but denied them any extraneous, evocative information to help

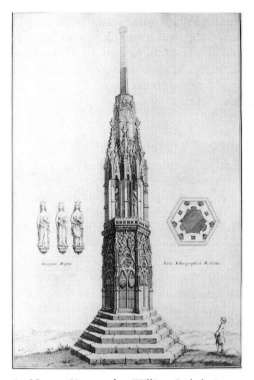

4 [George Vertue after William Stukeley], *Waltham Cross*, engraving, n.a., 1721, published in *Vetusta Monumenta*, I, pl. 7. © The British Museum.

locate these London structures in time and place. Apart from the scale references to human form – traffic or tourist – with which the viewer could identify, Vertue did not develop a human narrative to pinpoint the customs and practices relating to these urban monuments. Seemingly freed from the trappings of their contemporary situation, their singular, uninterrupted focus was, it would appear, crucial to the antiquarian desire for authoritive empirical information.

Such antiquarian representations were intended as diagrammatic 'illustrations of those minute particulars which would require volumes of description'.[42] And certainly the earliest subjects in *Vetusta Monumenta* actually remind us that engravings were not always valued as works of art.[43] So *King Street Gate Westminster* was published as part of a three-sheet fascicule, which included the corresponding depiction of *The Gate at White Hall* (1725) and another single sheet presenting the ground plans of both gates. Also seen on the single plate of *Waltham Cross*, this grouping of images set up an interplay of alternative categories of viewing. The first was representational – which placed the viewer in the same plane as the gate and thus attempted to recreate the visitor's experience. The second was linear, providing a theoretical overview of the relationship between the architecture and its immediate situation. 'Cross-referencing material bits of distant reality', as Barbara Maria Stafford has usefully suggested, was integral to the natural historians' and therefore antiquarians' method of synthesizing discrete parts to make up an 'encyclopedic' whole.[44] By providing 'Materials of Knowledge' to 'liberal' minds capable of abstract thought, the aggregate impact of these plates was, I imagine, intended to offer the antiquarian a comprehensive, all-round image which pretended to a three-dimensional view.[45] Moreover, when viewed in sequence in *Vetusta Monumenta*, such plates also promised their audience a more incisive and encompassing view than that afforded in reality where, like the figure depicted in *Waltham Cross*, they would be limited to viewing the monuments only from ground level. We may conjecture, once again, that such metropolitan representations served as valid alternatives to fieldwork or urban tourism.

The contemporary perception of Vertue's work as documentary evidence is suggested if we compare two differing appraisals from opposing ends of the critical spectrum. In 1768 the antiquarian Richard Gough praised the integrity of Vertue's

14

transcriptions by commending his 'extreme labour and fidelity'.[46] In contradistinction, William Gilpin, whose *Essay upon Prints* (1768) was part of the ongoing discourse on Taste, allowed that Vertue was 'an excellent antiquarian' but vehemently insisted that he was 'no artist'.[47] It transpires, therefore, that the early plates in *Vetusta Monumenta* were not viewed as works of art but were, instead, the results of antiquarian investigation which could answer the members' preconceived desire to 'capture the imperceptible'.[48] Despite Vertue's evident success in making the past visible for an antiquarian audience, the circulation of his prints contributed to the debate about the relative merits of publication and preservation.

Because the plates in *Vetusta Monumenta* intimated the results of quasi-scientific experiments conducted according to an established method, the Society and its audience were acutely aware of the question of their clarity and accuracy. Such issues were funda-

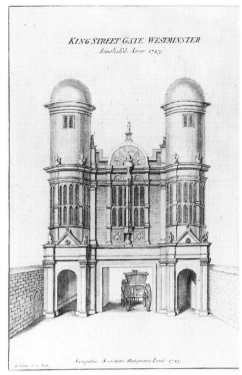

5 George Vertue, *King Street Gate Westminster*, engraving, 1725, published in *Vetusta Monumenta*, I, pl. 18. Courtesy of the Museum of London, Neg. no. 21137.

mental to the Society's corporate identity in the unchartable public perception that accompanied these plates' dissemination beyond the immediate circle of the Society of Antiquaries. Perhaps their sensitivity was related to the plethora of modest illustrations, produced by commercial draughtsman such as Benjamin Cole (plate 6), that were produced to elevate the many repetitive antiquarian accounts of London which were otherwise little more than 'vamped up' books 'consisting merely of disguised extracts' of repetitive text.[49] In these commercially led accounts of London, the compartmentalized, focused framework that the Society had championed for depicting metropolitan antiquities quickly found a broader audience. As a result the Society was keen to employ alternative methods to promote the sophistication and rigorous standards of prints that would officially bear its distinctive and aggrandizing endorsement 'Sumptibus Societatis Antiquariae Lond' (plate 5).[50] In order to establish the probity of this Latin certificate 'at the expense of the Society of Antiquaries of London' the Society was keen to assert the research that went into the production of each print. Many of the prints in *Vetusta Monumenta* were endorsed with inscriptions such as 'from an antient Drawing in the Possession of the Earl of Cardigan', which appears on a view of Richmond Palace in the time of Henry VII, or 'Said to be Design'd by Hans Holbein' which is seen on *The Gate at White Hall*. In contrast, the annotation on *King Street Gate* (plate 5) – which was agreed upon by a ballot of the members –

15

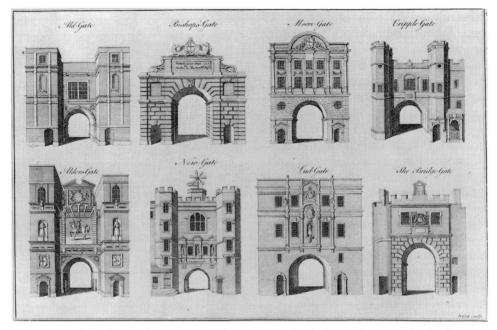

6 Benjamin Cole, [8 City Gates], engraving (*c.* 1756), published in William Maitland, *The History of London*, 2nd edn, 2 vols (1756), frontispiece, I. Courtesy of the Museum of London, Neg. no. 8999.

would seem to contradict its guarantee of authenticity as viewers must surely have realized the discrepancy between the actual status of the gate described as 'demolish'd Anno 1723' and this portrait, dated 1725.[51]

Antiquarians preferred to see the antique object *intact*; as a 'truly magnificent ... structure [which] was not that which most showed its age but that which, through careful ... refurbishment retained a fresh appearance in defiance of time'.[52] Representations encouraged this desire for a 'gloss of perfection' which enabled the viewer to imagine the subject in its prime – as it would have been experienced by its historical contemporaries rather than after years of neglect and redundancy.[53] This idea is most cogently supported by the etched adumbration of the lost finial and the pristine sculptures of *Waltham Cross* (plate 4). At one and the same time, these passages fulfilled the antiquarians' desire for visual accessibility and also, through the ephemeral character of the etched line, gave rise to a projection of things as they should have been. Whereas some of the earliest plates in *Vetusta Monumenta*, like Vertue's view of *Colchester Castle* (1732), did present subjects in a decidedly ruined and overgrown state, this was never true of representations of metropolitan antiquities. One explanation for this metropolitan distinction is found in Margaret Aston's argument that the 'ruins in a landscape' topos came about as a direct result of the ravages of the Dissolution and the resulting spectacle of ecclesiastical remains across the English country-side.[54] In London, however, church property actually suffered very little tangible damage as it was most often seized, deconsecrated and then awarded to Henry VIII's followers. Even the rubble left in the wake of the Great Fire had been quickly

swept away by the imperatives of rebuilding the commercial city.[55] As a result London had fewer noble and historical ruins than rural or provincial areas. In the later eighteenth century, a critique of architectural dilapidation and loss could, nonetheless, still be attached to London; it was situated in the increasing clash of 'heritage and improvement', as aesthetic standards, safety and traffic requirements led to large-scale rebuilding and the demolition of old structures.[56] Metropolitan buildings in manifest decay and the speed with which they were being replaced in the eighteenth century were two of the more incriminating signs of the eighteenth-century antiquarian's inability to halt the progress of modernization.

In the preface to the first number of *Archaeologia* (1770) Richard Gough reiterated that the Society's main responsibility was the protection of ancient buildings against 'vandals, souvenir hunters and ... restorers'.[57] The eighteenth-century antiquarians' unfortunate impotence in this regard was emphasized by their frequent publication of souvenirs of *lost* or dying buildings. Vertue's *King Street Gate* – which had been removed for road-widening – and his reconstituted spire of *Waltham Cross* are evidence of an antiquarian editing of the modern which refuted actual decay or demolition by fixing an impression on copper. The antiquarian faith that such graphic records provided an acceptable alternative to action was central to their perception of the urban dynamic. Preempting loss was, as already mentioned, the primary motivation behind works such as Dugdale's history of St Paul's. By the late eighteenth century, however, this passive approach began to present a moral dilemma for many antiquarians. Their anxiety, as we shall see, increased in direct correlation to the level of building work in the city. Whereas James Peller Malcolm's commercially oriented publication *Views within 12 Miles round London* (1800) was pleased to announce that his etchings would 'preserve the perishable Forms of many a Building whose Fate has been pronounced', his satisfaction was not shared by those critics who hoped for intervention on the part of the Society of Antiquaries.[58] In 1788 a correspondent writing to the *Gentleman's Magazine*, under the pseudonym 'D.N.', censured the Society's complacent, self-interested investment in printmaking rather than in more active forms of restoration and preservation. These ambiguities were clearly expressed in his lament that:

> The art of engraving, which helps to make ancient buildings known, and preserves their form to a certain degree, contributes ... to their demolition ... No matter if the engraving be *inaccurate* – or exhibiting only a *partial view* – or any other way deficient – when the engraving is made, farewell to the things engraved![59]

Taking Waltham Cross, which 'cr[ies] out for repair', as his prime example he dismissed the Society's continuing regard for Vertue's outdated engraving when, in reality, the actual Cross was so imperiled as to be 'ready to fall'.[60] As a precautionary measure, he encouraged the Society to use their influence to convince the owners of antiquities of their *private* duty in safeguarding their property for the *public* good. It was, however, in his suggestion that a fund for restoration 'would hardly cost more than the engraving of vile drawings' that the connection between the Society's practical impotence and their print production was most pointedly attacked.'[61]

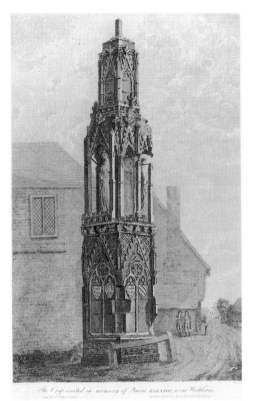

7 Isaac Basire after Jacob Schnebbelie, *The Cross erected in memory of Queen Eleanor, near Waltham*, etching, 1791, published in *Vetusta Monumenta*, III, pl. 16. Courtesy of the Museum of London, Neg. no. 15387.

In typical fashion, the Society reacted to D.N.'s scathing critique with another print: Jacob Schnebbelie's *The Cross erected in memory of Queen Eleanor, near Waltham* (1791), engraved by Isaac Basire (plate 7). If we compare Vertue's earlier rendition with this second plate of Waltham Cross, we witness the Society's changing response to metropolitan antiquities. Revelling in the influence of the Picturesque, one might ask how this fashionable, artistic style came to invade the plates of *Vetusta Monumenta* where, formerly, all signs of decay had been glossed over in the name of historical exactitude. One answer might be that the later Waltham Cross was published with a two-page text and a separate sheet where the necessary ichnography and sculptural detail were elucidated. As Schnebbelie's *Waltham Cross* was no longer an independent disseminator of antiquarian information, he was at greater liberty to emphasize the sentimental associations and ambience of this site. For an antiquarian audience used to seeing monuments frozen in their prime, the depiction of crumbling masonry and weeds situated Waltham Cross securely in the quotidian and as testimony of the inexorability of the decay wrought by time. By the 1790s the discourse on the preservation of antiquities had taken a new direction and the confident chauvinism with which such images were now published can be inferred from Richard Gough's anti-French polemic that 'I congratulate my country that so many monuments of art have yet survived ... while a *neighbouring Nation*, which was so stored with similar monuments, seems to have given them up a prey to a new system of policy.'[62] If England's enemies displayed such barbaric tendencies towards their past then, I argue, the very act of reporting such decay was a conciliatory measure which implied the enlightenment of permitting nature to run its course upon the fabric of national antiquities.

The Society of Antiquaries may have invested large amounts in publishing prints but, by the late eighteenth century, they could do little to conserve or restore the antiquities upon which their corporate identity rested. During the political upheavals of the 1790s they may have managed to turn this into a virtue, but D.N.'s earlier critique reveals the emergence of an antiquarian ambivalence which was specifically formulated in relation to the fate of metropolitan antiquities. D.N. looked 'upon these antique erections as national objects', but he

could not reconcile their preservation with the more public-spirited duties of building 'new bridges, and conducting new roads'.[63] Once the passage of metropolitan 'improvement' acts quickened around 1760, the Society's draughtsmen could do little more than 'rush to the bedsides of dying buildings [to make] their death masks'.[64] In consequence, the graphic record increasingly became the preeminent system for sustaining links with London's past in a cultural climate more aggressively attuned to the promotion of the city's commercial and international profile.[65]

The 'Improvements' of London and the Popularization of the Past

In the foregoing paragraphs I have attempted to show that antiquarian representations – though often considered problematic by their contemporaries – played an important part in shaping responses to London's past at a time when the appearance of that city was in flux. At the popular, more commercial end of the market (in contrast to the Society of Antiquaries) publishers were compelled to vie with each other and this gave rise to accounts of old London embellished with ever more pleasurable modes of picturing metropolitan customs and antiquities. A sense of the output of this industry is given in John Thomas Smith's Preface to his *Ancient Topography of London* (1810–15), where he complained that 'the country has … been inundated with histories of London, which have been stolen from each other, without adding a single record of new matter.'[66] (plates 8 and 9) In making this allusion and by continuing that 'Topographical books are frequently put aside by the inspector, as soon as the prints have been turned over', Smith attempted to market his own periodical publication as a more refined antidote to the genre.[67] It was certainly in the vanguard of a 'new style of embellishment; in which accuracy of representation combined with picturesque effect' succeeded in rendering antiquarian topography an 'object of fashionable pursuit'.[68]

Two representative plates from *Ancient Topography* which illustrate Smith's innovations are *South East View of the Old House Lately Standing in Sweedon's Passage, Grub Street* (1811) and *Houses Lately Standing on the West Corner of Chancery Lane, Fleet Street* (1812) (plates 8 and 9). Firstly, instead of individual monuments, they depict sites of vernacular architecture which 'for the most part were never before published' and, secondly, with their 'spirited' manner of etching, they appear unusually Picturesque in their 'close attention to mutilation … crumbled stone and decayed wood'.[69] In *Remarks on Rural Scenery* (1797) Smith had already shown an interest in the composition of the Picturesque which could be imposed upon a scene by including elements such as 'patched plaster … fissures and crevices of the inclining wall … [and] the mischievous pranks of ragged children'.[70] This visual vocabulary of the Picturesque can be seen at work in nearly all his plates in *Ancient Topography*; Smith, however, refuted this categorization by deriding other 'Topographical draughtsmen [who] introduce more than they see, in order to make their productions picturesque'.[71] Like Vertue before him, Smith's desire to deny his artistic intervention alerts us to the continuing expectation that antiquarian draughtsmanship should be a precise science. Though he deployed the Picturesque because of its undoubted commercial

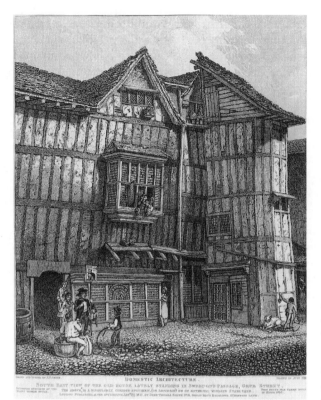

8 John Thomas Smith, *South East View of the Old House Lately Standing in Sweedon's Passage, Grub Street*, etching, 1811, published in *The Ancient Topography of London* (1810–15), facing p. 42. Courtesy of the Museum of London, Neg. no. 21321.

potential, Smith thus attempted to disassociate himself from the ramifications of a style whose very formulation was understood as artistic artifice and the strategic compilation of objects of aesthetic pleasure.[72] He did so by constantly gesturing towards the more empirical requirements of antiquarian data and by implying a level of intrepid fieldwork in his own 'discovery' of sites down darkened and insalubrious alleyways or when demolition or fire uncovered traces of London's historic structures. Additionally, by recording the date of his initial on-site sketch alongside formulaic phrases such as 'These Houses were taken down by the city in May 1799 to widen Chancery Lane', seen on *Houses Lately Standing on the West Corner of Chancery Lane* (plate 9), Smith's work responded to the needs of antiquarian topography and, as such, his views of lost antiquity had the capacity to generate a wide range of conflicting responses. Despite Smith's notational deference to antiquarian concerns, it would have been difficult for any observer to ignore that these scenes were chosen and composed for maximum moral and emotive effect.

In his discussion of picturesque prints, Tim Clayton has observed that these 'taught tourists what to appreciate in gardens or the natural landscape.'[73] While this is valid for rural subjects, as Smith promoted his *Ancient Topography* as an 'entertainment for the evening', we are alerted to the likelihood that viewers would have been grateful that they were distanced from the squalid sites that Smith presented.[74] William Hogarth and his competitors had certainly revelled in the human texture of the streets, but early antiquarian engravings had always

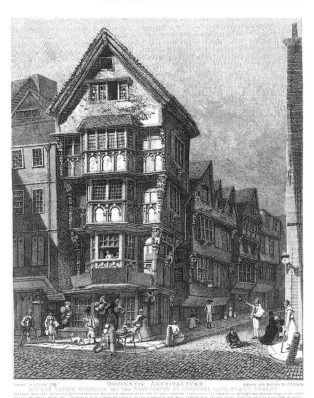

9 John Thomas Smith, *Houses Lately Standing on the West Corner of Chancery Lane, Fleet Street*, etching, 1812, published in *The Ancient Topography of London* (1810–15), facing p. 48. Courtesy of the Museum of London, Neg. no. 20614.

excluded the sort of human drama that typified urban life. Though topography and biography were inextricably intertwined in antiquarian accounts of the city, people were only mentioned when their noteworthy lives were invoked by their associations with tombs, palaces or monuments and other architectural features under discussion. Hence, by extrapolation, the sort of disenfranchised and abject characters who populate Smith's scenes never made an appearance in earlier topographical representations. On an aesthetic level, the incorporation of labourers, cripples, street vendors and the like was part of the Picturesque vocabulary that contributed visual variety to Smith's compositions. But as this urban poor scratch out their existence in the shadow of an antiquity to which they are oblivious, their presence turns these scenes into a form of impressionistic journalism which invites a variety of moral and social judgements relating to the city and its fabric.

For an audience sensitized to issues of antiquarian preservation the wretched figures with which Smith enlivened his London served as a comment on the architectural history and current conditions of the sites represented. Additionally, their dramatization with an urban underclass was, in Smith's view, intended to approximate 'a complete picture of former times'.[75] If read solely as representations of medieval London, Smith's images of overhanging, rickety buildings and blind courtyards would undoubtedly have added to the concept of a London once plagued by 'pestilence and perpetual fears of incendiaries'.[76] But

21

these were not simply images of an archaic past. The recent nature of these scenes was underlined, not just in their dated inscriptions, but also in Smith's insistence that characters such as the crippled 'Ann Siggs', hobbling along Chancery Lane (plate 9), were 'all drawn from life'.[77] Perhaps in order to mitigate this disturbing intrusion of *living* London into a work of antiquarian topography, Smith attempted to justify their presence as an analogy for 'London in former days, [which] has afforded characters for the pencil equally singular with those of the present time'.[78] This was, I suspect, a thin veneer; while the array of such dejected figures may have incited the sympathy of some viewers, the accompanying letter-press set up a more judgmental reading. Ostensibly depictions of ancient architecture, the moralizing content of these scenes was most emphatically engendered by Smith's antiquarian anecdotes which, in the case of *Sweedon's Passage*, recounted that the building – once the 'residence of Sir Richard Whittington' – had latterly been let out in tenements to poor people and had become 'a great nuisance', especially as 'A filthy old woman, who sold Duke Cherries on sticks ... occupied the upper wretched hole or loft.'[79] Making his opinions even more overt, Smith claimed that this 'lowest class of people' were less the victims than the perpetrators of 'frequent nuisances' and 'depredations' upon the ancient fabric that the City has 'suffered them to inhabit'.[80] Given that the shaping of urban space reflects the lifestyles that it fosters, it is not surprising that *Ancient Topography* can be interpreted as heralding the city's regeneration.

All this demonstrates that while Smith's *Ancient Topography* retained the patina of antiquarian data, albeit anecdotal, it was largely predicated upon a type of information and a mode of viewing which would have been unthinkable in early antiquarian imaging. No longer looking back nostalgically, the expected audience for such commercially oriented antiquarian publications was evidently looking forward to the sanitization and social regulation which was destined to replace such sights. The function of such representations of London's generic past – at a point of apparent closure – can be most cogently detected in *Vagabondiana* (1817) (plate 10), Smith's speedy response to the findings of the 1815 Select Committee on Vagrancy.[81] Preempting the later nineteenth-century interest in 'anecdotes and illustrations of deformed, eccentric, and sometimes crazed, persons on the streets of London', *Vagabondiana* is a series of portrait etchings which catalogued those 'curious characters' who, like the many decaying buildings of *Ancient Topography*, would soon be cleared away; 'compelled to industry' or 'provided for ... in their respective workhouses.'[82] Though *Vagabondiana* was promoted as a record for future antiquarians, in advising contemporary visitors how to distinguish 'the real object of charity' from 'the imposter', it served a far more immediately didactic purpose; one which capitalized upon the late eighteenth-century fashion for assessing social types according to physiognomy.[83] With its address to those who had found such beggars 'a pest for several years', *Vagabondiana* was less imbued with any regret for the clearance of these 'notorious' urban types than it was a celebration of the institution of 'parochial poor houses' which would soon result in the 'improvement of the streets', not just in aesthetic terms but also on a practical level for the visitor to London.[84]

By the early nineteenth century, the increase in population and the changes to the urban fabric were thought to have rendered London 'the epitome of the vast

and teeming modern metropolis'.[85] Though commentators often wrote of the alienating effects of its enormous scale and ceaseless motion, the 'highly charged' human spectacle of the streets of London was not, as Alex Potts has argued, singularly the province of literary representation.[86] The work of John Thomas Smith has demonstrated that London's social and architectural chaos could be visualized when it existed in a kind of temporal limbo: at a hiatus on a road heading from a once tangible past towards a phantasmagorical future. On condition that the site depicted was either condemned or recently removed, such detailed representations of low human life, due to their execrability, operated as synecdoches for the state of London's architectural fabric and the urgency of regeneration. Throughout the eighteenth century, treatises on 'metropolitan improvements' had drawn this parallel between urban environments and social life in their repeated proposals that London's architectural renewal would lead to a 'refinement' of morals, the increase of industry and the improvement of health.[87] Representations of London's ancient topography

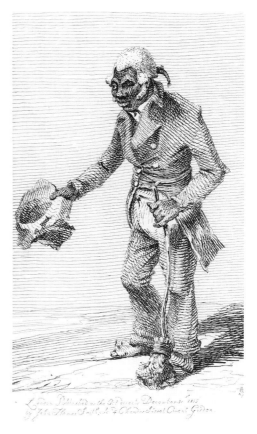

10 John Thomas Smith, [Untitled] (1815), etching, published in *Vagabondiana* (1817), n.p. Courtesy of the Museum of London, Neg. no. 10395.

as the eternal abode of disease and depravity should, despite their antiquarian bias, be interpreted in relation to the prevailing discourse on modern improvements rather than that of antiquarian preservation. Indeed, a dialectic between past and future underpinned the rhetoric of 'metropolitan improvements'. After all, the word 'improvement' denotes the process as much as the outcome and it was only through direct comparison of the old with the new that urban achievements could be assessed and the genteel reclamation of London promoted. The dogmatic confidence in the social and aesthetic advantages of such building projects can be illustrated by James Elmes's *Metropolitan Improvements* (1827) where the hyperbole of modern London's elegance and grandeur, with new 'healthy streets and elegant buildings' was repeatedly defined against the ancient disorder of 'pestilential alleys and squalid hovels'.[88]

Due to their expurgated nature, which tended to present London's antiquities as revered structures in their prime, earlier depictions of demolished monuments may have troubled the antiquarian conscience by reminding viewers of their inability to safeguard the objects of their attentions. Representations of the

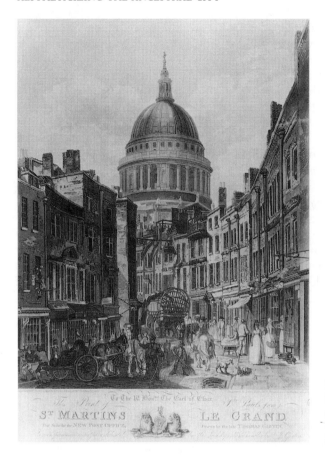

11 J. Baily after Thomas Girtin, *St Martins Le Grand* (1795), aquatint and etching, 1815. Courtesy of the Museum of London, Neg. no. 20693.

picturesque texture of such ageing monuments could equally have engendered wistful projections, but the advent of a more fully fleshed, socialized aesthetic for dramatizing London's past indicates the divergent concerns of a wider audience for antiquarian images. The extent to which antiquarian interests pervaded the popular perception of a London undergoing transformation can be deduced from John Girtin's publication of his deceased brother Thomas Girtin's (1775–1802) design for *St Martins Le Grand* in 1815 (plate 11).[89] Having grown up on St Martin's Le Grand, Thomas Girtin's sun-drenched sketch of 1795 reveals its artist's personal affinity for this bustling yet shabby location where sweepers and draymen cross paths with more fashionably dressed pedestrians. Twenty years later, when John Girtin eventually commissioned this aquatint, its message was intrinsically encapsulated by exactly these characterizations of contraflow problems, the commingling of social classes and the obscured view of St Paul's. Published to coincide with Parliament's decision to tear down St Martin's Le Grand for the construction of the new General Post Office, Girtin's plate was a celebration not of the past but of the future prognosis for this site. Robert Smirke's General Post Office, designed with Ionic porticoes and flanked by spacious routes along which the Royal Mail coaches could hurry, was eventually acclaimed the very apogee of modern achievement. But the building was not

inaugurated until 1829.[90] In 1815, therefore, when John Girtin issued this view, people could not yet know the exultant end point of this localized narrative of urban change and had to make do with depictions of what had been lost. If we accept that Girtin's portrayal of St Martin's Le Grand was not an uninviting scene, it served to justify modernization and at the same time to assuage the urban disorientation that must have accompanied such a lengthy programme of building works. To further consolidate the pastness of this view, Girtin inscribed the plate with two extra lines of antiquarian information (quoted directly from Thomas Pennant's *Some Account of London*), which summarized the Saxon foundation of the site, its control by the Dean of Westminster and the anomaly of its surviving status as a Liberty with 'the dreadful privilege of sanctuary allowed to Murderers, Robbers &c. &c.'. By drawing attention to the fact that it was only now that this archaic privilege was annulled, Girtin enhanced the appeal of *St Martins Le Grand* both as an antiquarian document and as a chronicle of urban history brought up to date. Though not in the mainstream of antiquarian publishing, *St Martins Le Grand* demonstrates that the celebration of modern London was a cumulative exercise and that any topographical representation could, potentially, contribute to this antiquarian mode of enjoying prints as a form of urban excavation. If, as Samuel Prout believed, some representations engendered peculiarly imaginative readings which allowed viewers to 'sit and securely traverse extensive regions ... without quitting the elbow chair', then the same armchair tourism could be true of time as well as space.[91] This was certainly the *Morning Herald*'s estimation when they advised that Thomas Girtin's now-lost panorama, known as the *Eidometropolis* (1800–01):

> might be fitted up, and form an elegant object in a Nobleman or Gentleman's park; it would be novel, and would furnish its owner with an opportunity of seeing London though in the Country, and would be particularly gratifying to his visitors, from the endless variety it contains. The Antiquary in a few years would see what London was, and mark the great alterations that are about to take place.[92]

<div style="text-align: right">

Lucy Peltz
The Museum of London

</div>

Notes

I would like to thank Mireille Galinou, Janice Peltz and Michael Willis for their support in the preparation of this article.

1 Roger l'Estrange, *Vox Civitatis: or, London's Call to her Natural and Adopted Children; Exciting them to her speedy Reedification* (London, 1666), n.p.

2 John Stow, *A Survay of London*, 2nd edn (London, 1603), n.p.

3 For an idea of the hundreds of illustrated antiquarian works on London see Bernard Adams, *London Illustrated 1604–1857* (London, 1983). For an introduction to the impact of English antiquarianism in the eighteenth century see, *Producing the Past: aspects of antiquarian culture and practice, 1700–1850*, eds Martin Myrone and Lucy Peltz (Aldershot, 1999), and Stuart Piggott, *Ruins in a Landscape: Essays in Antiquarianism* (Edinburgh, 1976).

4 Henry Hunter, *The History of London and its Environs* (London, 1811), p. xix.

5 Richard Gough, *Anecdotes of British Topography. Or, An Historical Account of what has been done for illustrating the Topographical Antiquities of Great Britain and Ireland* (London, 1768), p. iii.

6 *A Letter of Advice to a Young Gentleman at the University. To which are subjoined, Directions for young Students* (rpt, 1701, London, 1751), p. 12.

7 *The Topographer* (April 1790), p. 1 and ibid.

8 *A Letter of Advice*, op. cit. (note 6), p. 12.

9 ibid.

10 ibid., p. 13.

11 Sir John Fielding, *A Brief Description of the Cities of London and Westminster* (London, 1776), p. iii.

12 Thomas Pennant, *The Literary Life of the Late Thomas Pennant, Esq., by Himself* (London, 1793), p. 31.

13 Thomas Pennant, *From London to Dover*, 2 vols (c. 1789), MS extra-illustrated by Richard Bull. PLA Collection, Museum in Docklands.

14 Thomas Pennant's *Some Account of London* (London, 1791) was first published as *Of London* (London, 1790). William Maitland, *The History of London from its Foundations by the Romans to the Present Time* (London, 1739), p. v.

15 Don Manuel Alvarez Espriella [pseud. Robert Southey], *Letters from England* (rpt, 1807, London, 1951), p. 49. Letter from Horace Walpole to Thomas Mann, 16 July 1776, *The Yale Edition of Horace Walpole's Correspondence*, ed. W.S. Lewis, 48 vols (Oxford and New Haven, 1937–83), vol. 24, pp. 226–9 (p. 228). John Britton, 'Prospectus' for *Architectural Antiquities of Great Britain* (c. 1805), cited in Adams, op. cit. (note 3), p. 210.

16 Piggott, *Ruins in a Landscape*, op. cit. (note 3), p. 6.

17 Stow, *Survay*, op. cit. (note 2), n.p.

18 ibid., pp. 16 & 20.

19 Many examples which employed Stow's framework, either directly or in a somewhat modified form, could be cited, see for example John Ilive, *A New and Compleat Survey of London in Ten Parts*, 2 vols (London, 1742) or, Richard Phillips, *Modern London, Being the History and Present State of the British Metropolis* (London, 1804).

20 Edward Hatton, *A New View of London or, An Ample Account of that City* (London, 1708), n.p.

21 John Thomas Smith, *The Ancient Topography of London* (London, 1810–15), p. 1.

22 Felicity Owen, 'John Thomas ("Antiquity") Smith: A Renaissance Man for the Georgian Age', *Apollo*, vol. 140, no. 392 (October 1994), pp. 34-7.

23 For an excellent study of seventeenth-century printmaking, see Antony Griffiths, *The Print in Stuart Britain 1603–1689* (London, 1997).

24 George Vertue, *A Description of the Works of the Ingenious delineator & Engraver, Wenceslaus Hollar* (London, 1745).

25 Horace Walpole, *A Catalogue of Engravers, Who have been born in England; Digested by Mr. Horace Walpole from the MSS of Mr. George Vertue; To which is Added an Account of the Life and Works of the Latter* (Strawberry Hill, 1763), p. 2.

26 Letter from Nathaniel Hillier to Horace Walpole, 29 August 1763, *Horace Walpole's Correspondence*, op. cit. (note 15), vol. 16, pp. 63–8 (p. 64). Richard Godfrey, *Wenceslaus Hollar: A Bohemian Artist in England* (New Haven, 1994), p. 25.

27 Susan Stewart, *On Longing: Narratives of the Miniature, the Gigantic, the Souvenir, the Collection* (Durham and London, 1993), p. 142.

28 Malcolm Chase and Christopher Shaw, 'The Dimensions of Nostalgia', *The Imagined Past, History and Nostalgia*, eds M. Chase & C. Shaw (Manchester & New York, 1989), pp. 1–17 (p. 4).

29 Jean Starobinski, 'The Idea of Nostalgia', trans. William S. Kemp, *Diogenes*, vol. 54 (1966), pp. 81–103 (p. 93).

30 One of the key texts in the study of the cabinet of curiosity is O.R. Impey and A. MacGregor, *The Origins of Museums: The Cabinet of Curiosities in 16th-17th Century Europe* (London, 1985).

31 William Dugdale, *The History of St Paul's Cathedral in London* (London, 1658), n.p.

32 Letter from Horace Walpole to Samuel Lysons, 17 September 1789, *Horace Walpole's Correspondence*, op. cit. (note 15), vol. 15, pp. 201–3 (p. 203).

33 John Evelyn, *London Revived, Consideration for its Rebuilding in 1666*, ed. E.S. de Beer (rpt, 1666, Oxford, 1938), p. 3.

34 Espriella, *Letters from England*, op. cit. (note 15), p. 49. Robert Seymour, *A Survey of the Cities of London and Westminster, Borough of Southwark and parts adjacent*, 2 vols (London, 1734–5), vol. 1, p. 466. James Elmes, *Metropolitan Improvements; or, London in the Nineteenth Century* (London, 1827), p. 228.

35 *Sculptura-Historico-Technica: Or The History and Art of Ingraving* (London, 1747), p. v.

36 Arnaldo Momigliano, 'Ancient History and the Antiquarian', *Journal of the Warburg and Courtauld Institutes*, vol. 12, no. 2 (1955), pp. 285–315 (p. 285).

37 *Society of Antiquaries in London, Minute Book*, 14 December 1720, p. 37.

38 Entry in *Minute Book*, vol. 1 [c. 1718], cited in Stuart Piggott, *Antiquity Depicted: Aspects of Archaeological Illustration* (London, 1978), p. 7.

39 Vertue's career as the Society of Antiquaries engraver from 1717 to 1756 has recently been discussed in Martin Myrone, 'Graphic antiquarianism in eighteenth-century Britain: The career and reputation of George Vertue (1684–

1756)', *Producing the Past*, op. cit. (note 3), pp. 37–56.

40 ibid., pp. 45–8.

41 George Vertue, *Treatise on engraving, with drawings of various gravers* (1735) (esp. f. 47). Add. MS 23,081 ff. 39-60, Department of Manuscripts, British Library. See also George Vertue, 'Notebooks', 6 vols, *Walpole Society*, vols 18, 20, 22, 24, 26, 30 (1929–1952), esp. vol. 30, p. 143.

42 James Peller Malcolm, *Anecdotes of the Manners and Customs of London During the Eighteenth Century* (London, 1808), p. 2.

43 For the artistic potential of plates in *Vetusta Monumenta*, see Maria Grazia Lolla, '*Ceci n'est pas un monument: Vetusta Monumenta* and antiquarian aesthetics', *Producing the Past*, op. cit. (note 3), pp. 15–36.

44 Barbara Maria Stafford, *Body Criticism: Imaging the Unseen in Enlightenment Art and Medicine* (Cambridge, Mass., 1991), p. 44.

45 These matters were widely discussed in the eighteenth century. See, for example John Locke, *Of the Conduct of the Understanding*, ed. John Yolton (rpt, 1706, Bristol, 1993), p. 48.

46 Richard Gough, *Anecdotes of British Topography*, op. cit. (note 5), pp. xxxix.

47 William Gilpin, *Essay upon Prints*, 2nd edn (London, 1768), pp. 126–7.

48 Stafford, *Body Criticism*, op. cit. (note 44), p. 44.

49 Letter from Rev. William Cole to Horace Walpole, 12 February 1773, *Horace Walpole's Correspondence*, op. cit. (note 15), vol. 1, pp. 297–9 (p. 299).

50 The Society employed this publication line between 1720 and *c.* 1803. The term 'custody', in relation to their print publication, first appeared in the draft of their founding tenets. *Minute Book*, 1 January 1718, p. 6.

51 See *Minute Book*, 11 December 1723, vol. 1, p. 94.

52 D.R. Woolf, 'The Dawn of the Artifact: The Antiquarian Impulse in England, 1500–1730', *Studies in Medievalism*, vol. 4 (1992), pp. 5–35 (p. 25).

53 David Lowenthal, *The Past is a Foreign Country* (Cambridge, 1985), p. 145.

54 Margaret Aston, 'English Ruins and English History: the Dissolution and the Sense of the Past', *Journal of the Warburg and Courtauld Institutes*, vol. 36, (1973), pp. 231–55 (p. 232). H.C. Prince cites a number of early examples of melancholic response to ruined abbeys and monasteries in 'Modernization, restoration, preservation: changes in tastes for antique landscapes', *Period and Place; Research Methods in Historical Geography*, eds A.R. Baker & M. Billinge (Cambridge, 1982), pp. 33–43 (esp. pp. 39-41).

55 T.F. Reddaway's, *The Rebuilding of London after the Great Fire* (London, 1940), remains the most definitive account of these events.

56 Jonathan Barry, 'Provincial Town Culture, 1640–1780: Urban or Civic?', *Interpretation and Cultural History*, eds Joan H. Pittock and Andrew Wear (London and New York, 1991), pp. 198-234 (p. 218).

57 Richard Gough, 'An Historical Account of the Origin and Establishment of the Society of Antiquaries', *Archaeologia: or Miscellaneous Tracts, Relating to Antiquity*, vol. 1 (1770), pp. i–xliii (p. xxii).

58 James Peller Malcolm, *Views within 12 Miles round London* (London, 1800), n.p.

59 D.N., 'Correspondence', *Gentleman's Magazine*, vol. 58, no. 2 (August 1788), pp. 689–91 (pp. 689–90).

60 ibid., p. 689.

61 ibid., p. 690.

62 Richard Gough, *Sepulchral Monuments in Great Britain*, 2 vols (London, 1786–96), vol. 2 (1796), p. 293.

63 D.N., 'Correspondence', op. cit. (note 59), p. 690.

64 For a brief introduction to the improvement acts see John Summerson, *Georgian London* (rpt, 1945, Harmondsworth, 1978), pp. 123-32. Caroline Barron & Vanessa Harding, *English County Histories: A Guide*, eds C.R.J. Currie & C.P. Lewis (Stroud, Glos., 1994), p. 262.

65 Two of the most emphatic treatises on urban improvements are John Gwynn's *London and Westminster Improved* (London, 1766) and James Elmes, *Metropolitan Improvements* (1827).

66 Smith, *Ancient Topography*, op. cit. (note 21), n.p.

67 ibid.

68 Letter from John Britton to J. Norris Brewer, 24 August 1817, reproduced in J. Norris Brewer, *Introduction to the Original Delineations, Topographical, Historical, and Descriptive, Intitled the Beauties of England and Wales* (London, 1818), p. x.

69 Smith, *Ancient Topography*, op. cit. (note 21), p. 1.

70 John Thomas Smith, *Remarks on Rural Scenery; with Twenty Etchings of Cottages from Nature and Some Observations and Precepts Relative to the Picturesque* (London, 1797), p. 9.

71 Smith, *Ancient Topography*, op. cit. (note 21), p. 1.

72 The commercial appeal of the Picturesque is highlighted in Ann Bermingham, 'The Picturesque and ready-to-wear Femininity', *The Politics of the Picturesque: Literature, Landscape and Aesthetics since 1770*, eds Stephen Copley and Peter Garside (Cambridge, 1994), pp. 81–119.

73 Tim Clayton, 'The Print and the Spread of the Picturesque Ideal', *The Picturesque in Late Georgian England; Papers Given at the Georgian Group Symposium, 22 October 1994*, ed. Dana Arnold (London, 1994), pp. 11–19 (p. 16).

74 Smith, *Ancient Topography*, op. cit. (note 21), n.p.

75 ibid., p. 69.

76 Elmes, *Metropolitan Improvements*, op. cit. (note 65), p. 6.
77 Smith, *Ancient Topography*, op. cit. (note 21), p. 50.
78 ibid., p. 69.
79 ibid., p. 42.
80 ibid., p. 36.
81 Adams, *London Illustrated*, op. cit. (note 3), p. 263.
82 Donald J. Gray, 'Views and Sketches of London in the Nineteenth Century', in Ira Bruce Nadel & F.S. Schwarzbach, *Victorian Artists and the City: A Collection of Critical Essays* (New York, Oxford, Toronto, Sydney, 1980), pp. 43–58 (p. 51). John Thomas Smith, *Vagabondiana ! Or, Anecdotes of Mendicant Wanderers through the Streets of London* (London, 1817), p. v.
83 ibid., p. v.
84 ibid., pp. v, vi & 35.
85 Alex Potts, 'Picturing the Modern Metropolis: Images of London in the Nineteenth Century', *History Workshop*, vol. 26 (Autumn 1988), pp. 28–56 (p. 28).
86 ibid., p. 29.

87 Gwynn, *London and Westminster Improved*, op. cit. (note 65), p. viii.
88 Elmes, *Metropolitan Improvements*, op. cit. (note 34), p. 1.
89 Girtin's sketch is now at the Yale Center for Studies in British Art, see Susan Morris, *Thomas Girtin* (New Haven, 1986), cat. 32 & p. 23.
90 For a description of the workings of the Post Office see Herbert Joyce, *The History of the Post Office* (London, 1893).
91 Samuel Prout, *Rudiments of Landscape* (London, 1813), p. 17. My thanks to David Morris of the Whitworth Art Gallery for bringing this work to my attention.
92 William T. Whitley, 'Girtin's Panorama', *Connoisseur*, vol. 69, no. 273 (1924), pp. 13–23 (p. 16). Undated cutting, attributed to the *Morning Herald* (4 December 1802) and pasted into the Rev. Daniel Lysons, *Collectanea: or, A Collection of Advertisements and Paragraphs from the Newspapers, Relating to Various Subjects,* 4 vols, n.d., vol. 2, p. 177. C 103 K 11, BL. See also Morris, *Thomas Girtin*, op. cit. (note 89), pp. 23–5.

Peripheral Visions: alternative aspects and rural presences in mid-eighteenth-century London

Elizabeth McKellar

> No part of the kingdom, perhaps can present more attractive scenes than
> the environs of London; in which the man of leisure may find amusement,
> and the man of business the most agreeable relaxation ... rural elegance
> and rural beauty here appear in their most fascinating forms ... Extensive
> prospects charm the eye with undescribable variety: the landscape, less
> extensive invites the pensive mind to contemplation; or the creative powers
> of Art exhibit an Elysium where Nature once appeared in her rudest state.
>
> Preface to R. Lobb, *The Ambulator: Or, a Pocket Companion,*
> *in a Tour Round London*, 1782.

The vision of London as 'the new Rome' in the eighteenth century, the
magnificent, modern city at the heart of a great and expanding commercial
empire, has been widely accepted by both contemporaries and historians, albeit a
city in which 'the candlestick had replaced the column' in Jules Lubbock's
memorable phrase.[1] A distinctive urban, genteel identity was formed in the
classical environment of the newly built West End and 'the birth of the modern' in
this period has been associated with an exclusively metropolitan morphology and
milieu.[2] However, the polite enclaves of the élite were only one facet of a large
multi-centred connurbation. The built core consisted both of the Cities of London
and Westminster, as well as the Borough of Southwark with the multifarious
suburbs beyond. The capital, far from presenting a coherent whole, consisted of
multiple, distinct and sometimes conflicting environments. Daniel Defoe wrote of
it in *A Tour through the Whole Island of Great Britain*, 1724–6: 'It is the disaster
of London ... that it is thus stretched out in buildings ... and this has spread the
face of it in a most straggling, confused manner, out of all shape ... whereas the
city of Rome, though a monster for its greatness, yet was, in a manner, round with
very few irregularities in its shape.'[3] Just as Rome was defined by its hilly
topography, the Tiber and the Campagna, the lack of a definite boundary around
London resulted in blurred edges where open spaces contributed as much as the
built environment to the city's delineation and character. This essay argues that
we need to re-define and extend our concept of 'the urban' in this period to
incorporate the periphery as well as the centre, the impolite besides the polite, the

old alongside the new. The spas at Islington and Hampstead were a part of the alternative environment, both landscaped and built, of the London fringe. Their representation in both text and image in the middle decades of the eighteenth century was rooted in the particularities of local history and topography but at the same time was dependent upon and intimately related to the urban milieu. An investigation of these representations shows how urban identities were not solely constructed within the classical scenography of the West End but also extended into the fields and villages beyond.

City and country were closely connected at a number of levels throughout the long eighteenth century, most fundamentally their interdependence rested on the role of the adjacent rural areas in supplying food and produce to the town.[4] Londoners had long used the hinterland as part of their normal *locale* as a place for outdoor sporting activities, military exercises and for repose and relaxation. The landscape features of the capital were held to consist of the river environment of the Thames – most notably at Greenwich and Richmond, the flat meadowlands to the south, and what later became known as the 'Northern Heights' of Highgate, Hampstead and Islington.[5] Their purpose as urban playgrounds was greatly enhanced from the late seventeenth century onwards by the development of a range of commercial entertainments catering for all sectors of society, in which pleasure grounds, spas, inns, and tea and assembly rooms all vied for the custom of pleasure-seeking city dwellers. Guide books and traveller's accounts of the same period began to include the semi-rural zone as a new type of literature emerged which sought to convey the contemporary experience and distinctiveness of urban life. A strand which developed in opposition to the tradition deriving from Stow's *Survey of London*, first published in 1598, which concentrated on the historic core and perpetuated his antiquarian approach and subject matter; Strype's up-dating of the *Survey* of 1720, for example, was expanded only to include Westminster and the immediate suburbs.[6] There was an increased emphasis on providing practical information in these works which arose from their primary function as guide books. Edward Hatton's *A New View of London*, 1708, subtitled, *A Book useful not only for Strangers, but the Inhabitants*, took its format from a guide to Paris and was one of the first of this type, although his only forays outside the centre were to churches, such as St Mary's, Islington. Defoe in his *Tour*, 1724–6, devoted a separate section to the villages surrounding London, which he related were heavily used as dormitories by wealthy City merchants as well as providing playgrounds for day trippers. The view of the region presented in commercial guides of the period was necessarily heavily slanted to cater for the tourist itinerary. The much reprinted *Foreigner's Guide: Or a necessary and instructive Companion Both for the Foreigner and Native, in their Tour through the Cities of Westminster and London* of 1729 was produced in English and French in a facing-page format. In the 1740 revised edition the outlying parts form one of the four sections of the book, the others being: a description of the two cities; Palaces, Nobleman's Houses, Churches, Streets etc; and rates of coaches and watermen and roads to Dover and Harwich. The contents list indicates the elasticity of the concept of the London area, in accordance with the likely interests of visitors: 'A Description of the several Villages in the Neighbourhood; as Chelsea, Kensington, Richmond, Greenwich,

Woolwich &c. As also others more remote, viz. Hampton-Court, Windsor, Oxford, Cambridge, Bleinheim, Newmarket, Epsom, Tunbridge, Bath &c'.

It was not until the mid-eighteenth century that works devoted solely to the environs, as they began more commonly to be called, appeared. In 1761 the anonymous *London and its Environs Described*, known to be by Robert Dodsley, stated that although they 'contain many of the most remarkable feats and places in the kingdom, have never before been included in any account of that metropolis.' This was an exaggerated claim but his was the first book to include illustrations of the outskirts, (by Samuel Wale).[7] Dodsley presented his work in the language of the Grand Tour as 'a guide and instructor to the travelling Virtuosi ... in their little excursions to any part of these delightfully adorned and richly cultivated environs'. The plates were seen as being an integral part of the whole: 'we imagine they will not only be considered as an ornament, but that they will be found of use in illustrating the verbal descriptions.'[8] Dodsley's was the first account in which the balance shifted from a concentration on contemporary attractions to a more self-conscious presentation, in which historical and artistic associations took precedence. A trend escalated in subsequent works, such as R. Lobb's *The Ambulator: Or, a Pocket Companion in a Tour Round London*, which went through twelve editions between 1780 and 1820, and reached its culmination with Daniel Lysons, *The Environs of London, Being An Historical Account*, 1792–6, which combined picturesque nostalgia with the antiquarian diligence of a Stow, and which in its later extra-illustrated editions became hugely popular.[9]

Throughout the century much attention was given in the literature to the spa watering holes and pleasure grounds dotted all around the capital. *The Foreigner's Guide* of 1740 advised that, 'Near London also are several mineral and salutary Springs ... where in the fine Season People of all Ranks and Conditions resort either for Health or Pleasure.'[10] The two most popular waters, according to Defoe, were at Hampstead and Islington. To begin by examining the latter, which he considered to be within the circumference of London (a line of just over thirty-six miles by his calculations),[11] and which he inaccurately described as being, 'joined to the streets of London, excepting one small field'.[12] John Swetner's *View of the Cities of London and Westminster* (plate 12) shows that even in 1789, on the eve of Islington's major period of expansion, it was still several fields walk away from the ever-encroaching northern suburbs, while plate 13 by R. Dodd, executed two years earlier, testifies to the still predominantly rural aspect of the area. This was after the arrival of the New Road to connect Islington and Paddington, begun in the 1750s and extended eastwards in 1761 to the City.[13] Dodd's print presents two of the newly built fashionable Georgian terraces out in the fields to the north: Highbury and Canonbury Places of 1774–9 and 1776–80 respectively. By contrast, the elevated view shows that the character of the old area of settlement was very different, even in the late eighteenth century.

Swetner's panorama, taken from the steeple of the parish church of St Mary's, presents an image of semi-rusticity in the village set against the metropolis on the horizon. We can see here that the polite architecture of Highbury Place was by no means universal, although some classical terraces are visible snaking along the main roads. The foreground shows the area behind Islington Green, where the Upper and Lower Roads met, and is dominated by the irregular groupings, gables

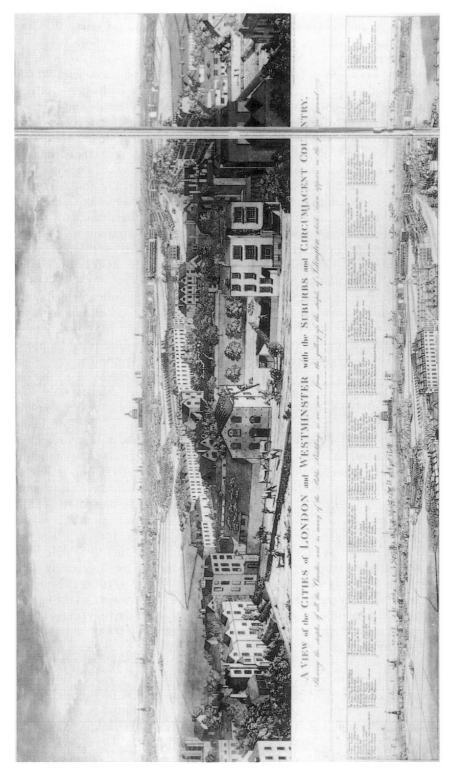

12 John Swetner, *A View of the Cities of London and Westminster with the Suburbs and Circumjacent Country*, 1789. By kind permission of the British Museum. The view was taken from the steeple of St Mary's, Islington. It was made possible by the use, instead of scaffolding, of an enveloping wickerwork structure while it was undergoing repairs.

13 R. Dodd, *The North View of Highbury & Canonbury Places*, 1787. By kind permission
of the British Museum. A view which while idealizing the haymakers in the foreground,
demonstrates very powerfully the abrupt physical relationship between the new terraces on the
outer fringes of the city and the green fields sites on which they were developed. The dome of
St Paul's may be glimpsed in the background.

and pitched roofs of a variety of residential, commercial and agricultural
structures and spaces of varying dates. Islington was known as the dairy of
London; in 1795 Daniel Lysons described it as 'principally occupied by cow-
keepers, and milk and butter (particularly the former) have long been noted as the
staple commodities of the place.'[14] Islington was also one of the main routes
connecting Smithfield market with the north and east and was an important
stopping point for those taking sheep and cattle to slaughter and sale there.[15] This
passing animal traffic and the holding pens on Islington Green and elsewhere
helped to promote this rustic image (see plate 22). The predominantly rural and
historic character of the village was captured by John Nelson in his *History of
Islington*, 1811, where he was admiring of 'the prospect down the Lower-street' in
which 'the irregular disposition of the houses, intersected and enlivened by the
variegated foliage of the different sorts of trees gives the scene a very agreeable
and picturesque appearance.'[16]

Islington's open aspect and the course of the artificially cut New River through
its fields had long made it popular as a place for fresh air and outdoor activities.[17]
The Foreigners' Guide reported in 1740 that, 'The Neighbourhood of the City

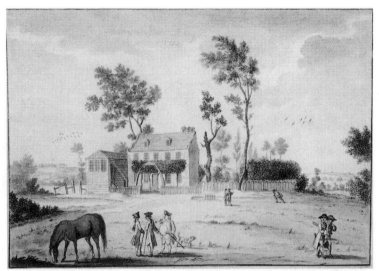

14 Anon, *Copenhagen House, Islington*, 1736. By kind permission of
the British Museum. This was a tea house in the fields to the west of
the village; the game of skittles was a speciality of the place. The
premises were greatly extended towards the end of the century when its
fortunes reached their height. The main building with its distinctive
gable ends was retained, however, and a new wing also with a
prominent external staircase was built at right angles replicating exactly
the position of the earlier weatherboarded structure.

makes it very much frequented.'[18] Wenceslaus Hollar, one of the first artists to
depict London's landscapes, portrayed it as place of lonely retreats and solitary
contemplation in his six *Views of London* of 1665 – all of Islington, and taken from
the Waterhouse on the New River. The area was transformed at the end of the
seventeenth century with the discovery in 1683 by Mr Sadler of a medicinal spring
in the gardens of his music house which he opened as a spa. This was followed in
quick succession by the establishment of its rivals: the New Tunbridge Wells or
Islington Spa, the Royal Oak, the White Conduit House and the London Spa. The
Islington pleasure houses fortunes waxed and waned during the long eighteenth
century, reaching their peak of fashionability in the 1730s, but throughout they
maintained a reputation for an exceptionally socially mixed clientele.

In response to this diversity a dual mode of depicting the Islington resorts
developed which veered between the wholesome and the licentious. Representa-
tions continued to present the area as a healthy, open space for family outings and
sporting activities, particularly fishing and shooting, as seen in plate 14. Scenes
showing the urban middle classes in their semi-rural playground, the poor man's
equivalent of the country estate, were common and frequently satirical in nature.
The *Gentleman's Magazine* wrote of Islington in 1791: 'Despise it not, because the
plodding cit there seeks to inhale a little fresh air, or his holiday prentice and
sweetheart regale with tea and hot rolls at White Conduit House.'[19] It was one such
'plodding cit' that Hogarth depicted in his engraving *Evening* of 1738, in which the
pretensions of the mercantile City élite to the aristocratic pastoral are portrayed
through the pathetic figure of a cuckolded dyer strolling with his wife and children

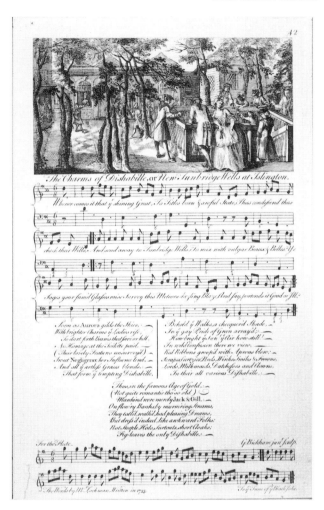

15 George Bickham Junior, *The Charms of Dishabille*, or *New Tunbridge Wells at Islington*, 1733. By kind permission of the British Museum.

along the New River past Sadlers Wells and the Hugh Myddleton Tavern. The plate was taken from *The Times of the Day* paintings commissioned for the rival attraction of Vauxhall Gardens by Jonathan Tyers in an attempt to differentiate his more refined riverside grounds from the plebian establishments to the north.

The spas around London promoted themselves for their health-giving purifications, fresh air and open countryside but they were also known as venues for drinking and gambling and gained a more ambiguous reputation as places of sexual immorality. From F. Colsoni's *Le Guide de Londres* (1693) for French visitors and Ned Ward's *The London Spy* of 1709 onwards the less respectable inns and pleasure grounds, particularly those of Islington, became a staple of sex tourism guides and low-life accounts of the city. This alternative tradition informs the Bickham view of *New Tunbridge Wells*, 1733, produced at the height of its success, when it was patronized by the Princesses Amelia and Caroline (plate 15). The poem is a risqué ditty by Lockman entitled *The Charms of Dishabille*, in which the potential risks and misalliances of mixed company, in both senses of the word, are titillatingly celebrated. The depiction of the healthy pleasures of the taking of the

waters and the enjoyment of the attractive grounds are juxtaposed in the plate with the more equivocal message both of the song, which asks whether such behaviour 'portends Good or Ill?', and the image itself, in which the languorous poses of those shown positioned round the stairs drinking from the spa, particularly that of the woman in the foreground, speak of the possibilities of unorthodox encounters in an intermediate space. A space neither town nor country, neither wholly occupied by the polite nor the impolite, an ambiguous arena in which it is suggested the normal moral and social codes of conduct might be suspended.

This indeterminacy was also the hallmark of the area's architecture. Islington's metamorphosis into an urban pleasure ground was not matched by any equivalent physical transformation. As the illustrations show, activities took place in the fields which had ringed the capital for centuries – dotted with cottages, inns and other structures, largely vernacular in feel and at most only semi-classical in style.[20] The various spas were largely housed in existing buildings which could generally be characterized as rustic until at least the latter half of the century, as can be seen in plate 16 of Sadlers Wells. In fact, the spring there dried up in 1697 after which the entertainments became the main attraction – along with a tea house. The entry in *The Foreigners' Guide* of 1740 states: 'Here you have all the Summer, Rope-Dancing, Vaulting, Singing, Musick &c. and every Evening there is a farce acted, which every Body may see, drinking and paying for one Bottle of Wine.'[21] The print published by Robert Wilkinson in 1814 provides two views of the building in its pre- and post-1764 states, the date of its rebuilding. The earlier view by George Bickham junior is of 1728 which was also placed above a song, in a similar fashion to his print of New Tunbridge Wells.[22] But whereas the latter presented an image of sophisticated, wordly pleasures for knowing urbanites, in the former the pretence of rural innocence is maintained. The song celebrates the bucolic setting of the resort beside the New River with its opportunities for healthy activities such as fishing as well as the other attractions, concluding with a paen of praise for the sweet air for which it was renowned.

> There pleasant streams of Middleton,
> In gentle Murmurs glide along:
> In which the sporting Fishes play,
> To close each weary'd Summers day:
> And Musicks Charms in lulling sounds,
> Of Mirth and Harmony's abounds:
> ...
> And Zephyrs with their gentlest Gales,
> Breathing more sweets than flow'ry Vales,
> Which give new Health and Heat repells,
> Such are the Joys of Sadlers Wells.

It is likely that this print and the poem were commissioned by the spa's owner at the time, Mr Forcer, as part of a commonly employed marketing strategy under which the semi-rural attractions of the hinterland were continuously promoted within the metropolis through the sale of prints and other souvenirs and in due course tickets as well. The 1733 publication *Islington: Or, The Humours of New*

16 Robert Wilkinson, *Sadlers Wells*, 1814. By kind permission of the British Museum. This plate combines R. Andrew's view of 1792 and George Bickham's of 1728 showing the building before and after its rebuilding in 1764.

Tunbridge Wells, for example, was advertised as being sold by 'the Pamphlet Shops of London and Westminster, and Miss Reason at the Wells'.[23] The exaggerated pastoral and mythological allusions of the song create an atmosphere of sylvan refinement, but far from taking place, as one might expect, in a suitably classical environment, the entertainments were housed in a pre-Georgian semi-vernacular building (plate 16)[24] set in a secluded walled garden. Seclusion had its pitfalls, however, and Forcer had to shift the programme to begin at 5pm and finish before nightfall after the City Marshal was robbed by three footpads on entering Spa Field in 1733.[25] The perils of journeying to Islington and even more so to Hampstead, a notorious highwayman's haunt, remained a perennial problem and various remedies were tried over the years, including armed escorts and specially chartered coaches.[26]

When Thomas Rosoman, a local builder, took over Sadlers Wells in 1746 the lease described the premises as 'the Brewhouse Storehouse Stables Granary Sheds Yards Walls Gardens Walks Trees Outhouses & other Buildings together with the Stage Benches & Galleries thereunto belonging and also all Ways Passages, Lights Pavements Water Springs Wells Watercourses Cellars Vaults Fixtures etc'.[27] In this list none of the structures is described in terms of their entertainment purposes, although other functions are clearly delineated, emphasizing the extent to which the enterprise was housed in converted buildings which retained their previous character and associations. Rosoman resurrected the Wells' fortunes as a palace of entertainments, following a period when it had been closed down for immorality. He pulled down the old rooms in 1764 and built a new theatre and a house for himself which can be seen in the upper print (plate 16) by Andrews. This was the building Wordsworth recalled visiting in 'The Prelude' in his youth, in the

years 1788–1802, calling it 'Half-rural Sadlers Wells' where he saw 'giants and dwarfs, Clowns, conjurors, posture-masters, harlequins'.[28] Although the second building incorporated classical features and proportioning, it retained a rustic feel with its steeply pitched roofs, the weather-vane on top of the theatre building and the dormer windows above the house. The illusion of absolute isolation was no longer sustainable and new terraces and buildings are visible in the background. The surroundings were also updated with the addition of lamps and railings along the river in the grounds. By this date urban nuisances were beginning to intrude and in c.1775 a wall and iron railing was placed along the Wells walk on the other side of the river to prevent passers-by 'throwing in their dogs, etc'.[29]

Islington, despite its proximity to the capital, maintained a rural aspect and vernacular buildings until the end of the eighteenth century. In the village this was probably more a matter of lack of need and opportunity rather than anything more conscious, survivalism rather than revivalism to employ Howard Colvin's useful distinction.[30] But with the vastly expanded number and range of entertainment venues which dotted the fields this was survivalism of a different order. Given the competition to provide novelty and even excess, the image projected by the buildings of Sadlers Wells of stability and permanence may seem puzzling. It seems likely that the failure to transform the attendant architecture into the polite classicism of the town was not a matter of oversight or neglect but a deliberate ploy to help provide a country feel. The spas adjacent to London marketed themselves as a more convenient alternative to those further afield, particularly Epsom and Tunbridge Wells. To emphasize the purity of their product the spa owners sought to perpetuate a rustic environment redolent of healthiness and tranquillity, even paradoxically, as this was being undermined by the large number of townspeople who flocked to them. New forms of social interaction and entertainment were being housed here but this does not mean that new forms of architecture were necessarily deployed to do so. Modernity, urbanity and the classical did not form an indissoluable holy trinity and in the case of the outer London spas new forms of entertainment and social engagement were accommodated within an environment constituted predominantly by the traditional and the rural.

To turn now to Hampstead which, like Islington, first became fashionable in the late seventeenth century with the opening of several spas and associated assembly rooms, shops, taverns and pleasure gardens. This first phase of popularity was short-lived and by the 1720s Belsize House to the south was enjoying most of Hampstead Wells' custom. Its fortunes revived in the 1730s and it remained a genteel resort for the rest of the eighteenth century.[31] Hampstead, in contrast to its southern neighbour Islington, was approximately four miles from the centre, and its greater isolation plus its spectacular position led to the creation of a particular identity, a hilltop *urbs in rure*. Situated on the slopes of one of highest hills around London, at its summit 443ft above sea level, it lies on a sandy ridge which runs from east to west forming the Northern Heights, which can be seen in John Rocque's map (plate 17).

Hampstead's spectacular growth and transformation from just another outlying village in the county of Middlesex was commented on by Defoe in the 1720s:

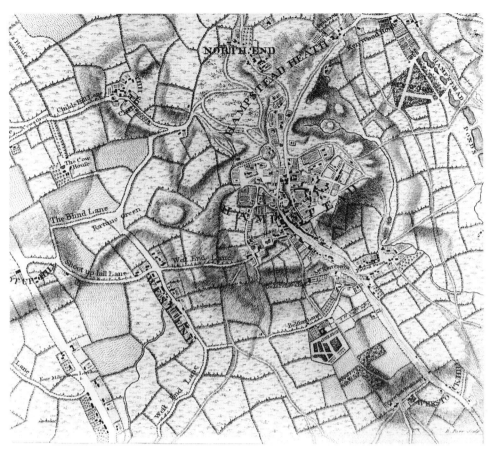

17 John Rocque, *An Exact Survey of the City's of London Westminster ... Southwark and the Country Near Ten Miles Round*, 1746. By kind permission of the Guildhall Library, Corporation of London.

> Hampstead indeed is risen from a little country village, to a city, not upon the credit only of the waters, though 'tis apparent, its growing greatness began there ... nor could the uneven surface, inconvenient for building, uncompact and unpleasant, check the humour of the town, for even on the very steep of the hill, where there's no walking twenty yards together, without tugging up a hill, or straddling down a hill ... But it must be confessed, 'tis so near heaven, that I dare not say it can be a proper situation, for any but a race of mountaineers, whose lungs have been used to a rarified air, nearer the second region, than any ground for thirty miles round it.[32]

Hampstead, according to the guide book *London in Miniature* of 1755, consisted of three distinct parts: the Village, the Wells further up the hill and the Heath.[33] The village was the existing settlement centred around the pond and the green – the area marked Pound Street on Rocque's map – and then continuing up the High Street. The area to the east of the High Street was the new development around the Wells, while further north and west large individual mansions can be seen.

39

These began to be built from the late seventeenth century onwards as out-of-town residences by the 'citizens and merchants of London', who were the 'chief inhabitants' of the place according to Dodsley.[34] The Heath at this date comprised the area of common land to the east and north of the settlement.

The Village consisted of a similar mix of buildings to those found in Islington, as can be seen in plate 20 (see page 508). For the most part it consisted of cottages, alleys and courts designed and arranged in a traditional fashion. A nineteenth-century description from James Thorne's *Handbook to the Environs of London*, 1876, conveys both its essentially cramped conditions and labyrinthine layout when viewed with a robust Victorian eye:

> The *Town* straggles up the slopes of the hill, towards the Heath on
> the top, in an odd, sideling, tortuous, irregular and unconnected fashion.
> There are the fairly broad winding High Street, and other good streets ...
> and alongside them houses small and large, without a scrap of garden, and only a very little dingy yard; narrow and dirty byways, courts and passages, with steep flights of steps, and mean and crowded tenements.[35]

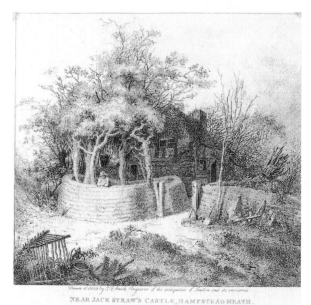

NEAR JACK STRAW'S CASTLE, HAMPSTEAD HEATH.

18 J.T. Smith, *Near Jack Straw's Castle, Hampstead Heath*, 1797. By kind permission of the British Museum.

On the Heath itself even more unprepossessing habitations could be found. Plate 18, *Near Jack Straw's Castle*, 1797, shows the type of temporary settlements which were common. These improvised cottages were to be found on any expanse of level ground and the one shown here was possibly part of a long-established hamlet called Littleworth, which stood on the summit and commanded spectacular views south to London and north to Hertfordshire.[36] The prime position was to be its undoing and in the early nineteenth century it was demolished to make way for villas with names such as Heath View, The Hill and Heath House. Such humble dwellings did not begin to be illustrated until the latter part of the eighteenth century, when they acquired antiquarian and picturesque interest.[37] Around the same time similar properties were colonized by incomers as bijou residences, particularly at the Vale of Health, where a bog was drained and dammed by the Hampstead Water Company in 1777 to form a new reservoir. Initially the lack of any elevation was thought to make the site suitable only for a row of cottages for the parish poor, but within ten years they were inhabited by

figures such as Leigh Hunt, becoming the centre for his bohemian circle.

Those who established squatter settlements on the Heath used the common land to graze their animals and cut turf and peat for fuel. The squatters hoped in time to become copyholders, who paid a fine for life to the Lord of the Manor, which provided him with an income and was cynically used, according to John Middleton, to help to reduce the parish's provision for the poor.

> Cottagers who live on the borders of commons, woods and copses, are a real nuisance, from the circumstances of a considerable part of their support being acquired by pilfering. ... The erecting of a cottage, and placing a poor family on the waste, and close to a wood, is a certain means of relieving the parish, at the expence [sic] of the proprietors of such property. This kind of grant, made in the front of other land, in the vicinity of London, or any other increasing town, is a serious loss to the owners of such land, as much of its value depends on its fronting a road or a green, and also in not having an unsightly cottage close to it.[38]

19 Flask Walk, Hampstead, first quarter eighteenth century, showing the low building line, prominent roofscape and broad proportions which resulted in a townscape different in feel and scale from that of the city centre. (Photo: Author).

The unsightly cottages and haphazard developments on the Heath were paralleled by a lack of regular arrangements in the town, even in the newly developed area around the Wells. This may have been partly due to its hilly topography, as Defoe thought, which discouraged regularized planning. It may also have arisen from the more individualistic nature of development in the outlying areas, as opposed to the large-scale estate operations of the centre, which resulted in a greater variety of arrangements. There were only two attempts to adopt formal layouts: Hampstead Square 1700–20, which for many years only consisted of a single terrace, and Church Row, begun in the early eighteenth century but not finished until the 1770s. The Row was intended for sub-letting to visitors to the Wells and the lack of individual mews behind it suggests that the houses were never envisaged as more than short-term residences. Rocque's map of 1746 (plate 17) shows it extending westwards from the High Street but not yet meeting up with the new church completed in the following year.[39] It was a relatively level street and with the church at one end provided one of the few opportunities for conventional topographical prospects. However, as Simon Jenkins comments, 'It seems an incongruously urban structure, isolated on the Middlesex hillside as if waiting for the new town to come out and rescue it.'[40] Even a central thoroughfare such as

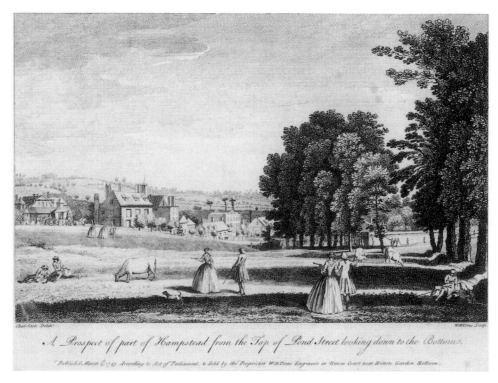

Chatelain Delin. W.H.Toms Sculp.

A Prospect of part of Hampstead from the Top of Pond Street looking down to the Bottom.

Publish'd March 25 1745. According to Act of Parliament, & Sold by the Proprietor W.H.Toms Engraver in Union Court near Hatton Garden Holborn.

20 J.B.C. Chatelain, *A Prospect of part of Hampstead from the Top of Pond Street looking down to the Bottom*, 1745. By kind permission of the British Museum.

Flask Walk which led down to the Wells was built in a vernacular idiom (plate 19). In 1755 it was described as a place, 'where a constant Assembly is kept during the Summer, and frequently Balls and Concerts of Musick'.[41] The gatherings, which included tea, evening and card parties as well as dances, took place from Whitsuntide until October, a guinea subscription admitting a gentleman and two ladies to the Ball Room every other Monday. A new Long Room was built in the 1730s which plate 21 shows to be a plain, two-storey building,[42] on which Fanny Burney's eponymous heroine in *Evelina* of 1778 appositely commented, 'this room seems to be very well named, for I believe it would be difficult to find another epithet which might with propriety distinguish it, as it is without ornament, elegance, or any sort of singularity, and merely to be marked by its length.'[43] Far from being an aberration the Long Room was in keeping with the rest of the surrounding environment which was traditional in character and style, as can still be seen in the surviving eighteenth-century architecture and layout of Hampstead and its close neighbour Highgate. At Hampstead, as at Islington, the approach deployed at Vauxhall Gardens of utilizing modern art and architecture in the service of commercial success and increased respectability was eschewed. Instead, in the case of these existing villages the reverse strategy seems to have been employed and the vernacular, with its associations of continuity, stability and permanence, was used to enhance an atmosphere of rusticity and informality, thus perpetuating an alternative environment to that of the town.

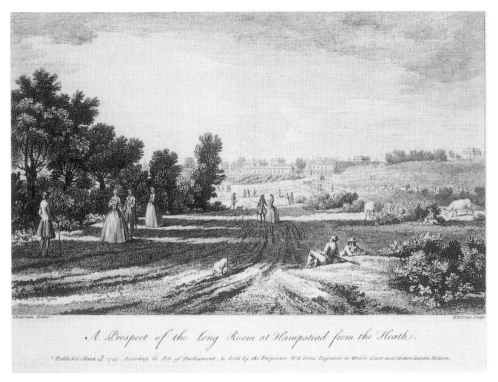

A Prospect of the Long Room at Hampstead from the Heath.

21 J.B.C. Chatelain, *A Prospect of the Long Room at Hampstead from the Heath*, 1745. By kind permission of the British Museum. The Long Room is to the left, the Ball Room to the right. Behind the former can be seen Burgh House, the residence of the spa doctor.

Jean Baptist Claude Chatelain's *Prospects of Highgate and Hampstead*, 1745 (reissued 1750 and 1752), was the first major series of views of Hampstead (plates 20 and 21). It created a new classicizing, genteel image for the spa very different from that of the prints of the 1720 and 1730s of the Islington resorts. The 'rural' still provides the dominant theme but under the hand of the Frenchman the rustic has been replaced by the elegant pastoral. Chatelain (1710–71) was one of a number of European artists who were satisfying a demand for landscapes in the manner of Poussin and Claude in the 1740s.[44] He was used by Samuel and Nathaniel Buck, along with Gravelot, for their town panoramas when they switched from a Dutch-influenced to a French look from 1743,[45] and he worked for Arthur Pond around the same time in making a series of landscapes after Claude and Gaspard Dughet.[46] He was in the vanguard of those who began to use the classical style not just for foreign but also native views, transforming the existing topographical tradition.[47] His *Prospects of Highgate and Hampstead* comprised eight views and were promoted in the *General Advertiser* of 1745 as being available at five shillings for the set from W.H. Toms at Union Court, Holborn.[48] Chatelain revitalized the depiction of the spa by a careful elimination of any actual details of its operations and clientele and a concentration instead on the magnificent landscape in which Hampstead was situated. He shifted the focus to the Heath which with its walks, fine views and scattered hostelries had become

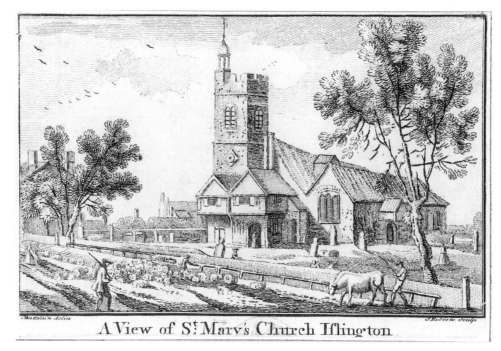

A View of S.ͭ Mary's Church Iflington.

22 J.B.C. Chatelain, *A View of St Mary's Church Islington*, 1750. By kind permission of the Guildhall Library, Corporation of London. It shows the medieval church which was demolished the following year.

an attraction in itself. The built environment was used to provide eye-catching landmarks or operated as a generalized backdrop of pleasingly irregular architectural scenography. Rather than presenting the semi-rural zone as a social melting pot, Chatelain ruthlessly excluded the bourgeoisie. His Hampstead is populated not by City merchants in their suburban homes but exclusively by the leisured gentry and a rustic chorus who are scattered artfully about the Heath tending their herds while their makeshift hovels are kept firmly out of view.

The advertisement for the Hampstead and Highgate *Prospects* of 1745 also mentioned eight views of the Thames between Chelsea and Isleworth by Chatelain as being available for the same price. Chatelain lived in Chelsea and he must have known of Thomas Preist's etchings of the river there and at Wandsworth and Chiswick of 1738, which were among the few landscape views around London to have preceded his own.[49] He developed a strong personal involvement with the Thames valley and these works were used to form the basis for his pocketbook of 1750, *Fifty small Original, and Elegant Views of The most Splendid Churches, Villages, Rural Prospects and Masterly Pieces of Architecture adjacent to London*, engraved by J. Roberts and sold by Henry Roberts. It was reported that he had devoted four years to making the sketches which covered all the areas around the capital with the exception of the east, extending only as far as Hackney in that direction.[50] The *Fifty Views* concentrated more fully on the specifics of the village environment, its history and contemporary life than Chatelain's universalized portrayal of the classical idyll at Hampstead. They included agricultural activities

as well as polite pastoral pursuits, alongside a focus on individual historic buildings, which suggests a need to cater for antiquarian as well as artistic interests. The *View of St Mary's Church Islington* (plate 22) demonstrates the differing approach of the two series. The one transforming the Northern Heights into a British Campagna for the privileged classes, dotted with the odd animal contentedly grazing, while in the other sheep are driven en masse to slaughter past buildings and locations delineated in detail.

The frontispiece to the *Fifty Views* stated that it was '... Design'd for the Improvement of Such Gentlemen and Ladies as have a Taste for Drawing, and Colouring, or are Delighted with the several Exhibitions of the Diagonal Mirror'. Its pocket-sized format made it for suitable for carrying around to the sites illustrated. In this way Chatelain brought together two current vogues; that for sketching and that for viewing perspectives through concave glasses, which developed after c.1745, and led to a huge expansion in the market for prospects.[51] Chatelain was also involved in producing illustrations for another popularizing publication of 1737 by John Rocque entitled *A New Book of Landskips Pleasant and Useful for to learn to Draw without a Master*.[52] The early date of this project and Chatelain's career overall confirms Timothy Clayton's analysis in *The English Print 1688–1802* that an interest in landscape imagery, and associated activities such as sketching and perambulations, were far more widespread in the mid-eighteenth century than has previously been thought to be the case.[53] Clayton attributes the mis-dating of the interest in romantic scenery to the 1760s rather than the 1740s to both an over-reliance on literary sources and the mis-attribution of many works from the earlier period to the London printseller John Boydell (1719–1804) who re-issued them under his own name. Well before Gilpin's *Picturesque Tours* of 1782 people were both visiting and appreciating the London environs for their scenery, as well as other attractions, and were buying depictions of them in significant numbers. Henry Overton re-issued twelve of Chatelain's views of Thames villages as early as 1752, proclaiming that, 'The great Call for, and Success foreign Views have met with, occasioned the Proprietor to publish these English landscapes and Villages, which are equal if not superior, to any Foreign ones of the Size and Price, ever published in England.'[54]

It is significant that views around the metropolis, and not just those of the well-known Richmond–Twickenham riverscape, should be in the forefront of this movement in the 1740s. It was, after all, the landscape most immediately accessible to the influential, taste-making élite. We need to rethink not just the date at which 'picturesque' depictions of nature began, as Clayton has suggested, but more broadly about ideas of rurality in the pre-Romantic era. Furthermore, the interaction of the cosmopolitan and the rustic visible in the London hinterland requires us to reformulate our characterization of city and country as two necessarily opposed and discrete entities. This exploration of interstitial spaces has provided a picture of far more complex and heterogenous landscapes in which cosy suburban villages and farms intermixed with industrial enterprises, shanty settlements and out-of-town leisure developments. The image of the city presented here, far from weakening the case for London as the new Rome in this period, in fact strengthens its claim to be the prototype of the fractured modern connurbation: a city of extremities socially, economically and physically, in

which the peripheral far from being marginal was central to core aspects of metropolitan identity and experience.

Elizabeth McKellar
Birkbeck College, London

Notes

1 Jules Lubbock, *The Tyranny of Taste: The Politics of Architecture and Design in Britain 1550–1960*, New Haven & London: Yale University Press, 1995, p. 7.

2 See Peter Borsay, *The English Urban Renaissance: Culture and Society in the Provincial Town, 1660–1760*, Oxford: Oxford University Press, 1989; David H. Solkin, *Painting for money: the visual arts and the public sphere in eighteenth-century England*, New Haven & London: Yale University Press, 1993, chap. 4; Miles Ogborn, *Spaces of Modernity: London's Geographies 1680–1780*, New York: The Guilford Press, 1998; Elizabeth McKellar, *The birth of modern London: the development and design of the city, 1660–1720*, Manchester: Manchester University Press, 1999.

3 Daniel Defoe, *A Tour through the Whole Island of Great Britain*, 1724–26, ed. Pat Rogers, Harmondsworth: Penguin, 1971, pp. 286–7.

4 John Middleton in his *View of the Agriculture of Middlesex*, London, 1798, reported that the numbers of cows kept around London were 7,200 in Middlesex and 1,300 in Kent and Surrey (p. 330). He wrote that the county consisted of arable land to the east and west, meadow and pasture to the north, and nursery ground and gardens in the west from Chelsea to Brentford and in the east from Stepney to Islington.

5 The term was popularized by William Howitt's *The Northern Heights of London, or Historical Associations of Hampstead, Highgate, Muswell Hill, Hornsey and Islington*, London: Longmans, Green & Co, 1869.

6 John Strype, *The Survey of London*, enlarged edn of John Stow, London, 1720.

7 Bernard Adams, *London Illustrated 1604–1851*, London: Library Association, 1983, p. xiii.

8 Robert Dodsley, *London and its Environs Described*, 1761, preface.

9 Adams, *London Illustrated*, op. cit. (note 7), pp. xiv–xviii.

10 Anon, *The Foreigner's Guide*, 2nd edn, London, 1740, pp. 10–12.

11 Defoe, *Tour*, op. cit. (note 3), p. 294.

12 ibid., p. 287.

13 Information on Islington from: John Nelson, *History, Topography and Antiquities of St Mary's, Islington*, London, 1811; William J. Pinks, *The History of Clerkenwell*, London,

1865; John Richardson, *Islington's Past*, New Barnet: Historical Publications, 1988; Victoria County History, *The County of Middlesex*, vol. VIII, 1988; Eric A. Willats, *Streets with a Story: The Book of Islington*, London: Islington Local History Education Trust, 1988.

14 Daniel Lysons, *The Environs of London*, London, 1795, pp. 123–4. He estimated the number of cattle at 1,200–1,500.

15 In 1754 29,000 oxen and 267,000 sheep passed through the Islington turnpike together with other animals. Richardson, *Islington*, op. cit. (note 13), p. 9.

16 Nelson, *Islington*, op. cit. (note 13), p. 272.

17 An artificial watercourse cut 1609–13 by Sir Hugh Middleton to bring fresh water to London.

18 *Foreigners' Guide*, op. cit. (note 10), p. 148.

19 *The Gentleman's Magazine*, 1791, part 1, pp. 216–17, as quoted in George Laurence Gomme (ed.), *The Gentleman's Magazine Library 1731–1868*, 'English Topography', part 16, London, vol. 2, London: Eliot Stock, 1905, p. 222.

20 For more on this outer London development, particularly in relation to housing, see: Elizabeth McKellar, 'The City and the Country: The Urban Vernacular in late Seventeenth- and early Eighteenth-century London', in Neil Burton (ed.), *Georgian Vernacular*, London: The Georgian Group, 1995.

21 *Foreigners' Guide*, op. cit. (note 10), p. 146.

22 A format later used for his *Musical Entertainer* (1737–39).

23 Miss Reason being the principal character and 'Mistress of the Wells' in the story.

24 See Denis Arundell, *The Story of Sadlers Wells*, London, Hamish Hamilton, 1965, p. 16. He is incorrect, however in dating the Bickham print at 1745, a later edition, and this in turn makes his dating of the changes to the music house to 1737 unreliable.

25 ibid., pp. 10–11.

26 A tradition it is felt necessary to continue to this day with the 'Sadlers Wells Express Bus', which since the opening of the latest building in 1999, leaves for the West End after each performance.

27 As quoted in Arundell, *Sadlers Wells*, op. cit. (note 24), p. 15.

28 William Wordsworth, 'The Prelude', 1850, bk. VII, 'Residence in London', 267–72.

29 As quoted in Arundell, *Sadlers Wells*, op. cit. (note 24), p. 31.
30 Howard Colvin, 'Gothic Survival and Gothick Revival', *Architectural Review*, March 1948, pp. 91–8.
31 Information on Hampstead from: Thomas J. Barratt, *The Annals of Hampstead*, London, 1912; Alan Farmer, *Hampstead Heath*, London: Historical Publications, 1984; Simon Jenkins & Jonathan Ditchburn, *Images of Hampstead*, Richmond-upon-Thames: Ackermann, 1982; J.L. Park, *The Topography and Natural History of Hampstead*, London, 1814.
32 Defoe, *Tour*, op. cit. (note 3), p. 339.
33 Anon, *London in Miniature. The Whole collected from Stow, Maitland ... Intended as A Complete Guide to Foreigners*, 1755, p. 250.
34 Dodsley, *Environs*, op. cit. (note 8), p. 134.
35 James Thorne, *Handbook to the Environs of London*, 1876, p. 285.
36 Farmer, *Heath*, op. cit. (note 31), pp. 28–31; Jenkins & Ditchburn, *Images*, op. cit. (note 31), pp. 83–6.
37 Prior to this only the cottage where Sir Richard Steele had stayed on Haverstock Hill one summer in 1712 and the house of the Covent Garden coffee house owner Tom King (depicted by Chatelain in 1745) had been used in topographical views of the area.
38 Middleton, *Middlesex*, op. cit. (note 4), pp. 42–3.
39 M.H. Port, *Hampstead Parish Church. The Story of a Building through 250 Years*, London: St John-at-Hampstead Parochial Church Council, 1995.
40 Jenkins & Ditchburn, *Images*, op. cit. (note 31), p. 37.
41 *London in Miniature*, op. cit. (note 33), p. 250.
42 This was the second Long Room. The first one had been closed *c.*1720 as it was attracting too many disreputable elements and ironically re-opened as a chapel-of-ease.
43 Fanny Burney, *Evelina; Or the History of a Young Lady's Entrance into the World,* 1778, London: Macmillan, 1903 edn, p. 268.
44 His name is given as both Chatelaine and Chatelain and his real name was Philippe. See Bryan, *Dictionary of Painters and Engravers*, 1886; Samuel Redgrave, *A Dictionary of Artists of the English School*, London: George Bell, 1878; Joseph Strutt, *A Biographical Dictionary; containing an Historical Account of All the Engravers*, London, 1785. I am grateful to Michael Symes for help with references on Chatelain and Timothy Clayton for kindly providing additional information.
45 Ralph Hyde, *A Prospect of Britain: The Town Panoramas of Samuel and Nathaniel Buck*, London: Pavilion, 1994, pp. 27–8.
46 Bryan, *Dictionary*, op. cit. (note 44), 1886.
47 On the history of representations of London and the environs see: Adams, *London Illustrated*, op. cit. (note 7); Julius Bryant, *Finest Prospects: Three Historic Houses: a study in London Topography*, exhib. cat., English Heritage, 1986; David H. Solkin, *Richard Wilson. The Landscape of Reaction*, exhib. cat., Tate Gallery, 1982, chap. 4.
48 Reference provided by Timothy Clayton.
49 The inscription on the prints advertised that they were sold by Preist himself 'near the ferry at Chelsea' and by W.H. Toms at Union Court, Hatton Garden, Holborn. They were reissued by John Bowles in 1742.
50 Redgrave, *Dictionary*, op. cit. (note 44), 1878.
51 Timothy Clayton, *The English Print 1688–1802*, New Haven & London: Yale University Press, pp. 140–1.
52 His design for the cover and four landscapes survive among the Chatelain prints in the British Museum.
53 Clayton, *English Print,* op. cit. (note 51), pp. 157–61.
54 ibid., p. 163.

'Beastly Sights': the treatment of animals as a moral theme in representations of London, *c*.1820–1850

Diana Donald

During the first half of the nineteenth century London grew at a phenomenal rate.[1] It nearly trebled its population, and the built-up area spread so far that in Engels's words, writing of the mid-1840s, 'a man may wander for hours together without reaching the beginning of the end, without meeting the slightest hint which could lead to the inference that there is open country within reach.'[2] Yet during this same period, when the life of many British people seemed increasingly divorced from the experience of the natural world, the treatment of animals became a national preoccupation. A succession of bills, from 1800 onwards, resulted in the first anti-cruelty law in 1822. It covered only cattle and horses, and a more comprehensive law superseded it in 1835. In the intervening period, a number of groups were established, which aimed to enforce and extend this legislation, and to arouse public indignation about the abuse of animals. The Society for the Prevention of Cruelty to Animals (later the RSPCA) was founded in 1824.[3] By the early 1830s there were two breakaway groups, the Association for Promoting Rational Humanity towards the Animal Creation, and the Animals' Friend Society.[4] Each produced a magazine, respectively the *Voice of Humanity* and the *Animals' Friend*, and from 1832 the SPCA also issued printed annual reports. There is much evidence that public interest in the issues involved went far beyond the devoted circles among whom these periodicals first circulated. In the popular mainstream publications of the time, including illustrated magazines and fiction issued in parts, man's relationship with animals is a recurring theme, and, as this article will show, it was often represented in imagery of remarkable force and interest.

Many of these publications referred to London in their titles, and, in varying degrees, evoked metropolitan life in their contents. What, then, is the connection, if any, between rapid urbanization and the repeated attempts to reform public opinion on the treatment of animals? Many writers have defined it in paradoxical terms: it was their very distance from the brutal realities of nature and agriculture and the increasing marginality of animals in the life of the metropolis, that enabled city dwellers to cultivate a gentler attitude towards them. The most influential formulation of this view can be found in Keith Thomas's *Man and the Natural World* of 1984: 'The triumph of the new attitude was closely linked to the growth of towns ... first expressed ... by well-to-do townsmen, remote from the agricultural process and inclined to think of animals as pets rather than as working livestock.'[5]

This argument from a negation – the supposed absence of real working animals from the experience of Londoners – makes it hard to explain the urgency, even the sense of moral crisis, which is apparent in the anti-cruelty writings and images of the period. But in fact the argument is open to objections on many grounds.[6] It tends to overlook the interdependence of 'city' and 'country' at every level, both material and conceptual, and assumes a fixity of viewpoint which is belied by the actual fluidity of the London population in the nineteenth century. The moneyed classes with their servants and dependants moved seasonally between the metropolis and the countryside, and the labouring classes, too, ebbed and flowed in response to the opportunities for casual work and the demands of their trades.[7] The monstrous spread of the city could indeed be measured by the increasing distances which drovers had to traverse with their herds between open pastures and Smithfield market; and Henry Mayhew reported that sellers of caged songbirds in the London streets especially noticed 'the changes which have added to the fatigues and difficulties of their calling', the 'two thousand miles of houses ... built in London within the last twenty years' which now lay between them and their catch sites.[8]

As these examples imply, animals, so far from being peripheral, were ubiquitous in nineteenth-century London; absorbed into its working economy and patterns of consumption in a variety of species and purposes so complex it would fill a volume. Exhibitions of wild and imported animals ranged from the grand new zoological gardens through travelling menageries and mobile cages in the streets, to the shabby specimens shown in inn yards. Performing animals, dressed in human clothes and harshly trained to simulate human social behaviour, danced and acted in the London streets, fairs, circuses and theatres.[9] The baiting of bulls, bears and badgers continued well into the nineteenth century, as did cock and dog fights; and, when those pursuits were declared illegal, gambling on rat kills by dogs in specially constructed pits became a lucrative branch of London's sporting industry.[10] Far more important than the display of animals for entertainment, however, was their use as food. The growing population of the metropolis increased the need, while it choked the available spaces, for ever greater numbers of cattle and sheep to be driven in, marketed and slaughtered; and these supplies were augmented by 'town-made' pork and poultry, reared by the poor of London.[11] The use of animals for riding and draught was also finely calibrated to the social hierarchy. The splendid carriage horses of the aristocracy appeared in shining contrast to the broken-down hacks they might themselves become, pulling omnibuses, cabs and hackney coaches through the London thoroughfares. On a lower level still were the despised donkeys of the carters and costermongers which Mayhew saw at Smithfield, 'their white velvetty noses resting on the wooden rail', as they lined up, waiting to be goaded into a saleable semblance of liveliness, or consigned to the knackers.[12] Growing traffic and mileages increased the demand for draught animals of all kinds, and apparently the first thing that visitors noticed about London was that it smelt like a stable yard.[13]

In studying all these interactions between humans and animals, one becomes aware of the blend of mutuality and exploitation they involved, and of the animals' essential role not only in London's systems of labour and trade, but in the emotional experience of city goers and dwellers. Such creatures were not the

vestiges of a rural culture lingering into the industrial age: their presence in such numbers was a *function* of London's growing financial dominance, luxurious consumption, developing infrastructure and architectural improvement. It was the increasingly ferocious competition between commercial proprietors which led to the overworking of draught horses; it was the scale of London's building and engineering projects which taxed their strength.[14] As Lewis Gompertz, founder of the Animals' Friend Society, commented, 'the works of civilized society' entailed a grievous imposition on the animals which 'civilized' man regarded as his inferiors. London Bridge could be admired as a production of human genius, but its construction represented a savage violation of the natural world: 'could all the torture and destruction that this has caused to the poor horses, who drew the stones and cleared the rubbish, be brought to light, what an emblem of crime would this beautiful bridge exhibit.'[15] The callous commodification of working animals obtruded itself on Londoners; 'The unceasing sound of the lash in our streets', noted a SPCA pamphlet of 1829, and 'the increased rate of travelling and loads imposed ... common and daily evils ... chiefly perpetrated by the most ignorant orders of society, and permitted by the higher classes'.[16] It was not philosophical distance from sites of cruelty, but painful proximity to them which prompted Londoners' protests; and the reforming groups, whatever their ideological and tactical disagreements, had this in common: that their principal object was reform of the cruelties of the capital's streets and markets, both in legislative campaigns and prosecutions.[17]

The paradox expressed by Gompertz was central to the discourse of literature of the period. Writers celebrated the march of intellect and improvement in Britain which the metropolis embodied, but simultaneously deplored its costs for both man and nature: part of the wider debate that crystallized in the 1840s about the whole system of capitalism. Political radicals had often, in a Rousseauist spirit, blamed the heartless abuse of animals on the development of modern urban society. As the Jacobin John Oswald expressed it, in *The Cry of Nature* (1791), 'the fate of the animal world has followed the progress of man from his sylvan state to that of civilization, till the gradual improvements of art, on this glorious pinnacle of independence, have at length placed him free from every tender link.' The slaughter of animals for food merely led the way to the evils of social and political injustice: 'Hence the establishment of towns and cities, those impure sources of misery and vice; hence arose prisons, palaces, pyramids, and all those other amazing monuments of human slavery; hence the inequality of ranks, the wasteful wallow of wealth ... the abject front of poverty, the insolence of power ...'[18] While such extreme views were rare, a sense of malaise, of alienation from 'nature' and 'natural' feeling,[19] and religious compunction about the cost to animals of human luxury, were widespread in the early nineteenth century. Cruelty to animals was not only an egregious evil in itself; it provided a powerful metonym for the ills of society in general,[20] and this may partly explain the frequency with which the issue was aired in the popular magazines of the time. The predominance of enlightened attitudes to animals, marked by the initiation of the various anti-cruelty measures, was often cited as a prime instance of moral progress. Yet the prevailing cruelties which legislation seemed powerless to correct represented one of the direst symptoms of moral degeneration. Were such

barbarities a residue of the past, which the ongoing march of education and refinement would annihilate? Or were they an intrinsic aspect of laissez-faire capitalism itself, as Carlyle and Engels believed the oppression and pauperization of the working classes to be? In the very first article in his *Illuminated Magazine*, in 1843, Douglas Jerrold gently teases the man who 'living only in the nineteenth century … has some vague, perplexing notion that he has missed an Eden' in the former 'golden times of England'. Such people forget all the specifically modern benefits they enjoy; comforts and conveniences brought within the financial reach of all Londoners, new standards of civility and 'humanizing, refining pleasures'. 'In our maudlin sensibility', he writes ironically, 'we have taken under our protection the very brutes of the earth … cast the majesty of the law around the asses of the reign of Victoria.' This progress is measured visually by the wood-engraved vignettes running down the page: the first showing a bear-baiting in the reign of Elizabeth; the last, Epsom races with their 'high moralities' and a London omnibus. Yet this magazine was itself, contradictorily, to expose the brutal working conditions of children in the mines and of the London seamstresses, as well as cruelties to animals: 'if our hearts were as tender as nature made them, and had not gone through a sort of macadamizing process', such suffering would be intolerable.[21]

The London omnibuses and Londoners' race meetings which had furnished Jerrold's symbols of nineteenth-century civilization were themselves often used in the reverse sense. In 1845 *Punch* published a cartoon entitled *The New Grand-Stand Omnibus* – 'Worthy the Attention of the "Society for the Prevention of Cruelty to Animals" '(plate 23).[22] It alludes to the permitted overloading of the omnibuses, motivated by considerations of profit: a monstrous pile of top-hatted City gentlemen commuting (significantly) from 'Bank' to the suburbs is pulled along by only two emaciated horses. The composition recalls those Georgian prints which showed John Bull crushed by a towering superstructure of high-taxing ministers and placemen, suggesting a subconscious analogy between the fate of animals and the human poor.[23] Historians who have seen in the efforts of the SPCA and other reforming groups principally an urge to social control of the deviant lower orders,[24] miss their connection with deep-seated anxieties about capitalism and its social effects. As a subscriber wrote to the *Animals' Friend* in 1833 under the title 'The Omnibus Nuisances': 'In an age of improvement the march of feeling should keep pace with the march of intellect', but 'in one place … feeling seems to have retrograded … humanity … sacrificed to selfishness. This place is the metropolis.' 'The life consuming and excruciating labours' imposed on the omnibus horses expressed the values of an urban middle class so hardened that 'the only chord which touches their heart is the purse string.'[25] Animals were not simply the victims of this system, but were represented as its antithesis: uncompetitive, improvident, guileless, innocent and tranquil. David Mushet in *The Wrongs of the Animal World* (1839) invited his readers to 'Compare a crowded street; each individual panting and striving to outdo his fellow … a spirit of repulsion and contest, the ruling feature of the mass' with 'a troop of oxen grazing in a meadow … the noble placid sedateness … all seeming to breathe a spirit of peace and harmony with nature'.[26] The age-old contrast of the city and 'nature' was to prove fundamental to the animal imagery with which this article is concerned.

THE NEW GRAND-STAND OMNIBUS.

WORTHY THE ATTENTION OF THE "SOCIETY FOR THE PREVENTION OF CRUELTY TO ANIMALS."

23 Anon., *The New Grand-Stand Omnibus*, wood engraving in *Punch*, 1845. Manchester Central Library.

Perceptions of humanity's interaction with animals in the modern city went through successive stages, influenced not only by the gradual permeation of reformist notions, but by the developing character of popular publishing itself, and the attitudes of the authors and artists it employed. This becomes especially clear in comparing the varied output of George Cruikshank. At the moment of his transition from caricature to serious illustration, he collaborated with the sporting journalist Pierce Egan and with Isaac Robert Cruikshank in the production of the immensely successful *Life in London*, which originally appeared in monthly parts during 1820–1, and for a time was widely pirated and imitated.[27] The London adventures of those relentless hedonists, Corinthian Tom and Jerry Hawthorn, youths whose wealth comes respectively from the city and the country, are a particularly vivid visualization of the relationship between capital (in both senses) and nature. It is encapsulated in the description of Hyde Park, where 'splendid equipages' rattle along 'under the guidance of charioteers of the highest blood and pedigree. The prime *"bits of blood"* from the choicest studs in the kingdom, prancing about as proud as peacocks, and almost unmanageable to their dashing drivers ...' In this virile, headlong pursuit of metropolitan pleasures, hunting and riding metaphors abound. Tom was 'a perfect hero with the whip' ... 'in the "hey-day of blood"' ... 'continually on the *fret* to obtain unrestrained liberty'.[28] But if these expressions suggest a kind of vitalism identifying men with animals (a particular aspect of the symbiosis of the two which has already been proposed as a characteristic of nineteenth-century London), the actual encounters between them described in the book, particularly baiting and animal fights, involve a cruelty that must have shocked the sensitive. *Life in London* flies in the face of a hundred sermons and tracts which had already condemned these cruel sports of the

metropolis as the relics of a more barbaric age, and, indeed, within a decade of the book's publication they had been suppressed, at least in public.

The aquatint of *Tom & Jerry sporting their blunt on the phenomenon Monkey, Jacco Macacco, at the Westminster Pit*, dated 1820 (plate 24),[29] is consciously in the tradition of Hogarth's *The Cockpit* of 1759;[30] Pierce Egan's text emphasizes, like Hogarth's image, the motley crowd drawn from all social classes, yet united by the nearly insane passions of the event. Whereas Hogarth's spectators are in the grip of gambling fever, however, and constitute a satire on human folly, Egan's and the Cruikshanks' seem to be obsessed with the raw emotions of the animals themselves, in this life-and-death struggle: the monkey, 'with as much *cunning* as a prize-fighter', inflicting fatal wounds on the heavily bleeding dog. A year after the publication of *Life in London* in book form, Richard Martin, in introducing his successful bill in the House of Commons to prevent the ill treatment of cattle, cited the sufferings of this same famous monkey and a white bitch dog called Puss to exemplify the brutalities of the metropolis.[31] If Egan knowingly flouted such protests, and appealed to a readership which derided them, the book certainly uses contests between *animals*, whether cock or dog fights, racing or hunting (scenes of all these lined Corinthian Tom's bachelor 'Conversation Room'), to symbolize the 'Ups' and 'Downs', the *human* struggle for success, or for existence itself, in early nineteenth-century London, which the frontispiece of the book symbolically pictured.[32] Advantages of birth, industriousness or good fortune might propel some to the heights of prosperity and respectability, while others went to the wall. The effects of the ruthless system which Egan presents are made apparent at every level, very often through text illustrations of animals, wood-engraved from the Cruikshanks' designs. At turn-out time from the opera house, the coachmen of fashionable ladies, vying to be first away, crash into and break a hackney carriage and bring its skeletal horses to their knees, one laying its exhausted head on the cobbles. When an overloaded donkey accidentally slips its foot into the plug-hole of a street drain (plate 25), Tom and Jerry stop to amuse themselves with the bitter mutual recriminations of the costermonger and his wife who own it: she fearful of losing the hard-won load of vegetables, he threatening her with violence and 'giving the poor animal some terrible blows with a stick'. 'Jerry laughed as heartily as if he had been witnessing a pantomine; indeed, the scene altogether was highly ludicrous ... The *donkey* soon mended his pace, and our heroes kept laughing at the circumstance till they arrived at *Corinthian-House*.'[33]

The cut-and-thrust economic competition which *Life in London* represented in such pitiless terms was central to the conceptualization of the experience of men and animals apparent in the illustrated publications of the succeeding decades; but the *values* they expressed differed widely – evidence of an increasingly sophisticated apprehension of the nature of laissez-faire capitalism, and the contradictory emotions to which it gave rise. In some cases, as has been mentioned, these contradictions can be related to the changing perceptions of individuals. George Cruikshank, in particular, progressing from the apparently cynical commercialism of his early activity as a political caricaturist to the status of a revered moral campaigner, renounced the sensationalism that characterized his illustrations to *Life in London* in favour of a passionate denunciation of

24 Issac Robert Cruikshank and George Cruikshank, *Tom & Jerry sporting their blunt on the phenomenon Monkey, Jacco Macacco, at the Westminster Pit*, 1820, etching/aquatint in Pierce Egan, *Life in London*, 1821. By permission of the British Library.

metropolitan society. *Sunday in London*, published in 1833, framed Cruikshank's exquisitely detailed drawings, reproduced as wood-engraved vignettes, with a connecting text contributed anonymously by his friend John Wight.[34] The book's ostensible subject was the social injustice of Sir Andrew Agnew's bill to enforce stricter observance of the Sabbath by a ban on street trading, and the moral hypocrisy of the affluent classes, manifested in their own disregard for the Christian spirit of Sunday. However, this idea widens into a comprehensive indictment of the acquisitive materialism which deadens man's innate sympathies and reifies both labouring men and animals as expendable commodities. Here Cruikshank and Wight seem to revisit the episodes of *Life in London*, and to interpret them in an opposite sense. 'The *sporting* Sunday papers' bought by the middle classes provide 'a register of the "extraordinary feats" which "celebrated horses" have by wet whip and bloody spur been *encouraged* to perform', as well as notices of shoots by 'the valiant Tomtit and Sparrow Clubs' of Battersea Fields and 'of all the coming bull-baitings, badger-baitings, and duck-huntings': a mental set which is faithfully replicated in the Sunday-morning cat hunts and mongrel fights watched by their social inferiors. 'The lovers of dogs' flesh! – Lo you! How the intellect of the age doth *progress*!'[35] This bitter irony echoes the sense of outrage expressed in the first magazine dedicated to the reform of metropolitan cruelties, *The Voice of Humanity*, which in 1830 had deplored the 'intense anguish and terror' of the baited animals; London's shame was even intensified by the proximity of the Westminster Pit, 'this den of infamy, vice, and cruelty', to the

welcome visitor. JERRY'S merry song and lively company will also insure him a good reception. I shall do every thing in my power to promote perfect harmony, and I think we may, at least, picture to ourselves a few '*gay moments*,' But let us return home as soon as possible, as I have ordered an earlier dinner than usual, that I might keep to my appointment."

The progress of the TRIO was interrupted for a short period, in their way to *Corinthian-House*, through the streets, with the following dialogue between a *costard-monger* and "his *voman*," whose *donkey* had accidentally slipped one of his feet into a plug-hole.

JERRY laughed as heartily as if he had been witnessing a pantomime; indeed, the scene altogether was highly ludicrous. TOM smiled; and LOGIC was on the broad grin. "*Vy* don't you mind *vat* your *arter*," said POLL, "instead of rolling your *goggles* about after all manner of people; it *voud* be much better for you if you did, I knows. Here don't you see all the carrots and greens, that cost me every *mag* I *coud* raise last night, will be down in the dirt and

R

25 After Isaac Robert Cruikshank and George Cruikshank, wood-engraved text illustration in Pierce Egan, *Life in London*, 1821. By permission of the British Library.

Abbey and Parliament buildings.[36] Meanwhile 'they who rule both the roast and the boiled – the Lords Spiritual and Temporal, and the Commons in Parliament' also continued to sanction the brutal scenes on Sunday evenings when droves of cattle and sheep were forced into Smithfield during the time of evening service at nearby St Paul's, in preparation for the Monday market.[37] But the most shaming instance of the mercenary callousness of the age was its treatment of horses. Coach horses, whipped up outside the fashionable theatres, 'stand trembling and struggling "'midst the mortal fray, astonished at the madness of mankind".' The middle orders, again, in their Sunday excursions, were 'the great supporters of the cruelty-van, or *omnibii* interest, which, by dint of hard work and whipcord, kills up its annual thousands of those four-legged "*machiners*", heretofore ignorantly called "horses"' ... 'small lank-sided panting jades in a *galloping* consumption' which, in their accelerated decline, leading inexorably to 'the knacker's shambles'

44 THIRD PORTION OF

dripping beneath the broad glare of the blessed sun, and in the light of ladies' eyes !"*

The poor used-up-and-dead horses are going to the boiling-house, to be still further *used-up* in the concoction of cat's meat, candles, and compost ;— that being the sole end and object of *their* creation ; but whither are the *Lords* and *Ladies* of the creation going ?

The " knacker's drag," thus obscenely laden, is a common and peculiar feature of *Sunday* in *London ;* and though some people may think it a very nasty and horrible exhibition, it would surely be " a gross interference with the liberty of the knacker" to prohibit him from bringing in his mangled victims until after dark; or to compel him to hide the hideous obscenity by having a cover to his cart.

26 After George Cruikshank, wood-engraved text illustration in his *Sunday in London*, 1833. By permission of the British Library.

were deliberately hit upon 'the raw' – open sores – by the omnibus drivers to extract their last strength: 'It may be *cruelish*, perhaps, but it's all fair in the way of *trade*.' Even the fine mounts and carriage horses of the nobility, which Tom and Jerry had so much admired in the London parks, were subjected to this system of 'consumption', and like a *memento mori* 'through the glittering rout the *knacker's drag* winds *jogglingly*, laden with *used-up-and-dead* horses, obscenely mangled – their torn-out bowels dangling and dripping beneath the broad glare of the blessed sun, and in the light of ladies' eyes! ... going to the boiling-house, to be still further *used-up* in the concoction of cat's meat, candles, and compost'.[38] These outrages are toned down in Cruikshank's vignette (plate 26), which conveys the essence of the contrast between the sunlit, elegant street and the darkly silhouetted knacker's cart with its grim cargo, the driver's whip raised over a gaunt horse which will shortly join in death the one it drags. There is in fact a striking disjunction between the physical explicitness of Wight's text – including many details more repugnant even than those quoted here – and the relative

restraint of Cruikshank's images, where indignation is contained by notions of artistic decorum; just as the subtlety of social observation in these fastidiously fine wood engravings is in conscious contrast to the vulgarities and grotesque exaggerations of Cruikshank's early caricatures.

Satirical depictions of the arrogance and moral humbug of the rich or of the degraded fecklessness of the poor in London were easily accommodated within the tradition of comic-genteel illustration, but representations of the sufferings of *animals* risked accusations of 'lowness', arising from their purely physical character. Thus Cruikshank could provide a vivid distillation of the scene at the door of a fashionable church, where the smug ceremoniousness of the well-heeled is set off against the distress of their horses, made to work even on Sundays.[39] However the greater savagery of the animal fights, the abuse of omnibus horses and of cattle at Smithfield, which Wight evoked so bitterly in *Sunday in London*, was not illustrated by Cruikshank at all. The same generalization holds true both of the *Comic Almanack*, started in 1835, in which Cruikshank was again a prime mover, and later of *Punch*: cruelty to animals in London, and the efforts of the reforming groups to suppress it, occupied a large discursive and critical space in their texts, but these themes were seldom illustrated. Where vignettes of animal subjects *were* inserted, they tended to be of a facetious character, playing on puns or allusions to human affairs, as though apologizing for the cause they promoted.[40]

This analysis highlights the particular difficulties of the reformist groups themselves in their appeal to the educated classes. Visual images were uniquely able to transmit the shock of first-hand experience, so that, in Lewis Gompertz's words, 'cruelty is picturesquely brought home to our own doors and hearts.'[41] But a public which found even the depiction of child labour in the mines distasteful and unwarranted might balk at disconcerting exposures of the dark secrets of the metropolis, in particular the visceral horrors of the slaughterhouses. The cause of prevention of cruelty to animals could easily be denigrated by its antagonists as trivial and local, incapable of being directed by the universal, philosophical principles applicable to human affairs. The patrician William Windham, in opposing a bill of 1802 to abolish bull baiting, had already used an artistic analogy: he 'regretted the minuteness with which he was obliged to enter into the consideration of the subject', but 'to examine the character of a daub of Teniers was often a work of more difficulty than to describe the beauties of the Madonna of Raphael'[42] ... Actual 'daubs of Teniers' and other works in the Dutch and Flemish tradition might, of course, be redeemed by moralizing humour, or by the pleasures to be derived from a convincing depiction of nature. However, such pleasures were impossible when the subject disgusted the spectator. This was the argument of Pyne's *Microcosm: Or, a Picturesque Delineation of the Arts, Agriculture, Manufactures, &c. of Great Britain*, the second edition of which (1806) had a commentary by C. Gray. It is remarkable that, in a text ostensibly intended to 'explain' plates of rural and industrial subjects, and traditional trades, cruelties to animals peculiar to London are often at the forefront of the writer's mind, and are described at length. The list is by now familiar. Stage-coach and hackney-carriage horses are relentlessly overworked by their avaricious masters; cattle suffer terribly in Smithfield, and 'we cannot pass along the streets of the metropolis near any of the flesh-markets, without having the butchering of

unfortunate animals exposed to our sight. The humane are obliged to turn away their eyes from such spectacles of horror.'[43] However, very few of these 'spectacles of horror', so feelingly described in the text, figure among Pyne's drawings. He fills many pages with the picturesque rustics who are, as Gray explains, 'however disagreeable ... in real life ... peculiarly pleasing in imitation, when accurately copied ... No subject, when well treated, is more popular.'[44] But the brutal trades of the metropolis are represented in only the most indirect and idealizing ways, the vignette format allowing the artist to exclude their urban locales. A horse that has died in the market is surrounded by concerned spectators, in a scene of elegiac gentleness.[45] Slaughtermen stunning and bleeding oxen in an (apparently) grassy setting are gracefully posed, the blade of the pole axe invisible, outside the field of the design. Yet even this depiction was, Gray thought, beyond the limits of acceptability:

> There are some scenes of nature ... which ought not to be copied ... What ... is the use of copying what can only inspire a horror, which even the pleasure that uniformly arises from seeing an accurate and lively imitation, cannot do away? ... which can only set the mind of sensibility a thinking of the hourly, indeed, the unintermitting scenes of misery, and we fear, too often of cruelty, caused by our enjoyments at table to harmless animals. Necessary they may in part be; but the less we see and think of them, the better.[46]

Written accounts of such 'unintermitting scenes of misery' in nineteenth-century London were legion, but *illustrations* of them could only be sanctioned by an ethical force strong enough to override considerations of taste. One very important exemplar must have presented itself to the editors of the humane journals: Hogarth's *The Four Stages of Cruelty*, published in 1751.[47] Just as Dickens invoked Hogarth as realist and moralist to justify his own unglamorized vision of London's criminal underworld in *Oliver Twist*,[48] so the potency of Hogarth's images of London's cruelties showed the way to his nineteenth-century successors, and it is in this light they are discussed here. The scene for the 'Second Stage of Cruelty' (plate 27) is the wide street of Holborn. Behind the spectator lies Holborn Hill, the ascent of which notoriously overstrained draught horses, as they toiled among the sheep and bullocks that spilled out of Smithfield Market on their way to the slaughterhouses – a sight still familiar a century later. But beyond, westwards, lie the Inns of Court, one of which is visible on the left in Hogarth's picture, embodying legal authority; and beyond that again – glimpsed here as a bright opening in the distance – lie the streets leading to the West End, seat of parliamentary power and aristocratic privilege. At this place of transition between the world of the legislators and that of the brutalized lower orders who frequented the Smithfield area, Tom Nero, a hackney coachman and the anti-hero of Hogarth's story, aims violent blows with his thick whip handle at the head of his horse, which has fallen and broken its leg; its staring ribs, the great sore on its chest rubbed by the harness, its distended tongue, tell their own story of dreadful ill treatment, and its tears testify to a sensibility greater than that of its human tormentor. On the right a drover is beating an exhausted lamb to death; in the

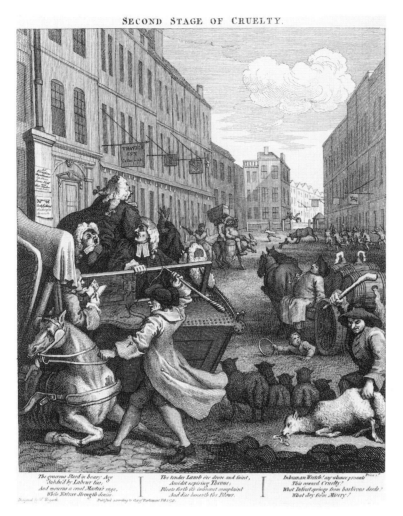

SECOND STAGE OF CRUELTY.

The generous Steed in hoary Age
Subdu'd by Labour lies,
And mourns a cruel Master's rage,
While Nature Strength denies.

The tender Lamb o'er drove and faint,
Amidst expiring Throes,
Bleats forth its innocent complaint
And dies beneath the Blows.

Inhuman Wretch! say whence proceeds
This coward Cruelty?
What Interest springs from barbrous deeds?
What Joy from Misery?

27 William Hogarth, *Second Stage of Cruelty* in *The Four Stages of Cruelty*, 1751, etching and engraving. The Whitworth Art Gallery, University of Manchester.

distance, a donkey is grotesquely overloaded, and a bull is baited through the street on its way to slaughter. Thus did Hogarth appear to anticipate the whole agenda of the nineteenth-century reformers for legal action against the cruelties of the capital. However, *The Four Stages of Cruelty* represents an indictment of society as a whole, not simply of the ostensible lower-class perpetrators of street cruelties. Here it is the avaricious lawyers themselves who, by packing into the hackney coach for their journey to Westminster, have caused the horse to collapse; and the flocks, cattle and beer dray clearly have the same West End destination.[49] Metropolitan luxury and commercialism are associated with metropolitan cruelties as surely as they would be by later moralists, and set in implied contrast to the traditional social order and sense of reciprocal obligations associated with the countryside:[50] it is not difficult to see a deliberate parallel

between the country servant girl savagely murdered by Tom Nero in plate III and the innocent lamb of plate II, which has been driven in from its rural pastures to form a cruel sacrifice to the devouring greed and callousness of Londoners. As the author of *A Dissertation on Mr. Hogarth's Six Prints* ... remarked in 1751, in discussing *The Four Stages of Cruelty*, the voice of reason, impelling man to social duties, was now 'quite drowned in the Pleasures of the World, suffocated with Cares of acquiring Riches, lost in the high Flights of Ambition, or struck dumb and senseless by vicious habits'.[51]

Hogarth intended this harsh admonition to be seen by as many people as possible, and his first idea was to issue the series as woodcuts, for sale to the same public who bought cheap broadsides and the 'dying speeches' of criminals.[52] Although this project foundered, the etchings finally published were described by Paulson as having a 'primitive strength' or 'brutal woodcut effect', designed for maximum impact rather than aesthetic subtlety.[53] The artist himself explained his didactic intentions in his autobiographical notes:

> The leading points ... were made as obvious as possible, in the hope that their tendency might be seen by men of the lowest rank. Neither minute accuracy of design, nor fine engraving, were deemed necessary, as the latter would render them too expensive ... to be useful ... To expressing them as I felt them, I have paid the utmost attention, and as they were addressed to hard hearts, have rather preferred leaving them hard ... to rendering them languid and feeble by fine strokes ... The prints were engraved with the hope of, in some degree, correcting that barbarous treatment of animals, the very sight of which renders the streets of our metropolis so distressing to every feeling mind. If they have had this effect, and checked the progress of cruelty, I am more proud of having been the author, than I should be of having painted Raphael's Cartoons ...[54]

The deliberately coarse and shocking physicality of these images seems to have been meant as a deliberate affront to polite taste. Even an enthusiast for Hogarth's prints like Charles Lamb described them in 1811 as 'mere worthless caricatures, foreign to his general habits, the offspring of his fancy in some wayward humour'.[55] Nevertheless, the altruism to which Hogarth laid claim, the end justifying the means, certainly enhanced his posthumous reputation among the reform-minded. John Ireland's impassioned commentary on *The Four Stages of Cruelty*, published in *Hogarth Illustrated* (1791), itself became a widely quoted text, and Hogarth's story was endlessly recalled by preachers and legislators.[56] The high regard in which he was now held as a public benefactor clearly influenced the aspiring George Cruikshank, for whom kindness to animals became, as we have already seen, something of a personal crusade. In *My Sketch Book*, a collection of autonomous drawings which is consciously Hogarthian in its blend of physiognomic drollery and 'compassionate reportage' of London life,[57] a sheet dated 1835 includes a vivid sketch captioned 'The Omnibus Brutes –, q[uer]y, which are they?' (plate 28) Both theme and setting, the steep slope of Holborn Hill, and the pregnant question raised by the title, obviously refer to *The Four Stages of Cruelty*. The pathos of Cruikshank's image is partly dissipated by

28 George Cruikshank, etching in *My Sketch Book*, dated 1835, reproduced from a stereotype in the popular edition, n.d., Manchester Metropolitan University Library.

its comic accompaniments. However, in another etching of this period which Cruikshank publicly donated to *The Voice of Humanity*, the vision of animal suffering was unmitigated. This was *The Knackers Yard or the Horses last home!*, an image that, within the repertory of animal imagery, had unprecedented tragic power.

Up to a thousand old or diseased horses were slaughtered each week in London by the mid-nineteenth century, at about twenty knackers' yards situated principally at Holborn Hill, Islington, Bermondsey, Whitechapel and Wandsworth. Mayhew was characteristically fascinated by the economic intricacies of this lucrative trade, which supplied the cats' and dogs' meat of the metropolis together with horsehair, the fat used for greasing harness and wheels, bones for manure and many other by-products. He mentions that the slaughter took place at midnight, allowing the carcases to be boiled in time for the next day's distribution by the carriers; their buyers were mainly tradesmen, mechanics and poor labourers.[58] Such dispassionate accounts, dating from a time when legislation had already removed some of the abuses associated with horse slaughtering,[59] do not convey the moral anguish it caused to the conscientious throughout the late eighteenth and early nineteenth centuries, nor the trauma experienced by those few who, by negotiation, subterfuge or agility, passed the locked gates of the yards and witnessed for themselves the night-time horrors within. Many voices of reform, from Erskine addressing the Lords in 1809 to *The Herald of Humanity* of 1844, detailed these cruelties in pleading for legislative action: the acute thirst and starvation of the horses as they awaited, often for several days, the moment of their death (delayed so as not to overstock the market and bring down carcass prices), and the careless indifference of the slaughterers to the plight of their charges, which might even (if any strength remained) be profitably hired out for the lowest and most arduous night work in the streets.[60] The human avarice manifested at each stage of the horse's decline to this 'last home' was another emblem of the cutthroat commercialism that commodified men as well as animals: it sprang to mind when both Thomas Paine in *Rights of Man* and Thomas Carlyle in *Past and Present* compared the fate of old horses 'turned adrift' or left to the mercies of those who hired out hacks, to that of the penurious discharged labourer. The only difference, as Lewis Gompertz pointed out, was that the horse's destination was worse than any workhouse or 'the vilest prison'.[61] Many writers thought of the noble nature and original beauty of the creatures whose essential services to 'civilized' man were thus requited. 'It is painful' the Rev Henry Crowe wrote in *Zoophilos* (1820) 'to compare him in the prime and vigour of his days ... "his neck clothed with thunder" ... and in after life, when his powers and beauty fail, degraded to a wretched state ... Such *consumption* of these ill-fated animals ... much resembles that of any other article of trade. They seem to be bought with a sordid, remorseless spirit, as if they had no more feeling than the wheels.'[62] Yet even in the knacker's yard, several writers noted, the experienced eye could pick out the graces of the thoroughbred, the former darling of its privileged first owner; rather as Dickens in his famous piece on London's hackney coaches and their drooping, blinded horses evoked the pathos of both as 'a remnant of past gentility ... progressing lower and lower in the scale of four-wheeled degradation, until it comes to – *a stand!*'[63] Might not

this token of the precariousness and mutability of fortunes in nineteenth-century London remind many of their own possible fate?

Cruikshank's etching of a knacker's yard (plate 29) appeared in the first volume of *The Voice of Humanity* (1830–31), then published under the aegis of the SPCA; it was several times reworked, reissued and copied for other journals, and also distributed as an independent picture.[64] 'This sketch, by our celebrated artist, the Hogarth of the present age ... is an inimitable production of natal genius,' claimed the editor, adding that Cruikshank had philanthropically donated it in the service of the cause; 'never' added the *Sunday Times*'s reviewer in 1831, in an echo of Hogarth's affirmation, was Cruikshank's 'genius better engaged than when he laboured to fix attention on the miscreant abominations ... in such places'.[65] The scene was said, improbably, to have been sketched on the spot, its 'fidelity and truth' made apparent in a close correspondence to the accompanying text, and indeed to several other written accounts.[66] The scarred and starving horse in the centre is reduced to chewing the mane of another, while those confined in the shed gnaw the door frame to allay their hunger. More terrible than these signs of 'silent, patient, endurance', worse even than the brutality of the knacker's men, are the marks of a regime fixated on the need to extract every last penny of profit: even the animals compete for survival, as a fighting bulldog, pigs, ducks and chickens batten on the carcases and bones in this indescribable midden. Yet the whole image, with its tumbledown buildings and variety of livestock, is like a ghastly parody of the picturesque farmyard scenes beloved by the contemporary public, and points up the contrast between a countryside imagined as innocent and the unnatural perversions of the urban economy. 'When we look forth upon the face of nature', wrote David Mushet in 1839, '... that beautiful world ... all bearing some impress of life, of purpose and of joy; – and then turn to recollect what those who have seen, never shall forget ... the tortures and starvation inflicted upon those ... who, in the state of nature, had ... lain down ... to die in peace ... by men polished in all refinement of the civilized world ... does not the blood run chill with fear at the incomprehensible delusion which can fill the heart of man?'[67] *The Voice of Humanity* even spoke of the 'unearthly impressions' of those who actually visited the yards, which 'neither pen nor pencil' could convey: a true vision of hell, damning evidence of the fallen state of *man*, in which the whole natural world was involved, whether as victims or corrupted fellow predators. The Rev Thomas Greenwood, one of the leaders of the Association for Promoting Rational Humanity, thought it was 'an awful sign of the times, that so far from our humanity having kept pace with the progress of civilization and the spread of religious knowledge ... the very heathen, discharged more faithfully the duties towards the inferior creatures, than Christians, so called, do at the present day ... The groans of our unfortunate animals are daily wearying heaven, and their blood crying to it from the ground.'[68] It is significant that Egerton Smith reissued Cruikshank's print in his *Elysium of Animals* (1836), describing the knacker's yard as a 'Golgotha' or 'earthly purgatory' from which the horse's spirit passes to 'that state of bliss' which 'a kind Providence' has vouchsafed: a place resembling the paradise of biblical prophecy, where all predation has ended – but unbiblical in so far that tyrant man is banished from it.[69]

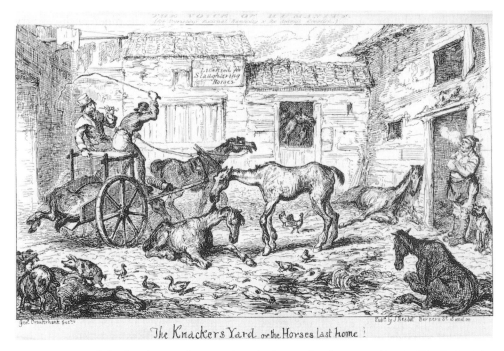

29 George Cruikshank, *The Knackers Yard or the Horses last home!*, etching in *The Voice of Humanity*, 1830–1, second state, as re-published 1832–3. By permission of the British Library.

 The anxieties evident in the many protests against the treatment of horses in London were redoubled on the subject of Smithfield Market, the reform of which, preferably by removal to the suburbs, was from the start the prime objective of the anti-cruelty groups and journals. Already in the eighteenth century the needs of London's growing population and the congestion caused by increased building and vehicular traffic made the Smithfield site, in the heart of the city, unsuitable as a market for live cattle and sheep, and cruelty to the animals was almost inevitable. By the mid-1840s over 210,000 cattle were sold there each year, together with 1.5 million sheep: figures which represented roughly a three-fold increase since 1730.[70] The many slaughterhouses in central London were an equal cause for protest, on both humanitarian and hygienic grounds, and were often compared unfavourably with the public abattoirs of Paris.[71] However, successive attempts at legislative control and reform of the London meat trade proved ineffectual against an array of vested interests connected with the Smithfield site, whose collective voice dominated the City of London's Common Council.[72] Only in the late 1840s, when a cholera epidemic in London heightened the public's alarm about diseased meat and the uncontrolled disposal of blood and offal, and when the issue was taken up in the mainstream press (including *Punch* and the *Illustrated London News*), did government action seem likely. In 1855 Smithfield was finally closed as a live animal market, and a new site opened near Islington.[73]
 Here, too, a bald recital of the facts does little to convey the symbolizing power of Smithfield in the imagination of Londoners. It was, first of all, a shaming blot on the imperial capital. 'Among the various and extensive improvements

which have now for a long time been carrying on in various parts of the town', wrote *The Voice of Humanity* in 1830, 'the most material improvement' it needed was neglected: 'To no inhabitant of this overgrown metropolis ... is it necessary to say how great a disgrace the scenes of confusion, uproar, and barbarity ... exhibited at Smithfield ... are, not only to the town itself, but even to the character of the country.'[74] The historical reputation of the Smithfield area seemed to be contributory. The autos-da-fés of martyrs and the public executions formerly carried out there; the duelling and brawling; the crowd disorder and abuse of performing animals associated with Bartholomew Fair: all signified a 'spirit of cruelty' which supposedly still haunted the site.[75] For *The Herald of Humanity* in 1844, Smithfield Market, 'with all its brutal cruelties, its abandoned and frightful demoralization' was 'the focus of all the lowest dregs from the vilest purlieus of the town, – and consequently, the very nursery of all crime, from drunkenness and robbery, to ruffianism and murder'.[76] The writer might have remembered the vivid evocation in Dickens's *Oliver Twist* (1837–9), where Oliver and Bill Sikes pass through Smithfield early on market morning, on their way to rob a suburban house:

> The ground was covered, nearly ankle-deep, with filth and mire ...
> Countrymen, butchers, drovers, hawkers, boys, thieves, idlers, and
> vagabonds of every low grade, were mingled together in a mass ... the
> hideous and discordant din that resounded from every corner of the
> market; and the unwashed, unshaven, squalid and dirty figures ... bursting
> in and out of the throng; rendered it a stunning and bewildering scene,
> which quite confounded the senses.[77]

Little wonder that the brutal Sikes there meets many old acquaintances. Yet, as successive writers on Smithfield and the slaughterhouses made clear, their sordid brutalities stemmed from a *system* of rapacity in which the higher classes were implicated. This referred not only to the luxurious tastes and rising meat consumption of Londoners, but to the City of London's self-serving obstruction of reform. A Common Councilman challenged by John Lawrence about the campaign for removal of the market pronounced it nonsensical; for 'why do men submit to be cooped up in cities, but to get money, the grand object?'[78] In 1847 *Punch* purported to 'magnify and analyse' a droplet of 'Smithfield fluid', and, as the accompanying engraving illustrated, found that 'Mammon is one of the chief ingredients, though Folly forms no inconsiderable portion of the disgusting mixture.'[79]

The descriptions of Smithfield were eloquent and very numerous. Writers emphasized especially the cruelty of driving the animals great distances on the hoof, as they converged on the metropolis from distant grazing grounds; the hunger and thirst they suffered during the long hours in the market itself; the active cruelty of the drovers and bystanders in coercing them in and out of the chaotically crowded space; and the unregulated barbarities of the actual methods of slaughter. As in the case of horse slaughter, the fact that the worst of the abuses took place under cover of night confirmed their hellish quality. The author of *An Enquiry into the Present State of Smithfield Cattle Market* (1848) noted that

Smithfield on a Sunday evening had been compared to 'Dante's description of Pandemonium ... the glaring torches passing backwards and forwards amongst the frightened beasts, and the continued sound of the heavy blows inflicted on the ... poor animals'. No pen could describe the impression: it 'must be seen to be believed; – and yet all this takes place in London.' The reference to Pandemonium is an indication that here, too, the grief and guilt of observers were expressed in religious analogies: 'now that the faggots no longer blaze around the forms of human martyrs', as they once had at Smithfield, 'must the passions of hardened men find vent in cruelty to "the brutes that perish?"' – and under the very shadow of 'the principal Protestant Church in Europe'?[80] In this 'purgatory', it was the Lord Mayor of London, asserted *The Voice of Humanity*, who became the 'Inquisitor General'; the drovers and dogs were the 'Imps and Tormentors' of the cattle.[81] The Christian connotations of the lamb led to slaughter suggested to some writers an analogy with the sufferings of Christ himself, which is echoed even in the phraseology of one of Dickens's evocations of Smithfield, 'A Monument of French Folly'. The parallels with the passion story were indeed striking: the journey to the city; the encounter with moneychangers in the precinct of the temple itself; the 'night's endurance'; the scourging and thirst; the *via dolorosa* trodden by the animals among a mocking 'crowded multitude'; the falls; the final terrible death.[82] In this spirit, an illustration of 'The Usual Mode of Slaughtering a Calf' (by slow bleeding) which the SPCA commissioned in 1828, and which was said to be 'taken from life', showed the calf suspended upside down against a post, like Christ on the cross, flanked by its indifferent tormentors.[83]

Lewis Gompertz, founder of the Animals' Friend Society, would not, as a Jew, have entered into such Christological allusions. However, a comparable sense of *identification* with animals is central to his belief in equality between men and other species. In fact, he proposed, and sometimes even published, illustrations of humans undergoing, in imagination, the tortures to which animals were subjected in London.[84] Thus the wood engravings he commissioned for *The Animals' Friend* magazine have a raw directness which precludes spectatorial detachment. Indeed, their deliberate violence, crudity and materiality outdo Hogarth's in *The Four Stages* and risk comparison with cheap murder sheets and their woodcuts; they closely resemble these in manner, particularly in the bold tonal contrasts, coarse hatchings and emphatic poses.[85] Despite the genteel readership of *The Animals' Friend*,[86] Gompertz rejected any kind of artistic refinement in its illustrations, perhaps feeling that this would involve a compromise with the very 'improvement' he believed to be complicit in the system of cruelty. The *Night View of Smithfield Market* (plate 30),[87] first published in 1840, is lit only by a sickle moon and the torches of the drovers, a 'ferocious set of miscreants' who, with their bludgeons and dogs, force the cattle into circles or 'ring droves'. These subhuman, yelling faces and the chaos of animals and buildings give a sense of nightmare and unmitigated moral darkness. Already in 1839 *The Animals' Friend* had 'with repugnance laid the disgusting details of the slaughter-house' before its readers in visual form (plate 31); feeling 'the necessity of such exposure, in order to lead to amendment'.[88] Like the horse knackers, the slaughterers worked in the semi-secrecy of private, uninspected

premises; 'dismal dungeons' in cellars and back alleys where light and air never penetrated, made more foul by the masses of blood, offal and excrement on the floor and surrounding streets.[89] Gompertz's illustrator does not give a naturalistic impression of the scene like Cruikshank's *Knackers Yard*, but rather a demonstrative concentration of horrors which in reality were probably dispersed. Sheep are flung down from street level (many broke limbs in the fall), then butchered and skinned while still alive. An ox is slowly slaughtered by breaking open its skull with an axe and then stirring its brains with a rod and cutting its throat: as the slaughterer tramples its body to force out the blood, it still turns its head up accusingly to look in his face.[90] What is chiefly striking in this depiction is the demonic energy of the plebeian slaughterers, which is again reminiscent of the visual rhetoric of the murder sheets. Yet responsibility for this outrage on nature was not to be laid at their door alone. Writers from Mandeville to John Stuart Mill noted that one effect of the luxury and 'refinement' of metropolitan society, 'the subdivided industry of our commercial age', was to remove consumers from a sight of the agonies which might otherwise arouse 'primitive pity'.[91] However, nature's revenge reached even these privileged originators of the cruelties to animals. Dickens warned that 'Into the imperfect sewers of this overgrown city, you shall have the immense mass of corruption ... lazily thrown out of sight, to rise, in poisonous gases, into your house at night, when your sleeping children will most readily absorb them, and to find its languid way, at last, into the river that you drink.'[92]

Many evocations of the fate of cattle in London thus contrast the innocence of the natural world with urban 'corruption', a corruption which is both physical and moral. It is a striking illustration of Raymond Williams's argument that 'the greed and calculation, so easily isolated and condemned in the city, run back, quite clearly, to the country houses, with the fields and their labourers around them ... The exploitation of man and of nature, which takes place in the country, is realized and concentrated in the city'; but this economic interdependence is seldom admitted.[93] Rather, the inhuman horrors of the one were heightened by false antithesis with the supposed charms and natural affections of the other. Sometimes the relationship was imagined in humorous terms. The *Comic Almanack* for 1838 included a fictitious letter home from the servant of a country squire on a visit to London, reporting that they both pined for their 'old friends', the animals they had known all their lives, and therefore spent their days in Smithfield, 'ful of orses & cows & carves & pigs & shepe & other Beestly sites' (beastly sights: but the misspelling conveys its own meaning).[94] More often, however, the contrast was a tragic one. The author of *An Enquiry into ... Smithfield* reported that when cattle, unused to cruel treatment, left the hands of the attentive farmers and were consigned to the London drovers, they became so disfigured by suffering that in a few hours their original owners could not recognize them, and even their voices were 'much changed'. 'In vain', said *The Voice of Humanity* 'does the skilful grazier turn them into the finest pastures, and bestow upon them all the pains and care ... to render them objects of attraction and delight, to the artist, and to the epicure ... no sooner do they scent the smoky air of our crowded city than they are submitted to indignities and sufferings inconceivable' ...[95]

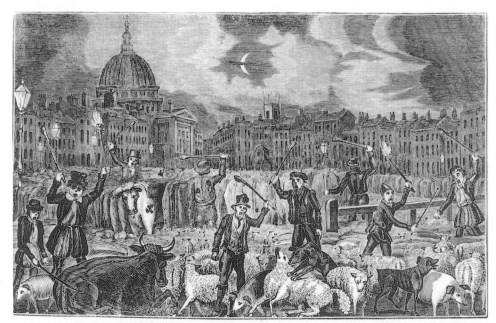

Plate 1. NIGHT VIEW OF SMITHFIELD MARKET.

30 Anon., *Night View of Smithfield Market*, wood engraving in *The Animals' Friend*, 1840.
By permission of the British Library.

Strong evidence of the degree to which these ideas haunted the consciousness of
the early Victorian public may be found in an unexpected place: the *Illustrated
London News*, started in 1842. The patriotic ebullience which permeated this richly
illustrated weekly journal, and ensured its success with a wide public, could not, one
would think, be more different from the moral pessimism of the anti-cruelty
magazines. Faith in technology, in the machinery of government, in the growth of
London and the building of empire (what the *Illustrated London News* itself called
its 'progressive spirit and persevering will'),[96] could best be conveyed by an uplifting
treatment of the chosen themes. As the *Illustrated London News*'s short-lived rival,
the *Pictorial Times*, remarked, such illustrations as appeared in both journals were
calculated to 'instruct and refine the feelings and the taste, as well as to convey
information'. They were a 'permanent genial influence', whereas an 'ugly or
brutalizing print, hung upon the wall of a room, does moral injury to all who
habitually look upon it.'[97] It has been suggested that in the 1840s the *Illustrated
London News*'s programme dictated an artistic as well as a political conservatism,
which failed to capture the authentic experience of metropolitan life, its ostensible
subject;[98] but such judgements interpret its title and intentions too narrowly. The
chief impression one receives from its pages is of a 'masculine' vigour and vitality:
an impression often conveyed not by literal illustration of commercial or industrial
life, but by pictures of *animals*. From the start the *Illustrated London News*
resounds to the thunder of horses' hoofs and the bellowing of wild beasts locked in
combat, motifs which occasionally spill out of the vignette or half-page format and
run over the page in compositions of arresting originality.

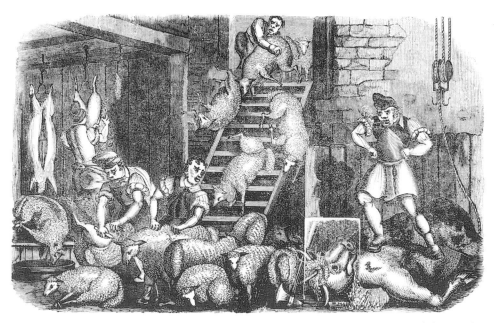

31 Anon., untitled wood engraving in *The Animals' Friend*, 1839. By permission of the British Library.

The equine subjects range from the performing horses at Astley's amphitheatre to royal cavalcades, military reviews and campaigns, hunts and race meetings. The latter must have been extremely popular, as they become a regular feature, of increasing exuberance and verve. The earliest version of the subject, drawn by Constantin Guys and John Gilbert in 1843 (plate 32), represents Derby Day as 'truly a national scene ... which arouses ... the sympathies of hundreds of thousands of people of all classes of society throughout the great metropolis of Britain'. In this joyous mass exodus from London, 'youths aristocratic' pass Burton's classical screen and arch at Hyde Park Corner, a symbol of metropolitan grandeur and improvement marking the edge of the city, and hurtle along suburban roads past elegant villas, where even countrymen in smocks wave excitedly.[99] In these images, as in the anti-cruelty journals, one senses that animals fulfil a powerful metonymic function; but whereas the latter treat them as living evidence of the tragic effects of metropolitan commercialism, and hence a symbol of the ills of capitalism, here horses embody, by another kind of displacement, the united energies of the imperial capital, and 'the whips resound' without any trace of moral inhibition. To an unsympathetic eye, these animals might appear to be galvanized by what Carlyle called the 'half-frantic velocity of impetus' of the 'brute-world' of British national ascendancy and capitalist competition.[100] In a different spirit, the *Illustrated London News* claimed in 1851 that the merchant princes and citizens had 'by their well-directed industry' ... 'given a vital soul and life-like energy to inanimate matter',[101] a soul which these excited, dashing horses appear to share. Such images of urban dynamism are complemented by the *Illustrated London News*'s many picturesque scenes of traditional farming and rural pursuits, which emphasize the reciprocity of landowners' benevolence and

LEAVING TOWN.

Hurrah for the Downs! hurrah!
Swell nobs, swell mobs, away!
Be your hopes as bright as the morning light

That ushers the Derby Day!
Hurrah for the rush—the throng—
The stream that flows along

Of life and joy, hurrah!
The bounding steed, the *knacher* old,
The lady fair the gipsy bold—

The jest, the laugh—the shout, the scold—
The rent of rags, the sheen of gold—
Are all on the road! Hurrah!

THE SWELL DRAGS

Whip, whip! on moves a joyous freight
Of youths aristocratic!
In comet-like, bold, dashing course
They *come it* quite erratic.
Loudly on air as on they fly,
Their shout and laugh float back—

Again, again, their whips resound.
In haste to see *"the crack."*
Unlike a searcher for the drowned
Whom waves and wind repel,
Our modern lordlings ply *the drag!*
However great *the swell.*

HORSE-VAN.

Though dark and dull this van appears,
It holds within a *racer* (ray, sir)
Of no slight magnitude, indeed,
Which will be claimed by *Day,* sir.
Which horse it is of all of these,
Like ladies' hair in papers,

Is known to none, but all agree
Outside are many gapers.
Strange cavalcade! but stranger still
Enough to make one smile,
The man that lingers in *the rear*
Is van guard all the while!

RINGING TO SADDLE.

Talk of trumpet, of drum, and of clarion, and all
The peals that to battle belligerents call,
A sound more exciting is borne on the air!
'Tis the bell that to saddle bids jockeys prepare.

The whole tribe of Scotts, Days, and Robinsons, springing
From rest or from slumber, respond to its ringing;
While the thousands around, with fresh longings and hopes,
Show their eager impatience, and press to the ropes.

[Drawn by C. Guys and J. Gilbert; and engraved by Orrin Smith and W. J. Linton.]

32 After Constantin Guys and John Gilbert, *Epsom Races*, wood engravings by Orrin Smith and W.J. Linton in the *Illustrated London News*, 1843. Manchester Central Library.

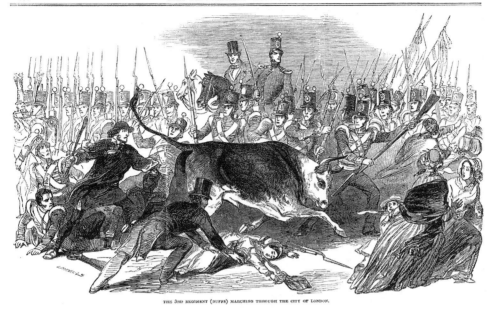

THE 3RD REGIMENT (BUFFS) MARCHING THROUGH THE CITY OF LONDON.

33 Ebenezer Landells, *The 3rd Regiment (Buffs) Marching Through the City of London*, wood engraving in the *Illustrated London News*, 1846. Manchester Central Library.

the dutiful gratitude of the peasantry. The harmonious interdependence of country and city, and also of different social classes, is evoked by the many scenes of agricultural shows, particularly that of the aristocratic Smithfield Club, held in the dignified surroundings of the Baker Street Bazaar in London's West End. Its arcaded halls, with handsomely dressed ladies and gentlemen promenading past the pens of the huge prize animals, are depicted with the compositional balance and perspectival symmetry of a Renaissance predella; for the shows were meant to epitomize the wished-for (but hardly actual) prosperity and unity of the whole nation. They were 'a characteristic of nationality' and of 'the flourishing agriculture of happy England ... Upon her fresh and wholesome broad lands, and in the midst of hardy tillage, spring up that fine race of sturdy yeomen who ever and anon pass from the ploughshare to the battle-field with such stalwart proof of manly health and vigour.'[102]

Smithfield market itself could only with difficulty be accommodated to such a triumphal view of the capital and its relationship to the rural roots of the national economy. The successive representations of it in the *Illustrated London News* are a fascinating index of response to public opinion, of editorial attempts to find an appropriate idiom in which to present it to the readers, and of a latent anxiety which finally becomes manifest. Initially they cluster at the poles of urban vitality and rural passivity which have been analysed above. In the former category must be placed the extraordinary engraving by Landells of *The 3rd Regiment (Buffs) Marching Through the City of London* of 1846 (plate 33). Despite this title, the ostensible subject is an incident when a bullock from Smithfield market, 'irritated by the noise of the drums and the glare of the red coats', stampeded and killed a

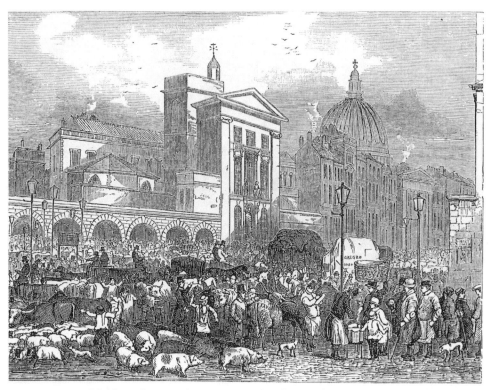

34 Anon., *Smithfield Market*, wood engraving in the *Illustrated London News*, 1848. Manchester Central Library.

girl, prompting fresh complaints and demands for the removal of Smithfield to the suburbs. Yet the *visual*, as distinct from the textual, meaning is created by the exciting affinity of the rampaging, virile bull and the serried ranks of soldiers and fixed bayonets, to which the dead girl and frightened women form only an expressive foil. The scene corresponds quite closely to one of the royal bull fight at Madrid which the *Illustrated London News* described enthusiastically a few pages later.[103] At the other end of the spectrum, in the spirit of a rural idyll, is the depiction of Smithfield Market which appeared in 1848 to illustrate Thomas Miller's 'Picturesque Sketches of London, Past and Present'. This nostalgic article evokes a 'neighbourhood ... hallowed by a thousand poetical associations', but virtually ignores the barrage of contemporary protests about the cruelties of the market. Instead, the 'splendid assemblage of cattle' pleasantly conjures up 'images of homesteads and thatched granges, far off amid the dreamy murmur of open fields', whence the animals came. A drover with his faithful dog, who would delight 'the eye of a Landseer', is 'no bad emblem of one of John Bull's bulwarks'. The engraving itself (plate 34) forms a remarkable contrast with the image of Smithfield published by Gompertz in *The Animals' Friend* (plate 30). Instead of a dark chaos of human and canine savagery, we have a placid early morning scene where the sun lights up the stabilizing architectural features of the market area, particularly St Bartholomew's Hospital with its benign associations, and flights of birds wheel over St Paul's. The stolid John-Bullish buyers and groups of animals

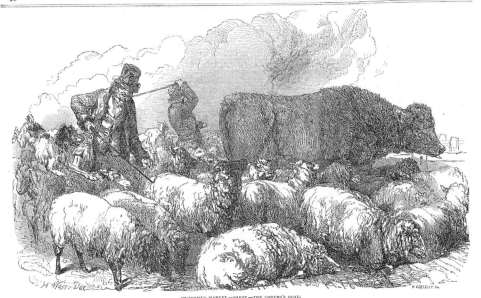

SMITHFIELD MARKET.—SHEEP.—THE DROVER'S GOAD.

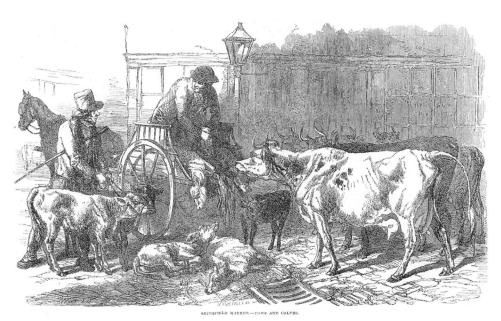

SMITHFIELD MARKET.—COWS AND CALVES.

35 After Harrison Weir, *Smithfield Market. – Sheep. – The Drover's Goad* and *Smithfield Market. – Cows and Calves,* wood engravings by Henry Vizetelly in the *Illustrated London News,* 1849. Manchester Central Library.

give more the impression of a country fair than the barbaric urban frenzy depicted in *The Animals' Friend*.[104] However, even the *Illustrated London News*, wedded as it was to City interests, could not in the end resist the gathering tide of revulsion against the abuses of Smithfield, which was fomented by epidemics of typhus and cholera; in 1849 the editors performed a *volte face*, with an illustrated article supporting Mackinnon's parliamentary campaign for the closure of Smithfield. Nevertheless, the high artistic tone of the journal had even here to be maintained, in order to dignify its subject: the text commentary includes a long passage from Dickens's description of Smithfield in *Oliver Twist*, which has already been quoted, and the illustrations are by Harrison Weir, 'one of our ablest Artists', who has 'portrayed the evils of the system sought to be remedied, in a series of scenes sketched in Smithfield Market, yet presenting but a tithe of the cruelty and nuisance which have been for ages perpetrated in one of the most crowded localities of the metropolis'.[105] This 'tithe' admits a poignant image of bound calves loaded on a cart, their heads dangling painfully over the side and nuzzled by a distressed cow (plate 35, bottom). The latter detail had occurred in an illustration of the same subject in *The Animals' Friend*, from which Weir may have taken it, but Gompertz had driven the point home with a matching picture of *human children* stacked up in a cart like the calves, which would have been unthinkable in the *Illustrated London News*.[106] Although Weir's ramshackle buildings and open drain hint at the insanitary filth of the city slaughterhouses, this picture, with its careful composition and distribution of light and shade, retains a pleasing picturesqueness which diminishes the affective qualities of the subject.[107] Even the illustrations of the drovers' cruel use of goads (plate 35, top) observe the artistic decorum which had been recommended and exemplified in Pyne's *Microcosm* nearly half a century earlier. The vignette format largely excludes a setting, and all we see is the sky with billowing clouds, redolent of open country rather than the congested metropolis. A more concrete representation of the urban locales, where cruelties to animals were actually perpetrated, would have provoked those troubling doubts about the nature of 'progress' and 'improvement' in London which this article has explored, and compromised the positivist stance of the *Illustrated London News*. Paradoxically, faith in the *city* could only be sustained by apparent retreat to the *country*, and inherited artistic conventions, as has been shown, played an indispensable part in this process.

Diana Donald
Manchester Metropolitan University

Notes

This essay relates to work on a larger project, a book on animal imagery in British art, *c*.1750–1850. I am most grateful to John Hewitt for reading the essay in draft, and for advice and suggestions based on his wide knowledge of nineteenth-century illustrated periodicals.

1 The metropolitan population rose from 864, 845 in 1801 to 2,362,000 in 1851. Eric E. Lampard, 'The Urbanizing World', in H.J. Dyos and Michael Wolff (eds), *The Victorian City: Images and Realities*, London, 1973, vol. 1, p. 4.

2 Frederick Engels, *The Condition of the Working Class in England*, first published in

Leipzig, 1845; introduced by Eric Hobsbawm, St. Albans, 1969, p. 57.

3 Edward G. Fairholme and Wellesley Pain, *A Century of Work for Animals: the History of the R.S.P.C.A., 1824–1924*, London, 1924. Arthur W. Moss, *Valiant Crusade: the History of the R.S.P.C.A.*, London, 1961. An archive is held at the Society's headquarters at Horsham. James Turner, *Reckoning with the Beast: Animals, Pain, and Humanity in the Victorian Mind*, Baltimore and London, 1980, pp. 40f.

4 ibid. and Robert W. Malcolmson, *Popular Recreations in English Society 1700–1850*, Cambridge, 1973, pp. 125f, 172f.

5 Keith Thomas, *Man and the Natural World: Changing Attitudes in England 1500–1800*, Harmondsworth, 1984, pp. 181–2. Cf. Turner, op. cit. (note 3), p. 25; Keith Tester, *Animals and Society: the Humanity of Animal Rights*, London and New York, 1991, pp. 54–5, 101–2. Cf. the comments of Steve Baker on Thomas's and Tester's viewpoints in *Picturing the Beast: Animals, Identity and Representation*, Manchester and New York, 1993, pp. 18–19.

6 Hilda Kean in *Animal Rights: Political and Social Change in Britain since 1800*, London, 1998, pp. 28f, has recently demonstrated the importance of animals' presence in London, and the metropolitan focus of early anti-cruelty legislation.

7 Raphael Samuel, 'Comers and Goers', in Dyos and Wolff, op. cit. (note 1), vol. 1, pp. 123f.

8 Henry Mayhew, *London Labour and the London Poor*, first published 1851, enlarged edn (4 vols.) 1861–2; reprinted London, 1967, vol. 2, pp. 58f, 65.

9 Joseph Strutt, *The Sports and Pastimes of the People of England … from the Earliest Period to the Present Time*, first published 1801; new edn by William Hone, London, 1830, pp. 241–2, 245–57. Mayhew, op. cit. (note 8), vol. 1, pp. 3–4; vol. 3, pp. 181f., 214f. Dix Harwood, *Love for Animals, and How It Developed in Great Britain*, New York, 1928, pp. 223f.

10 Mayhew, op. cit. (note 8), vol. 1, pp. 451–2; vol. 2, pp. 55–7; vol. 3, pp. 5f. Malcolmson, op. cit. (note 4), pp. 45f., quotes detailed descriptions of baiting methods.

11 Richard Perren, *The Meat Trade in Britain 1840–1914*, London, Henley and Boston, 1978, p. 43.

12 Mayhew, op. cit. (note 8), vol. 1, p. 28, and cf. vol. 2, p. 23.

13 Mayhew, op. cit. (note 8), vol. 2, p. 193. Harriet Ritvo, *The Animal Estate: the English and Other Creatures in the Victorian Age*, Cambridge, 1987, pp. 125f.

14 For example, John Bourne's *Drawings of the London and Birmingham Railway … with an Historical and Descriptive Account by John Britton FSA*, London, 1839, makes clear the extensive use of horses in carting materials

and earth, and in powering equipment for the building of embankments and drainage of tunnels.

15 Lewis Gompertz, *Fragments in Defence of Animals, and Essays on Morals, Soul, and Future State; From the Author's Contributions to the Animals' Friend Society's Periodical …* , London, 1852, pp. 9–10.

16 Lewis Gompertz, *Objects and Address of the Society for the Prevention of Cruelty to Animals*, London, 1829, p. 9. Gompertz was then still Honorary Secretary of the S.P.C.A.

17 ibid., pp. 8–11. See the listings of the S.P.C.A.'s prosecutions, initially in *The Voice of Humanity* and, from 1832 onwards, in the Society's own printed annual reports. Prosecutions instigated by Gompertz's group were reported regularly in *The Animals' Friend* from 1833 onwards. In both cases, London drivers and drovers were the main targets. Cf. Anon., *The Collective Wisdom; Or, Sights and Sketches in the Chapel of St. Stephen …* , London, 1824, pp. 47f, for an account, and a graphic illustration by Cruikshank, of direct interventions at Smithfield Market by Richard Martin, who had introduced the 1822 Act against cruelty to horses and cattle. Shevawn Lynam, *Humanity Dick: a Biography of Richard Martin, M.P.*, London, 1975, pp. 197f, 208–225. Cf. E.S. Turner, *All Heaven in a Rage*, London, 1964, pp. 128–9, 143–6; Ritvo, op. cit. (note 13), p. 137; Kean, op. cit. (note 6), p. 37.

18 John Oswald, *The Cry of Nature; Or, An Appeal to Mercy and to Justice, On Behalf of the Persecuted Animals*, London, 1791, pp. 66–7, 77–8.

19 Walter E. Houghton, *The Victorian Frame of Mind 1830–1870*, New Haven and London, 1957, pp. 77–89.

20 Cf. Turner, op. cit. (note 3), pp. 30–7, 53–7.

21 *The Illuminated Magazine*, vol. 1, May–October 1843, pp. 3–8, 45–52, 97.

22 *Punch*, vol. 9, 1845, p. 146.

23 For example, H.T. Dickinson, *Caricatures and the Constitution 1760–1832*, Cambridge, 1986, pl.111: a caricature by George Cruikshank of 1819, showing John Bull as a collapsed bull.

24 Notably Malcolmson, op. cit. (note 4), pp. 89f, 160–1; Ritvo, op. cit. (note 13), pp. 129f; Kean, op. cit. (note 6), pp. 64–6.

25 *The Animals' Friend*, vol. 1, 1833, p. 34.

26 David Mushet, *The Wrongs of the Animal World*, London, 1839, p. 79.

27 J.C. Reid, *Bucks and Bruisers: Pierce Egan and Regency England*, London, 1971, pp. 50–86.

28 Pierce Egan, *Life in London; Or, the Day and Night Scenes of Jerry Hawthorn, Esq. and his Elegant Friend Corinthian Tom … in their Rambles and Sprees through the Metropolis*, London, 1821, pp. 46, 50, 72, 150, 155. The latter phrase was a coachman's term for

29 ibid., pp. 223–5.

30 Ronald Paulson, *Hogarth's Graphic Works*, revised edn, 2 vols., New Haven and London, 1970, cat. no. 206, pl. 228.

31 Lynam, op. cit. (note 17), p. 205.

32 Louis James, *Print and the People 1819–1851*, London, 1976, pp. 80–1, illustrated.

33 Egan, op. cit. (note 28), pp. 331–2, 241–2.

34 Robert L. Patten, *George Cruikshank's Life, Times, and Art*, vol. 1: *1792–1835*, London, 1992, pp. 374–8.

35 *Sunday in London. Illustrated in Fourteen Cuts, by George Cruikshank, and a Few Words by a Friend of His; with a Copy of Sir Andrew Agnew's Bill*, London, 1833, pp. 20–1, 57, 60–1. This seems to be a direct attack on Cruikshank's former associate, Egan, who was a main player in the development of sporting Sunday newspapers. Reid, op. cit. (note 27), pp. 118, 127.

36 *The Voice of Humanity*, vol. 1, 1830, pp. 24–7.

37 *Sunday in London*, op. cit. (note 35), pp. 68–74.

38 ibid., pp. 3, 22, 43–4, 47–9.

39 ibid., p. 37.

40 For example, 'Jolly Dogs. – Abolition of the Truck System', in the *Comic Almanack* (1st series, 1835–43), 1840, J.C. Hotten reprint (n.d.), p. 208; 'Gross Injustice' in *Punch*, vol. 3, 1842, p. 222. The very first number of *Punch* had contained 'A Conversation Between Two Hackney-Coach Horses' about their cruel treatment: vol. 1, 1841, p. 7, unillustrated.

41 Gompertz, *Fragments*, op. cit. (note 15), pp. 245–7.

42 *The Parliamentary History of England*, vol. 36, London, 1820, col. 835. Commons debate on John Dent's Bull-baiting Bill, 24 May, 1802.

43 *Microcosm: Or, a Picturesque Delineation of the Arts, Agriculture, Manufactures, &c. of Great Britain, in a Series of Above a Thousand Groups of Small Figures for the Embellishment of Landscape ... the Whole Accurately Drawn from Nature, and Etched, by W.H. Pyne; and Aquatinted by J. Hill. To which are now added Explanations ... By C. Gray*, vol. 1, 2nd edn, London, 1806, pp. 13, 16, 27–8; vol. 2, 1808, p. 22.

44 ibid., vol. 2, p. 20 and cf. p. 11.

45 ibid., vol. 1, p. 16; illustrated by Kean, op. cit. (note 6), p. 49.

46 ibid., vol. 2, p. 18.

47 Paulson, op. cit. (note 30), cat. nos. 187–90, pls. 201–4.

48 Charles Dickens, *Oliver Twist*, 1837–9; preface to the third edition of 1841.

49 Since Thavies Inn, on the left, was on the south side of Holborn, they are evidently coming *from*, not going *to*, Smithfield, as often stated.

50 Hogarth was probably influenced here by Henry Fielding's *An Enquiry into the Causes of the Late Increase of Robbers*, 1751.

51 Anon., *A Dissertation on Mr. Hogarth's Six Prints Lately publish'd, viz. Gin-Lane, Beer-Street, and the Four Stages of Cruelty*, London, 1751, p. 59.

52 John Nichols, *Biographical Anecdotes of William Hogarth; With a Catalogue of His Works*, 3rd edn, London, 1785, pp. 316–17. Paulson, op. cit. (note 30), cat. nos. 189–90, pls. 278–9. Publication of the woodcuts preceded that of the corresponding engravings, rather than being a follow-up venture, as often implied.

53 Ronald Paulson, *Hogarth: His Life, Art, and Times*, vol. 2, New Haven and London, 1971, p. 110. Paulson, *Hogarth*, vol. 3, *Art and Politics, 1750–1764*, New Brunswick, 1993, pp. 17, 26–35.

54 Quoted from the edited version published in John Bowyer Nichols's *Anecdotes of William Hogarth, Written by Himself*, London, 1833, pp. 64–5.

55 Charles Lamb, 'On the Genius and Character of Hogarth', first published in *The Reflector*, no. 3, 1811. Cf. the comments of Mark Hallett in *The Spectacle of Difference: Graphic Satire in the Age of Hogarth*, New Haven and London, 1999, pp. 222–33.

56 It was frequently cited as proving the social dangers of countenancing cruelty to animals, for example, Thomas Young, *An Essay on Humanity to Animals*, Birmingham, 1804, pp. 2, 53; Henry Crowe, *Zoophilos; Or, Considerations on the Moral Treatment of Inferior Animals*, 2nd edn, London, 1820, pp. 104f. Hogarth's images were also often invoked in parliamentary debates by supporters of anti-cruelty measures, for example, in 1809, 1824 and 1825: *Parliamentary Debates*, vol. 14, col. 1031*; New Series vol. 10, col. 868; vol. 12, col. 1010.

57 Patten, op. cit. (note 34), pp. 362–73.

58 Mayhew, op. cit. (note 8), vol. 1, pp. 181–3; vol. 2, pp. 8–9.

59 It is summarized by Ann Datta in 'Animals and the State: A review of English law before 1870', in Paul Foster (ed.), *Animals and the Law*, Otter Memorial Paper no. 10, Chichester, 1998, pp. 30, 32, 33.

60 Erskine's speech introducing his Cruelty to Animals Bill, 15 May, 1809: *The Parliamentary Debates*, vol. 14, 1812, col. 563. This was subsequently printed as a pamphlet and circulated by the S.P.C.A., whose *Objects and Address* (note 16) and Minute Books also often refer to the knackers' abuses. *The Herald of Humanity; or, the National Animals' Friend Society's Quarterly Chronicle* (produced by a splinter group of the Animals' Friend Society), no. 1, 31 March, 1844, pp. 2–10, gave a particularly detailed, harrowing account of the London knackers' yards, including the

eyewitness accounts of police officers.

61 Thomas Paine, *Rights of Man*, part 2, 1792; introduced by Eric Foner, Harmondsworth, 1985, p. 242. Thomas Carlyle, *Past and Present*, 1843; introduced by Douglas Jerrold, London, 1960, p. 269, and cf. pp. 151–2. Gompertz, *Fragments*, op. cit. (note 15), p. 167.

62 Crowe, op. cit. (note 56), pp. 44–6.

63 Charles Dickens, *Sketches by Boz*, 1839; chap. 7, 'Hackney-coach Stands'.

64 *The Voice of Humanity*, vol. 1, 1830–1, opposite p. 121. The plate was reworked, notably with the addition of the sign reading 'Licensed for Slaughtering Horses' (meant to show the inadequacy of the existing inspection system) and more foraging creatures, and reissued in vol. 3, n.d. [1832–3], opposite p. 134. It could be bought as a separate print for 6d plain, or 1s on good India paper, and possessed 'independent of the interest of the subject, so considerable a degree of merit, that we hope our friends will have it framed'; it was sent, ready framed, 'To any respectable hotel, tavern, or coffee-house, where it would be hung up': vol. 1, p. 165. In a *Prospectus* for vol. 3, n.d. [1832], it was advertised 'neatly framed and glazed ... Price 3s 6d' and there are several other references. It was copied for example, in the *Pictorial Times*, vol. 2, August–December 1843, p. 197. Patten, op. cit. (note 34), pp. 344–6.

65 *The Voice of Humanity*, vol. 1, p. 133. *The Sunday Times*'s and other laudatory reviews were reprinted in a *Prospectus* for vol. 2, n.d. [1831], pp. 4–6.

66 *The Voice of Humanity*, vol. 1, 1830–1, pp. 127–36; vol. 2, n.d. [1831–2], pp. 51–3; vol. 3, n.d. [1832–3], pp. 134–9. Even the various diseases of the fallen horses depicted by Cruikshank were specified. Presumably he based the scene on others' eye-witness accounts.

67 Mushet, op. cit. (note 26), pp. 125–6.

68 *The Voice of Humanity*, vol. 3, pp. 134–5; vol. 2, p. 154.

69 Egerton Smith, *The Elysium of Animals: a Dream*, London and Liverpool, 1836, p. 44.

70 *An Enquiry into the Present State of Smithfield Cattle Market and the Dead Meat Markets of the Metropolis ... by John Bull*, 2nd edn, London, 1848, p. 15. Mayhew, op. cit. (note 8), vol. 2, p. 194. Perren, op. cit. (note 11), pp. 32f.

71 For example, *The Voice of Humanity*, vol. 1, 1830–1, pp. 7–11; Charles Dickens, 'A Monument of French Folly', *Household Words*, 8 March, 1851, in *The Uncommercial Traveller and Reprinted Pieces* (*The Oxford Illustrated Dickens*), introduced by Leslie C. Staples, Oxford, 1987, pp. 589–600.

72 *An Enquiry ...*, op. cit. (note 70), pp. 10f. Philip E. Jones, *The Butchers of London: a History of the Worshipful Company of Butchers of the City of London*, London, 1976, pp. 103–4. Perren, op. cit. (note 11), pp. 36–41.

73 Kean, op. cit. (note 6), pp. 58–64.

74 *The Voice of Humanity*, vol. 1, p. 7.

75 Thomas Pennant, *Some Account of London*, 4th edn, London, 1805, vol. 3, pp. 163–6. Smithfield's connection with political radicalism – from the killing of Wat Tyler to the mass meetings held there in the early nineteenth century – contributed to this sense of turbulence and lawlessness.

76 op. cit. (note 60), no. 1, p. 2.

77 Chap. 21, 'The Expedition'.

78 John Lawrence, *A Philosophical and Practical Treatise on Horses, and on the Moral Duties of Man towards the Brute Creation*, vol. 2, 3rd edn, London, 1810, pp. 482–3.

79 *Punch*, vol. 12, 1847, p. 248. *Punch* was at this time mounting a sustained attack on the vested interests connected with representatives of Smithfield who opposed removal of the market, with numerous articles and cartoons.

80 op. cit. (note 70), pp. 32, 36. Cf. Charles Knight (ed.), *London*, first published in 1841–4, 'revised ... to the present time by E. Walford', London, n.d., pp. 319–21.

81 op. cit., vol. 1, 1830–1, p. 41.

82 Quoted phrases from 'A Monument of French Folly' (note 71), p. 591. *The Voice of Humanity*, vol. 1, p. 142, specifically recalled the description of Christ as a lamb led to the slaughter.

83 *Objects and Address* (see note 16), frontispiece, 'From an original Painting by Wright, taken from Life'; re-used for the title page of *The Animals' Friend*, no. 1, 1833, and elsewhere. The artist was presumably either John Massey Wright or John William Wright.

84 In his *Moral Inquiries on the Situation of Man and of Brutes*, London, 1824, p. 108, Gompertz suggested the experiment of trying the whips, spurs and girths that were inflicted on horses 'on your own back and limbs'. In *The Animals' Friend*, no. 9, 1841, pp. 74–5, he included an illustration of children piled on a cart like calves, and said he would have liked to add prints showing humans hooked up for slow bleeding like calves, or flung into slaughter cellars etc. On Gompertz's philosophy, cf. Kean, op. cit. (note 6), pp. 36–7. Rather than concerning himself with the relative cruelties of Jewish and Gentile methods of slaughtering animals, Gompertz advocated and adopted a vegan diet; see *Fragments*, op. cit. (note 15), p. 207.

85 Cf. Thomas Gretton, *Murders and Moralities: English Catchpenny Prints 1800–1860*, London, 1980, for example pls. 2, 4, 13.

86 It sold for 6d, later raised to 1s. One typical correspondent, a surgeon, claimed that he left it on the parlour table as a 'silent monitor': no. 9, 1841, pp. 20–1.

87 *The Animals' Friend*, no. 8, pp. 35–6, 65, reprinted in *Fragments*, op. cit. (note 15), p. 243.

88 no. 7, p. 32, reprinted in *Fragments*, ibid., p. 245.

89 *The Voice of Humanity*, vol. 2, n.d. [1831–2], p. 9.

90 This part of the wood block has clearly been plugged; perhaps the position of the animal's head was an afterthought.

91 Bernard Mandeville, *The Fable of the Bees*, 1723, Remark (P). *The Voice of Humanity*, vol. 1, 1830–1, p. 42. John Stuart Mill, 'Civilization', in *London and Westminster Review*, April 1836; in *Essays on Politics and Society*, ed. J.M. Robson, *Collected Works of John Stuart Mill*, vol. 18, Toronto, Buffalo, and London, 1977, p. 131.

92 'A Monument of French Folly', op. cit. (note 71), p. 591.

93 Raymond Williams, *The Country and the City*, London, 1973, edn of 1985, p. 48.

94 loc. cit. (note 40), 1838, pp. 153–4. There were many comparable satires in *Punch*: for example, 'The Smithfield Arcadia', vol. 16, 1849, p. 81.

95 *An Enquiry*, op. cit. (note 70), pp. 10, 26. *The Voice of Humanity*, vol. 2, p. 44.

96 *Illustrated London News*, Preface to vol. 6, 1845.

97 *Pictorial Times*, Preface to vol. 2, 1843.

98 For example, Michael Wolff and Celina Fox, 'Pictures from the Magazines', in Dyos and Wolff, op. cit. (note 1), vol. 2, pp. 559f ; Alex Potts, 'Picturing the Modern Metropolis: Images of London in the Nineteenth Century', *History Workshop*, 26, Autumn 1988, p. 42.

99 *Illustrated London News*, vol. 2, 1843, pp. 386–8. One source for these depictions was probably Pierce Egan's 'panoramas': prints forming a long strip that wound out of a pocket-sized cylinder and represented sporting crowds on the road. Reid, op. cit. (note 27), pp. 41, 124, and cf. pp. 168–70.

100 Carlyle, op. cit. (note 61), pp. 18, 213.

101 Quoted Virginia McKendry, 'The *Illustrated London News* and the Invention of Tradition', in *Victorian Periodicals Review*, vol. 27, no. 1, Spring 1994, p. 13.

102 *Illustrated London News*, vol. 1, 1842, p. 481.

103 ibid., vol. 8, 1846, pp. 256, 276–8. Both text commentaries emphasized blood-letting and violent action.

104 ibid., vol. 12, 1848, pp. 75–6. 'Our real London characters' here include calmly judicious butchers and a poor sweep who kisses his condemned donkey goodbye. The article argued that the advantages of retaining the existing market site outweighed the disadvantages.

105 ibid., vol. 15, 1849, pp. 33, 35, 44–8.

106 See note 84 above.

107 Compare the depiction of the Smithfield horse and donkey market on p. 244, the lively charm of which belies the description of cruelties in the accompanying text. Peter W. Sinnema in *Dynamics of the Pictured Page: Representing the Nation in the Illustrated London News*, Aldershot, 1998, pp. 44, 95–102, similarly draws attention to the picturesque conventions which were used to aestheticize scenes of rural poverty in the *Illustrated London News*, often mitigating the troubling revelations of harsh social conditions in the text.

London Bridge and its Symbolic Identity in the Regency Metropolis: the dialectic of civic and national pride

Dana Arnold

In the opening years of the nineteenth century several new bridges were planned and built to improve communications across the Thames, and in response to the westward growth of London and demographic changes north of the river. The rebuilding of London Bridge has a special place in this sequence. Old London Bridge was one of a small number of buildings, monuments and institutions which encapsulated the identity of London. It had been the only link between the city and the south bank of the Thames for over 1,700 years. Its history as a focal point of the national road network, such as it was in the pre-modern era, had earned the bridge a certain fame and it was one of the sights of Britain, if not Europe. Its imposing presence to those arriving by road or river served to reinforce the centrality of London to the nation as a whole whilst it acted as a physical barrier to the city and a symbol of civic order and authority. The decision to rebuild London Bridge in the early nineteenth century brought with it all this historical baggage. The importance of London Bridge and its function as a potent symbol was not forgotten but the nature of the state and metropolis that it signified had changed considerably. This symbolic nature of the bridge is further vivified by the fusion of bridges and monuments in contemporary architectural practice. Taking a lead from Renaissance and antique models the monumental bridge design was a standard part of architectural training. This is brought into sharp focus with the competition to redesign the bridge because the construction of another symbol of urban and national supremacy coincided with the general scheme of the Metropolitan Improvements.[1] The new bridge endured as a symbol of the modern metropolis well into the twentieth century. Improvements to the bridge approaches in the 1890s prompted the complete erosion of the remains of Tudor London in the interests of the ever-expanding heart of the Empire. And the image evoked by the very name London Bridge ensured its survival to the present day. The current pre-stressed concrete structure was built in the late 1960s[2] and the rather plain, functional Regency[3] bridge was re-erected in Lake Havasu City, Arizona, where it stands as an isolated icon of London.

The long and complex histories of London Bridge raise interesting questions about the relationship between the symbolic and functional roles of buildings. A bridge can be a monument, a signifier of social or political pre-eminence, a national symbol or just a stretch of road that happens to pass over water. A consideration of the London Bridge c. 1800–40 in these contexts establishes

its symbolic identity in Regency London and presents the notion that this metropolitan river crossing can be viewed as a matrix through which fundamental aspects of urban identity can be explored. Of particular interest here is the definition and development of London's perimeters, entrances and infrastructure; the city as a site of celebration for nation, state and heroes; the balance of power between a national government interested in urban development of the capital and an established authority within the confines of the City of London.[4]

Defining perimeters and changing infrastructures

London Bridge was part of the physical apparatus that defined the city's perimeter; it was the first bridge across the Thames and the structure dated from medieval times. It also provided an important part of the infrastructure being, for most of the eighteenth century, one of the only three ways of accessing the northern bank of the Thames from the south side of the river. The nucleus of London – the Cities of London, Westminster and the Borough of Southwark – hugged the river and had London Bridge at its eastern edge and Westminster Bridge, begun in the late 1730s, at its western. The third bridge, Blackfriars, begun in 1760, was situated between the other two.

The prodigious growth of London in both physical size and population in the opening years of the nineteenth century changed the balance of the metropolis. And this is reflected in the construction of more bridges in the Regency period, including Vauxhall, Waterloo and Southwark Bridges, all of which were built between 1813 and 1819. The expansion of London not only stretched the shape and the perimeter of the city but also altered the relationship of the metropolis to the river. From the early eighteenth century London had gradually spread westwards. Initially this was the result of the demand for better quality housing by the merchant and middle classes. And as London grew in national importance as the capital city and the centre of government and court life, a house in the increasingly fashionable West End became essential for persons of *ton*.[5] As this westward move gathered pace, so the population began to increase. The first census in 1801 revealed that the population of London had reached 864,845. By 1811 this had grown to 1,099,104. In the next ten years it increased by nearly 20 per cent to 1,225,965. In contrast to the steady momentum of the increase in the overall population, the number of inhabitants of the City declined. According to Percy's *Histories*,[6] the population of the City fell during the eighteenth century from *c.* 140,000 in 1702 to *c.* 56,000 in 1821. This might imply a decline in importance for the City, but depopulation did not detract from its role as a trading centre. It remained a vital part of the economic life of London and London Bridge marked the entrance to it by road from Southwark and by river for ships arriving from the east coast. The westward growth of London was largely confined to the north bank of the Thames. But this did not necessarily diminish the role of the river as an important part of its infrastructure. It remained a vital link between the two ends of the metropolis and an effective means of transporting goods.

As London expanded its girth, so the south bank of the Thames was seen as an area with good development potential. Not least, the open land invited the

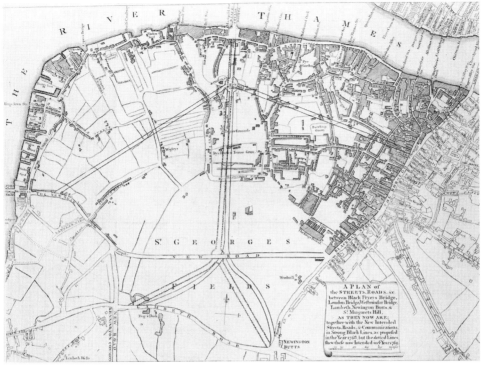

36 Anonymous, *A Plan of the Streets and Roads between Black Fryers Bridge, London Bridge, Westminster Bridge, Lambeth, Newington Butts and St Margaret's Hill*, 1769, engraving. Yale Center for British Art, Paul Mellon Collection.

building of the rational road system which eluded the north bank. This would not only provide good communications across Southwark but also connect with the bridges. This provided new entry points into London and a more effective way of moving across the city. For instance, traffic crossing over London Bridge into Southwark could travel westwards more quickly and access the West End via Westminster Bridge. In 1760 the decision to build Blackfriars Bridge was part of a larger scheme to provide such a road system, published in an anonymous plan dating from 1769 which linked the three bridges and the north and south banks of the Thames (plate 36). These ideas remained current for the next fifty years and informed the ideas behind the rebuilding of London Bridge and its approaches. Traffic congestion was not, however, confined to the roads as the growing importance of London as a trading centre led to an increase in river traffic and the need for more docks. *The Port of London Report* of 1799[7] outlined unrealized plans for the improvement of the congested London docks which adds an interesting supplement to the east–west communications south of the river (plate 37). This idea is taken up in *Porto-Bello or a Plan for the improvement of the Port and City of London*, drawn up by Sir Frederick Morton Eden in 1798. Here the demolition of Old London Bridge is proposed to accommodate the coal or timber trade 'near the heart of the metropolis', which was seen as a far more important element in the city's infrastructure than 'a crumbling ancient structure'.[8] The author proposed the construction of a new

81

bridge which would 'afford an opportunity for forming a Grand Street in a direct line from the wildest part of the Borough [of Southwark] to the Bank and the Royal Exchange'.[9] The Borough was seen as providing a mean entrance into the City with the area around London Bridge and Fish Street Hill being described as 'certainly very mean entrances into a large city; the latter, more particularly, from its narrowness and steep ascent'.[10]

The increased number of bridges diminished the river's role as a physical barrier between the north and south banks. By 1820 there were six main river crossings in the Cities of Westminster and London: Westminster, Waterloo, Vauxhall, Blackfriars and Southwark and London Bridges. The volume of traffic carried into the capital had grown substantially. A survey of 1810 carried out between 16 and 22 October of the use of Blackfriars and London Bridges gives a flavour of the volume and type of traffic flow.[11]

Type of traffic crossing	London Bridge	Blackfriars Bridge
People [means unspecified presumably on foot]	56,000	37,000
Coaches	871	626
Carts and Drays	2576	1269

Table A A survey of traffic across London and Blackfriars Bridges 16–22 October 1810 from S. & R. Percy, *The Percy Histories or Interesting memories of the rise, progress and presentation of all the capitals of Europe*, 3 vols, London, 1823.

The figures relating to the number of carts and drays are perhaps the most significant as they reveal how the bridges, and especially London Bridge, supported the City as a trading centre even though the population of that area was declining. This role remained vital as any loss of income from the food and general supplies sold in the markets and revenue from import duties from goods delivered to the Port of London would have diminished the City's wealth and importance to the urban infrastructure and economy. The wealthy West End was mostly supplied by traders in the City. And this dependant relationship was jealously guarded, as seen, for instance, in the vigorous and successful opposition to the proposal for a fish market at Westminster in the 1750s for the greater convenience of local residents, for whom the journey to the fish market in the City was lengthy, inconvenient and where they paid substantially inflated prices.[12] Indeed, the primacy of the City was seen to be threatened by the completion of the much needed Westminster Bridge in 1750 as the symbolic identity of London Bridge as the capital's only river crossing and entrance from the south would be diminished. Moreover, the new bridge would divert traffic, or rather the trade, away from the City. Westminster Bridge did indeed signal the growing importance of Westminster as the centre of national government and the socially fashionable end of town. The public outcry over the use of a foreign architect to design the bridge, the Swiss Charles Labeyle, is indicative of how river crossings were seen to embody national identities and functioned as monuments in the metropolitan landscape.

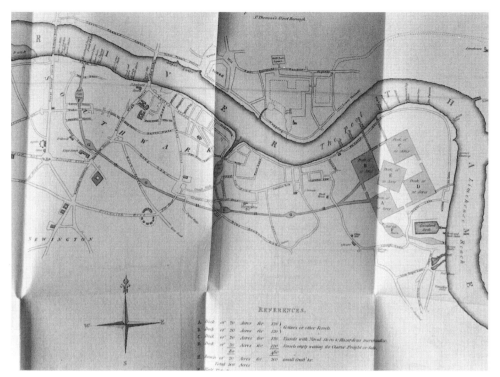

37 Port of London Authority Reports, vol. 1. *A Plan for the development of The London Docks*, 1799. Yale Center for British Art, Paul Mellon Collection.

The city as a site/sight of celebration for nation state and heroes

During and immediately after the Napoleonic wars London became a site/sight of celebration of victories over, and the eventual defeat of, the French and functioned as a signifier of a distinctive national consciousness and in turn this consciousness shaped the city itself. Moreover, the city, as a site of sights, gave geographical place to the spectacles concerning victory which included mock battles – re-enactments of major military triumphs – in the royal parks. There were also exhibitions of series of tableaux which narrated the endeavours of heroes such as Nelson and Wellington.

The entrance points by road to the capital were identified as sites of commemoration. This is seen in the designs for Hyde Park Corner, which had become a significant gateway into west London.[13] Freestanding monuments were also proposed to embellish the cityscape.[14] The mood is captured by William Wood, who wrote in his 'Essay on National and Sepulchral Monuments' in 1808 of the need to build monuments to commemorate great national heroes:

> from the most remote antiquity, until the present moment, from savages of the southern hemisphere, to the polished nations of Europe, all mankind have agreed in erecting sepulchral monuments, to mark their admiration of the illustrious dead.

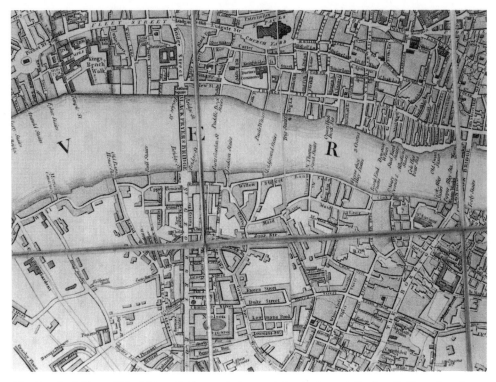

38 Detail of *Plan of Blackfriars Bridge, and the south bank*, from *A Pocket Guide to London*. Yale Center for British Art, Paul Mellon Collection.

Street names were another way in which the city could become a site of commemoration. The nomenclature helped to shape urban experience and served as a reminder to civic and national virtue. Percy's *Histories* identified 18 places named after Nelson, 11 after Trafalgar, 14 after Wellington and 10 sites named after Waterloo. Bridges also played a role in this construction of a distinctive urban identity and were also sometimes appropriated or re-appropriated for commemorative purposes. The fickleness of fame also played a part here. For instance, Blackfriars Bridge in pre-Napoleonic times was originally called Pitt Bridge to celebrate William Pitt, Earl Chatham, before the statesman's popularity waned. But Chatham Place stood and retained its name on the north side of the Thames. On the south bank the 'all-purpose' Albion Place punctuated this route in and out of London. To underline the responsiveness of urban nomenclature to the forces of history there was also a Nelson Square further south down the aptly titled St George's Road (plate 38). Even royalty was not exempt from readings of the barometer of political and popular favour. The Regent's Bridge became simply Vauxhall Bridge proving that even for George IV this was perhaps a bridge too far.

Attempts to acknowledge the Duke of Wellington's military achievement at Waterloo included the renaming of the Strand Bridge to Waterloo Bridge.[15] This is perhaps the most potent example of the symbolic identity of a bridge and its use as a site of commemoration within the metropolis. The plain doric form of Waterloo Bridge was recognized by some critics as preferable to the fussy monumentality of

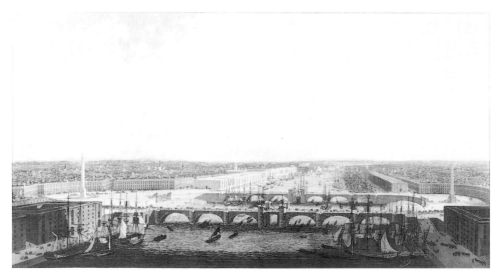

39 William Daniell, *View of London with the Improvements of the Port, as suggested by George Dance the younger*, *c*. 1800, engraving. Guildhall Library, Corporation of London.

'foreign designs' or the paper architecture of Soane.[16] Whilst Percy's *Histories* described it as 'a work not less pre-eminent amongst the bridges of all ages and countries than the event which it will commemorate as it is unravelled in the annals of ancient or modern history'.[17] The bridge had been under construction before 1815 and was opened for the second anniversary of the victory. Wellington was present at the opening ceremony when the bridge was draped with the flags of all nations and a 202-gun salute represented the number of French cannon taken in the battle. This takes the urban bridge beyond its practical and commemorative function as it becomes a monument. According to Percy's *Histories*, Waterloo Bridge was a popular sight in a city visited by many European luminaries. The sculptor Canova admired the bridge for its augustan qualities. This sentiment is echoed by Charles Dupin, according to Percy, 'another intelligent foreigner, who though it 'worthy of the Caesars'.[18]

The monumental possibilities of river crossings had already been recognized, but not realized, by George Dance the younger. His proposal of *c*. 1800 for a double London Bridge, partly to commemorate the Battle of the Nile and the nation in general, responded to the demands of London town planning and the need to upgrade the City. The two stretches of road across the river terminate in grand semi-circular *places* on either bank of the river. The Monument, a symbol of the City's recovery from the Great Fire of 1666, formed the centrepiece of the *place* on the north bank and an obelisk, presumably a reference to the battle of the Nile, was its pendant piece on the south bank. It is a vision of metropolitan modernity equal to any European capital city (plate 39). The fascination with the commemoration of living and dead heroes was incorporated into the academic tradition in architecture and this can be seen in the display of over forty mausoleum designs at the annual exhibition of the Society of Artists and the Royal Academy between 1768 and 1793.[19] Indeed, bridges and monuments were synonomous in European architectural practice and this certainly featured in

architectural education.[20] John Soane won the Royal Academy Schools' Gold Medal competition in 1776 with a design for *A Triumphal Bridge*. Soane's design synthesizes the complex meanings of a river crossing in a potent image of national glory and architectural magnificence which was perhaps too European for some critics and too expensive for others. Soane was taught by Thomas Sandby who was then Professor of Architecture at the Royal Academy Schools. Sandby's *Bridge of Magnificence*, one of the illustrations to his professorial lectures exhibited at the Academy in 1781, linked Somerset House with the Strand – the line of the later Waterloo Bridge – and comprised doric colonnades, domed wings and a central Italianate galleria. Sandby's pupil's prize-winning design included similar features but was more ornate and grand and included a pantheon adorned with statues as the central element. Soane's bridge was to be at Westminster and formed a new and grand entrance into London: a fine architectural response to the growing preeminence of the West End. Its strikingly modern, classical design which drew on antique Roman prototypes provided a sharp contrast to the ramshackle form of Old London Bridge.

The Thames bridges and the paper architecture relating to them offered the possibility of fusing architectural, political and social ideals. They became signifiers of cultural practices and values. But how did London Bridge and the competition to rebuild it fit into this contextual framework, given the idea of a bridge as a monument to the nation and as representative of the changing social and economic geography of London as a whole and, in this case, to the City in particular?

London Bridge

By the mid-eighteenth century Old London Bridge had undergone many necessary repairs and alterations but had received little in the way of aesthetic attention. By the opening years of the nineteenth century its appearance and its effect on the tides of the Thames caused equal concern earning this description: 'a thick wall, pierced with small uneven holes, through which the water, dammed up by all the clumsy fabric, rushes or rather leaps with a velocity extremely dangerous to boats and barges'.[21] The old houses which were remnants of the medieval bridge were removed in 1759 and the centre arch rebuilt by the Corporation of London's architects Robert Taylor and George Dance the elder in the same year (plate 40). This went some way towards improving the bridge's appearance and reducing the adverse effect on tidal flows, the widened central arch also allowing more river traffic, which improved trade; but these efforts were not enough. The first moves to redevelop the bridge and the surrounding area completely came at the end of the eighteenth century as part of the Port of London improvements.[22] Various new bridge designs were drawn up during the period 1799–1801 including Dance the younger's (plate 39). The surveyor Thomas Telford, who had given a negative report on the condition of the old bridge, came up with the proposal that it be replaced by a single-span structure – a celebration of the engineers rather than the architect's art (plate 41). This was not realized as there was some uncertainty as to the technical requirements of producing a cast iron bridge with a span of some 600

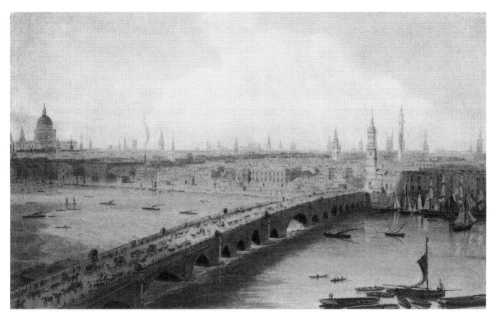

40 William Daniell, *View of London Bridge and St Paul's Cathedral*, undated, showing Old London Bridge, watercolour. Yale Center for British Art, Paul Mellon Collection.

ft. Yet it remained a potent symbol of modernity and printed images of Telford's design were in demand for over a decade after its publication. Attention turned again to the state of Old London Bridge in 1821 when John Rennie, another engineer, was also asked for a report on its structural condition. Rennie argued that further repairs and alterations would cost as much as a new structure. The engineer's opinion carried weight as he had already successfully worked on both Waterloo and Southwark Bridges. The Corporation acted on Rennie's advice and sought an act of parliament to allow them to replace the bridge.[23]

But it was not simply a question of a new structure to provide improved access and a more favourable aesthetic for this enduring symbol of London. London Bridge had since the sixteenth century housed the machinery which pumped the water supply for a large area of London.[24] Although the Old London Bridge Water Works were part of the obstruction to the tides[25] and the river traffic, their role in supplying residents across the city with water was vital. An inquiry into the water works revealed that over 216 gallons of water was pumped from the Thames every minute. This was directed across the metropolis and stored in reservoirs and underground tanks. The demand for water was continually increasing as the capital grew in size and population and it was the resources available from the City that helped to meet this need.[26] By 1821 the water works had over 10,000 customers and supplied 68 public buildings. The removal of the water works was essential for rebuilding the bridge but Parliament would only grant permission for this if the role of the Old London Bridge Water Works was transferred to the New River Company.[27] These terms were embodied in the act of parliament in 1823 which granted the Corporation permission to replace the bridge.[28]

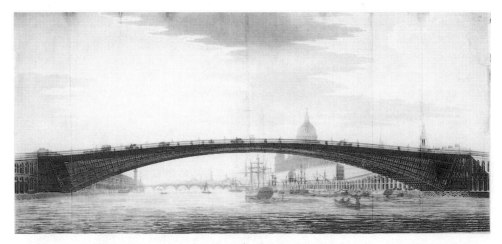

41 Thomas Telford, *Design for a Cast Iron London Bridge*, *c.* 1800, engraving. Guildhall Library, Corporation of London.

In the same year attention turned again to the design for a new London Bridge but the image of the metropolis it was to form part of and symbolize had changed considerably. London had not only increased dramatically both geographically and demographically but many of the Metropolitan Improvements had been implemented or were underway. Notably here Regent Street, Regent's Park and the monumental entranceway into the metropolis from the west at Hyde Park Corner[29] were beginning to transform the image of London from what Summerson described as a 'huddle of bricks with a steeped skyline' into a world-class city. These improvements were being orchestrated and overseen by the Offices of Woods and Works – agents of the Crown who were answerable to parliament and who were largely funded by the public purse. This self-conscious attempt to develop London into a world-class city had implications for the work at London Bridge. Here the responsibility for the work and the initial cost of the entire project fell to the Corporation of London, an autonomous body concerned with the local government of the City. The act of parliament which gave the City of London permission to replace London Bridge brought with it some financial support for the project. According to R.L. Jones, a member of the Bridge House Committee which oversaw the work, this was appropriate as the bridge 'was one of great and important public character', and the committee 'might fairly look to the Government for support and assistance.'[30] Despite its financial support, the government did not get involved directly with the design for the new bridge. But there were conditions which aligned the rebuilding of London Bridge to other parts of the Metropolitan Improvements. Like Hyde Park Corner and other projects belonging to the improvements, the width of the road was to be increased, together with the quality of its surface and steepness of its gradient.

Most of the new bridges across the Thames were built by private companies which speculated on the profits from tolls. But government funding was forthcoming for the rebuilding of London Bridge most likely because of the symbiotic nature of the cities of London and Westminster and in recognition of

the symbolic potential of London Bridge as an image of a modern metropolis. The government granted £150,000 to be raised by taxes.[31] Chief amongst these was the coal tax levied at 8d per ton for coal brought to the City for sale by land or through the Port of London. This was one of the principal sources of fuel for the whole of London. This blanket tax was directed towards a building project which was of benefit to a specific group in the City. A second duty on wine at 4d per ton was also granted. It was estimated that the yield from these two sources of revenue would reach the promised £150,000 by 1858. On its part the Corporation took out a loan of £1,000,000 at 4 per cent from the Bank of England and raised a further £250,000 from private lenders at the lower rate of 3.17 per cent.[32] The estimation of the level of duty required was over generous and the Corporation's borrowing had been covered by 1852.[33] If the tax continued to its intended date a further £300,000 would be raised, which could be used for other Metropolitan Improvements. But the income potential of these levies came to the attention of the Corporation of London as the new bridge was nearing completion. In 1829 proposals were laid before Parliament for improved London Bridge approaches at an estimated sum of £1,000,000. The monies raised from the coal tax were to be used to defray the cost.[34] There was vigorous opposition from the House of Commons, who objected to the appropriation of its future funds and the House of Lords where coal-mine-owning peers such as Lord Durham and Lord Londonderry objected to the potential curtailment of their incomes. Much to the chagrin of his fellow peers, the Duke of Wellington recognized the importance of the City and within it London Bridge to all levels of the capital's infrastucture and stepped in to rescue the scheme for the approaches and secure the funding for it.[35]

The competition

The competition to rebuild the bridge was drawn up by the City Committee for the London Bridge Estates (the Bridge House Committee). And several of the entries were exhibited at the Western Exchange, Old Bond Street, in 1823.[36] The Committee was chaired by Mr Montague and had been established early in 1822. The premiums offered for the winners were in line with other such competitions: £250, £150 and £100 for first, second and third prizes.[37] The instructions for the competition included that the bridge be faced with granite; that there should be five arches; and that the centre arch should be 23 ft above water level. The new structure should be erected no more than 70 ft west of the present (old) bridge. The note on style reveals much: 'It is desireable that the bridge should be worthy of the metropolis and the present cultivated state of science, due regard being had at the same time to Economy and convenience of traffic over and under the bridge during the progress and after completion of the works.' But the design should allow 'formation of the necessary approaches as is consistent with the character of so important an entrance to the city of London'. The Offices of Woods and Works refused to have anything to do with the competition or the selection of a winning design. Had it been a government-run project, one of the attached architects of the Office of Works – John Nash, Robert Smirke or Sir John Soane – would have

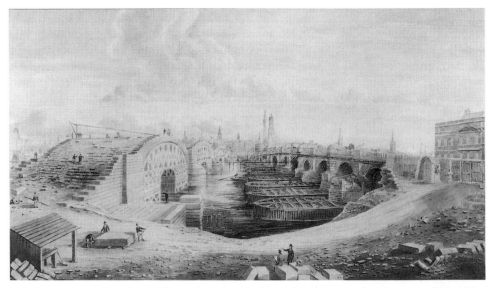

42 G. Yates (attrib), *The Building of London Bridge*, undated, watercolour over graphite. Yale Center for British Art, Paul Mellon Collection.

been given the commission. As a result, this prestigious project did not belong to the Metropolitan Improvements in the same way as Nash's Regent Street or Smirke's British Museum. Instead the new London Bridge expressed the enduring autonomy of the City and its dis-location from the rest of the metropolis. In recognition of the status of the attached architects, which would add the aura of authority to the competition, the Bridge House Committee employed Nash, Smirke and Soane on a private basis to judge the entries. The competition was, however, entered by architects of the second order. It was won by Charles Fowler with John Boorer and Charles Bushy coming second and third respectively. The grander competition plans, like the earlier proposal of Dance the younger, all took up valuable space on the north side of the river which could be used for commercial purposes. It was most unlikely that any City merchant would give up profitable real estate in the cause of urban beautification. The Crown had had a similar problem of landowners' reluctance to give up part of their estates for the improvements in the West End. But this was largely overcome with the use of compulsory purchase. The Corporation, however, had the financial interests of its traders as its primary concern. In the end all the entries were ignored in favour of Rennie's design: a plain, functional structure with few architectural embellishments.

The new London Bridge was executed by John Rennie junior as his father had died in 1821. This plan proposed that the new bridge be built on the exact site of the old one and elevated at either end to correspond with the level of the old approaches. A temporary timber bridge would be constructed for the duration of the building work. But the narrow approaches by Fish Street Hill were considered most unworthy for the magnificent new bridge and inadequate for the ever-increasing traffic. Rennie's estimate for the new bridge came to £430,000 with a further £20,000 for the construction of the temporary wooden structure. The

Bridge House Committee recommended that the bridge be moved 180 ft west of the old one so avoiding the steep hill of Fish Street (plate 42). The width of the bridge had been increased by 6 ft on Rennie's original scheme in the interest of greater public convenience. The Prime Minister Lord Liverpool agreed to the additional expenditure of £42,000 to accommodate the expected increase in traffic. This would, however, render 'new, more commodious, and much more expensive approaches necessary'. But the revised scheme would provide a fitting entrance into the City from the Southwark side of the river. Moreover, as attention turned increasingly to thoroughfares through London, London Bridge was seen as connecting with roads on both sides of the river and creating a continuous route across the city. It was in one sense a stretch of road which crossed water but in another monumental approaches offered some commemorative punctuation for this route through the metropolis.

In 1829 the Corporation of London presented designs for the bridge approaches to Parliament. A variety of plans was presented as a supplement to Rennie's original intentions for the approaches and particular attention was paid to the north bank of the Thames where the bridge entered the City.[38] Several drawings exist which relate to the scheme. Rennie junior had hoped that the commission for the design would go his brother-in-law C.R. Cockerell. A drawing by Cockerell held in the British Art Center at Yale suggests the architect got as far as producing a design (plate 43).[39] Another drawing by Henry Roberts, who worked in Smirke's Office 1825–9, also relates to the scheme and is held in the same collection (plate 44).[40] Robert's connection with the site and the City in general is compelling as in 1832 he won the competition for the Fishmongers' Hall which was adjacent to the new London Bridge on the City side of the river. Both Cockerell's and Robert's designs provide an adequate response to the urban vision of the Metropolitan Improvements. But the work was given to Robert Smirke, about whom it was remarked '[Smirke's] undoubted purity of taste (we wish we could add fertility of invention) much is to be hoped.'[41] Less generously, Cockerell lamented Smirke's embellishment of the London Bridge approaches, remarking that 'a more unworthy set of buildings was never designed.'

On the other side of the Thames the approach from Southwark now had The Monument – an emblem of the City in view and space would be made for an impressive approach road over 70 ft wide and with a gentle gradient of 1:30. The south side of the river was not forgotten in the plans to embellish the approach to the City. Two anonymous drawings of the London Bridge approaches from the Borough side also exist at Yale (plates 45 and 46). They are undated and represent different iconographic schemes and stylistic detailing. The one might refer to the Battle of the Nile as it has Egyptian-style elements[42] whilst the other has a more antique Roman feel and may refer to the augustan image of the Metropolitan Improvements.[43]

Two main themes emerge from this narrative. Firstly should monuments, as the bridge clearly was, be designed by architects or engineers? And secondly, if the bridge was a barometer of the general mood of the embellishment of London, how were the tensions revealed between national and civic pride; metropolitan and national systems of government?

91

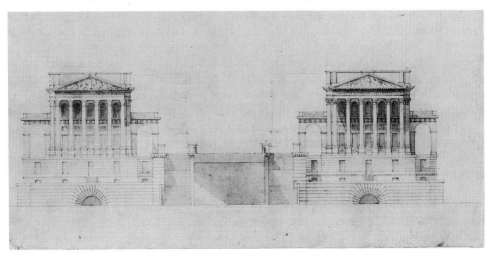

43 C.R. Cockerell, *Design for the Approaches to London Bridge*, undated, brown wash over pencil. Yale Center for British Art, Paul Mellon Collection.

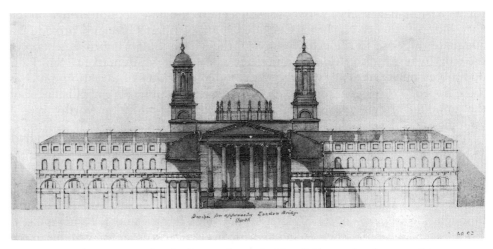

44 Henry Roberts, *Design for the Approaches to London Bridge*, undated watercolour over graphite. Yale Center for Britsh Art, Paul Mellon Collection.

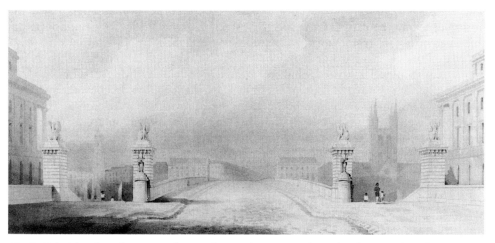

45 British School c19th, *Design for London Bridge Approach*, undated, pen, ink and wash. Yale Center for British Art, Paul Mellon Collection.

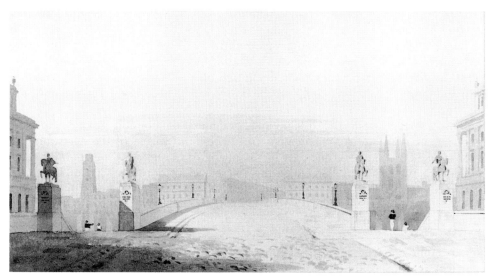

46 British School c19th, *Design for London Bridge Approach*, undated, pen, ink and wash. Yale Center for British Art, Paul Mellon Collection.

Architect versus engineer

The vigorous reaction by the public to the competition reveals much about the notion of urban identity and the specific role of London Bridge as a symbol within this metropolitan framework. A pamphlet published by I. Andrews in 1823 entitled 'London Bridge but no new Taxes'[44] contained a dedication to Nash, Soane and Smirke as the architects attached to the Office of Works. More specifically, the author criticizes their role in the London Bridge competition. Their presence may have given the gloss of authority to the contest but the premiums were criticized by both Andrews and anonymously in an open letter to the Member of Parliament George Sumner as being so low as to prevent 'men of adequate talent and reputation' from entering the competition.[45] Moreover the Bridge House Committee rejected the choices of the judges, disqualifying two of them on the grounds that the entrants had not followed instructions.

Pamphlets also appeared pleading the cause of the engineers. These stated that Nash, Soane and Smirke were qualified only to judge the stylistic and not the structural virtues of the new bridge. Andrews is also particularly vociferous on this point and laments the absence of an engineer on the judges' panel. This is endorsed in the open letter to George Sumner MP countering this view – written by 'an architect' anon. It states that there is a 'mistaken notion prevalent in these times that engineers only are capable of building bridges – but the most beautiful bridges in France and Italy have all been designed by architects. Engineers should only be used for the parts below the water in a great national work of this nature.'[46] There is no doubt that the significance of the bridge as a status symbol of London was recognized by the pamphleteers, and calls for the whole matter to be handed over to a parliamentary committee with public accountability were frequently voiced. This commission would, according to one pamphleteer, '[prevent] Old father Thames being disfigured by a Bridge unworthy of his station among the ruins of Europe' and that the bridge might become 'an ornament to the metropolis'.

The debates about the design and designers of London Bridge show its involvement with and disengagement from the main thrust of the Metropolitan Improvements. It had become part of the image of the modern metropolis, but it remained a fundamental element in the discrete identity of the City of London.

Ritual and association

The dynamic between central government and the City was curious. At the heart of it was a complex set of relationships centring on civic pride and the financial autonomy of the City's institutions which covered all manner of trades as well as banking. This was perhaps best typified in the Office of the Lord Mayor who had no equivalent elsewhere in London and was second only to the monarch within the confines of the City. But Westminster had begun to overshadow the City. The Metropolitan Improvements which were such a vital part of the creation of a modern metropolis were implemented with all the clout of a government project with state funding. The creation of a rationalized urban environment and not least

the construction of an effective road and sewer system was underpinned by the government's ability to raise revenue by taxation. But beyond this there was a more fundamental social and political friction between the cities of London and Westminster in the years directly preceding the 1832 Reform Act. Parliament was made up of only the very upper end of society – the ruling élite. The City, although represented in this body, comprised mainly middle and merchant classes who stood outside the area of national government because of their social caste. During the opening decades of the nineteenth century the metropolis became an instrument of the governmental system. The rationalization of street plans and the concerns for the well being of trade and the populace were hallmarks of this.[47]

The City of London was a discrete entity within the metropolis. It represented the financial and commercial interests of the capital and the country. The Corporation of London administered the business activities and acted as a kind of local government with the Lord Mayor as its principal official. These arrangements were deeply rooted in London's past as up until the middle years of the seventeenth century the City comprised the largest part of London as a whole and often stood in opposition to both the court and government. Its status was gradually challenged as London grew in size, so diminishing the City's physical dominance of the geography of the metropolis. Moreover, its autonomous local government was overshadowed by the increasing significance and clout of the systems of national government, as expressed through parliament at Westminster. But the City's sense of civic pride and will to preserve its privileges and rituals did not diminish.

The authority and prestige of the Corporation of London found physical expression in the grand architecture of the Mansion House c. 1740–50 by George Dance the elder.[48] Similarly, the importance of trade and commerce were represented in the rebuilding of the Bank of England by Sir John Soane in the 1790s and the Royal Exchange by Sir William Tite in the 1840s.[49] And, not least, St Paul's Cathedral, perhaps London's most enduring symbol, stands in the City. The size, scale and splendour of these edifices equalled the grand public building projects of the West End. There is no doubt that the rebuilding of London Bridge was seen to be as symbolic of the City's status as any of the other large building projects. But here, the part funding of the work by the state threatened the hegemony of the Corporation of London. Yet the built environment is only one signifier of social and political pre-eminence. The roles of place and ritual are equally important.

The City of London and its civic system had long been seen as representative of a kind of republicanism. Expressions of anti-establishment feeling and the wish for egalitarianism became increasingly frequent in the period 1760–1830 and the City was a regular location for these. The City authorities were not always in sympathy with the specific activities of those who demonstrated on their doorstep even if both parties shared a common concern for the right to vote. But the independent nature of the City and its symbolic identity as a body able to make a stand against national government made it an attractive location for expressions of dissent. John Wilkes is an early case in point. Wilkes campaigned to be MP for the City in order to further the case for universal manhood suffrage. His eventual election as MP for Middlesex in 1768 was a

victory for the cause. Celebrations by Wilkes's mainly working-class supporters took place in the City. The Corporation did not share the mob's enthusiasm, which resulted in the windows of the Mansion House being smashed.[50] The fight for the right to vote became increasingly vocal and vigorous in the post-Napoleonic era. Events in France had demonstrated the potential power of the masses and remained a vivid reminder of the possible consequences both of political egalitarianism or continued repression of electoral freedom. Support for enfranchisement came from the working classes and the politically impotent but increasingly financially predominant urban bourgoisie. Henry 'Orator' Hunt drew large crowds to his rally for the right to vote at Smithfield in July 1819. In September of that year, spurred on by the Peterloo Massacre, Hunt entered the City followed by a mainly working-class crowd. The procession ended at the Mansion House with calls for enfranchisement. The City authorities did not take up the cause of the masses, and it is probably as well. But the wealthy merchants and businessmen became increasingly agitated at their lack of political power. The financial and commercial institutions were nationally important and enabled government policy through taxation and loans. They were part of the identity of London and the nation as a whole. By 1830 the resentment at the government's failure to widen the franchise had reached a volatile level. As a result, in November of that year William IV declined his traditional invitation to attend the annual Lord Mayor's Banquet. The Prime Minister, Sir Robert Peel, had advised against it as the frequent anti-government riots and demonstrations which were taking place in the City compromised the king's safety.[51] The Cities of Westminster and London were indeed in opposition.

The City was then a site for the expression of social and political ideals which challenged national systems. But how did it maintain its image of authority and independence as the neighbouring City of Westminster, the home of national goverment, became increasingly dominant? The isolated grandeur of its key buildings no doubt helped embellish the authority of the City. But it was the public performance of institutional rituals which underpinned the Corporation of London's local hegemony and the national significance of the City. Most notable amongst these were the annual Lord Mayor's Banquet, where key government minsters were invited to speak on government policy,[52] and the Lord Mayor's Show. The latter remains a piece of street theatre which presents a sort of tradition borne out of ritual which fed off the absent presence of the monarchy in eighteenth-century London.[53] The Lord Mayor's offical residence, the Mansion House, acted as a kind of court providing opulent receptions for visiting dignitaries paid for by the Corporation of London. This presented an image of an alternative, more democratic governmental structure.

The ritual and public performance which surrounded the ceremonial laying of a building's foundation stone were used to ensure that London Bridge remained firmly identified with the City (plate 47). The foundation stone for the new bridge was laid in June 1825 by the Lord Mayor, Alderman John Garratt. The procession for the ceremony began at the Guildhall and the mayor used a ceremonial trowel bearing the arms of The Bridge House Committee and The Corporation of London. 'Ownership' of the project was further expressed as the

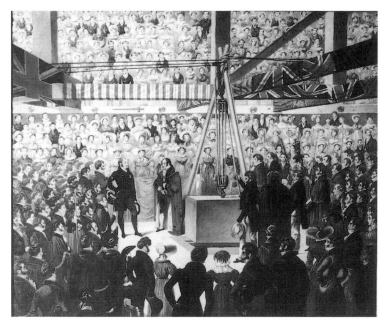

47 Charles Deane, *Laying the Foundation Stone for New London Bridge*, 1825, watercolour. Guildhall Library, Corporation of London.

City Sword and Mace were placed crossways on the foundation stone and as it was declared laid the Lord Mayor remarked the bridge 'would reflect credit upon the inhabitants, prove an ornament to the Metropolis and redound the honour of the Corporation.'[54] The proceedings culminated in a grand banquet in the Egyptian Hall of the Mansion House. The ceremony was witnessed by thousands and performed in the presence of the Duke of York, who took no part in the ritual. The opening of the new London Bridge took place in August 1831 and the old structure was demolished shortly after. By this time fears for royal safety in the City had subsided to an extent that William IV and Queen Adelaide attended the ceremony but the proceedings and celebratory banquet were confined to the bridge. The procession, led by William IV, to celebrate this important and highly significant entranceway to the metropolis and the City exited rather entered it. On declaring the bridge open, the king gave credit to the Corporation in his remark that 'it was one of the magnificent improvements for which the City London was renouned.'[55] The Duke of Wellington, who continued to do much to enable the building of the new bridge approaches, declined the invitation to participate in the opening ceremony on the grounds that the opposition expressed to his attendance at the Lord Mayor's Banquet the previous November, which the king did not attend, still stood. Wellington was vigorously opposed to the enfranchisement of the middle classes and had been told that his presence at the banquet would have been 'likely to create a disturbance, for the consequences of which the authorities of the City would not answer'.[56] The bridge's completion before the 1832 Reform Act and Wellington's boycott of the opening ceremony are contradicted by the Duke's

97

vigorous support of the project and the use of the coal tax as a means of funding it. The Duke of Wellington's attitude to the City was complex. Whilst he recognized the rights and privileges of the City and saw it as a valuable part of the constitution of the country he saw no need for its representatives to have a role in national government either as MPs or through the ballot box. London Bridge provides a focal point for these contradictory attitudes.

A consideration of the symbolic identity of London Bridge for the Regency metropolis reveals some important issues whilst some remain enigmatic. The dis-location of London Bridge from the emerging architectural identity of the new metropolis – especially its relative isolation from the other Metropolian Improvements in terms of the urban plan of London – had two main consequences. Firstly, the City and the bridge remained disconnected from the new and emerging road infrastructure of London. And the commemorative and monumental possibilities of the bridge, although widely discussed and acknowledged, were unrealized. Perhaps this was the result of the insular nature of the City authorities who wished no association with the nationalistic iconographies of the Metropolitan Improvements and the erosion of the local autonomy they represented. Secondly, the bridge's role in the economic infrastructure of the City cannot be underestimated. And this identifies it firmly, and perhaps fittingly through its functional engineer-designed structure, with the profit-driven trading heart of the city with its own discrete system of government.

<div style="text-align: right">

Dana Arnold
University of Southampton

</div>

Notes

Much of the research for this essay was carried out during my tenure as a visiting fellow at the Yale Center for Btitish Art. I would like to thank the staff of the Center, especially Elisabeth Fairman and Lori Misura, for their help in locating material. Sir John Soane's Museum also proved to be a valuable source of information and my thanks go to Susan Palmer for her assistance. I must also thank Adrian Rifkin who kindly read and commented on the final draft.

1 For a brief outline of the Metropolitan Improvements carried out in the opening decades of the nineteenth century see my essay 'George IV and the Metropolitan Improvements: The creation of a royal image' in D. Arnold (ed.), *'Squanderous and Lavish Profusion': George IV, his image and patronage of the arts*, London, 1995, pp. 51–6.

2 This was designed by the engineers Mott, Hay and Anderson with Lord Holford as the architectural adviser 1967–72.

3 Here the term 'Regency' is used simply to refer to the period *c*. 1800–40.

4 This thematic exploration of London is the basis of my book *Re-presenting the Metropolis: Architecture, Urban Experience and Social Life in London 1800–1840*, Scolar, Aldershot, 2000. Here a related methodology is used to examine the specific example of London Bridge. I am following Foucault's ideas about the heterotopic and heterochronic functions of space as expressed in M. Foucault, 'Of Other Spaces (Des Espaces Autres)', *Diacritics*, Spring, 1986, trans by J. Miskowiec, pp. 22–7. As such, London Bridge becomes a heterotopia – a counter site which re-enacts, represents and inverts the Utopian mirror image of the metropolis. It enables us to see London in its space–time location through a kaleidoscopic image of spatial oppositions, social rituals and cultural practices.

5 For a fuller discussion of the building of the West End, see J. Summerson, *Georgian London*, Peregrine, Harmondsworth.

6 S. and R. Percy, *The Percy Histories or Interesting Memories of the rise, progress and presentation of all the capitals of Europe*, 3 vols,

London, 1823.

7 Vol 1, Uv, Port of London Reports 1796–9, London, 2 vols, 1799.

8 Sir Frederick Morton Eden bart, *Porto-Bello or a Plan for the improvement of the Port and City of London* , London, 1798, p. 41.

9 ibid., p. 42.

10 ibid., p. 43.

11 As cited in Percy's *Histories*, op. cit. (note 6).

12 The Revd Henry Hunter, *The History of London and its Environs*, 2 vols, London, 1811, vol. 1, p. 693.

13 On this point, see my article 'The Arch at Constitution Hill: a new axis for London', *Apollo*, vol. 138, no. 379, September 1993, pp. 129–33.

14 Many of these plans – some of them quite improbable – are outlined in F. Barker and R. Hyde, *London as it Might Have Been*, John Murray, London, 1982.

15 The attempts to commemorate the military achievements of the Duke of Wellington discussed within the paradigm of Bataille's notion of sacrifice forms the basis of my forthcoming essay 'If only the Duke of Wellington had died at Waterloo! The problems of commemorating a hero in the absence of sacrifice', in A. Ballantyne (ed.), *Architecture and Sacrifice*.

16 I. Andrews, *London Bridge and No New Taxes*, London, 1823.

17 Percy's *Histories*, op. cit. (note 6), vol. 2, p. 130.

18 Charles Dupin was a French engineer who made several visits to Britain. His impressions of the engineering and technological achievements of the nation which had defeated Napoleon are recorded in his numerous publications, most notably here: *Voyages dans la Grande Bretagne, Entrepris relatives aux services Publics 1816–19*, Paris, 1824.

19 See D. Stillman, 'Death Defied and Honor Upheld: The Mausoleum in NeoClassical England', *Art Quarterly*, new series, vol. 1, no 3, 1978, pp. 175–213.

20 This was a pan-European phenomenon. For instance, mausolea were the theme for the French Academy's Prix de Rome in 1762 and similarly the Academie de Dijon in 1780 and in 1791 for the Academy of Parma.

21 As quoted in R.L. Jones, *Reminicences of the Public Life of Richard Lambert Jones Esq.*, London, privately printed, 1863.

22 The Third Report from the Select Committee upon the Improvements of the Port of London was published in 1801.

23 Rennie's Report was submitted on 12 March 1821. The original specification for the new bridge is held in the University of London Library MS. 158. Rennie died in October the same year.

24 This dates back to 1581 when Pieter Morice was granted a 500-year lease on one of the arches on London Bridge. The tidal flow was strong enough to turn his patented waterwheel and allow it to pump water up to Cornhill.

25 The waterworks needed a strong tidal flow which was strengthened by the many arches of Old London Bridge. As the number of arches decreased so did the waterwheel's ability to pump adequate supplies of water.

26 For a fuller discussion of London's water supply, see Matthew's *Hydralia: A Historical and Descriptive Account of the Waterworks of London*, London, 1835.

27 These were delicate negotiations as water was a precious commodity. £10,000 was paid to the proprietors of the London Bridge Water Works and they were guaranteed 5 per cent of the profits for the term of the 260-year lease. Jones, op. cit. (note 21), p. 10.

28 The Act for the Rebuilding of London Bridge and the Making of Suitable Approaches Thereto received royal assent on 4 July 1823.

29 See Arnold, 'The Arch at Constitution Hill: a new axis for London', loc cit.

30 R.L. Jones, op. cit. (note 21).

31 10 Geo. IV. *c*. 136 and 11 Geo.IV. *c*. 64.

32 The precise details and forecasts of the financial arrangements between the government and the Corporation are set out in *The First Report of the Select Committee on Metropolitan Improvements*, Parliamentary Papers 1837–8 XVI 418.

33 ibid.

34 R.L. Jones, op. cit. (note 21), pp. 32–3.

35 In recognition of his efforts the Duke of Wellington was honoured with an equestrian statue in front of the Royal Exchange. See A. Saunders (ed.), *The Royal Exchange*, London Topographical Society publication No. 152, London, 1997.

36 The catalogue for this exhibition is held at Sir John Soane's Museum, Soane PC 55/2.

37 An exhibition of competition designs for the completion of King's College, Cambridge, which had similar premiums, was exhibited at the same time. The catalogue for this is in Sir John Soane's Musuem, PC 55/2.

38 *A professional survey of Old and New London Bridges and their approaches*, 1831. Soane Museum PC 23/4.

39 C.R. Cockerell, Design for the Approaches to London Bridge, Yale Center for British Art, Paul Mellon Collection, B1975.2.632.

40 H. Roberts, Design for the Approaches to London Bridge, Yale Center for British Art, Paul Mellon Collection, B1975.2.635.

41 ibid., Soane PC 23/4, p. 43.

42 British School C19th, Design for London Bridge Approach, Yale Center for British Art, Paul Mellon Collection, B1975.2.634.

43 British School C19th, Design for London Bridge Approach, Yale Center for British Art, Paul Mellon Collection. B1975.2.633.

44 Soane Museum PC 52/3.
45 *The conduct of the Corporation of the City of London considered in respect of designs submitted to it for the rebuilding of London Bridge in a letter to George Holme Sumner Esq MP by an architect, 1823.* Soane Pamphlets PC 13/2.
46 ibid.
47 For a fuller discussion of the use of urban space as a instrument of governmental ideology, see D. Arnold, *Re-presenting the Metropolis*, op. cit. (note 4), and my article 'Rationality, Safety and Power: the streetplanning of later Georgian London', *The Georgian Group Journal*, 1995.
48 A thorough account of the building history of the Mansion House appears in S. Jeffery, *The Mansion House*, The Corporation of London and Phillimore and Co., Sussex, 1993.
49 There were similar tensions between national and local government in the rebuilding of the Royal Exchange. A detailed history of The Royal Exchange is given in A. Saunders (ed.), *The Royal Exchange*, op. cit. (note 35).
50 This incident and the career and significance of Wilkes to the process of parliamentary reform is discussed in P. Langford, *A Polite People*, Oxford: OUP, 1989, esp. p. 377.
51 Jones, op. cit. (note 21), pp. 47–8.
52 This tradition continues today. The Mansion House speech delivered by the Chancellor of the Exchequer is used by government to outline its financial policies.
53 For a discussion of the role of ritual and the invention of tradition see D. Cannadine, 'The Context, Performance and Meaning of Ritual: The British Monarchy and the "Invention of Tradition", *c*.1820–1977', in E. Hobsbawn and P. Ranger (eds), *The Invention of Tradition*, Cambridge: CUP, 1983, pp. 101–64.
54 Jones, op. cit. (note 21), p. 25.
55 *Professional Survey*, op. cit. (note 38), Soane PC 23/4 p. 42.
56 Jones, op. cit. (note 21), p. 58.

Government and the Metropolitan Image: ministers, parliament and the concept of a capital city, 1840–1915

M.H. Port

Writing in the *Fortnightly Review*, one of the widest-ranging of weighty Victorian periodicals, a commentator remarked that 'it has long been recognized that civilized and wealthy Governments should be patrons of art and architecture': the fact might be ascertained in almost any one of the great European capitals; while even 'petty south American republics' which repudiated their financial obligations 'frequently build Government offices which put to shame those of London.'[1] Not all the *Fortnightly*'s readers might have agreed with the basic premise, but lamentations over London's shortcomings were commonplace in the last century – even a senior civil servant could ask 'Why is it that London is deficient in all those public buildings which not only add to the splendour of continental capitals, but contribute so materially, at the same time, to the convenience and comfort of the public at large?'[2] What were the obstacles then, we may ask, to giving London a face as handsome as Vienna or St Petersburg, as beautiful as Paris? Some may perhaps deny that London's face was so ugly, but that was the common perception of the educated class at the close of the Victorian era.

There were two basic obstacles to constructing London in the image of an autocrat's capital: one was parliamentary government; the other the non-existence of a government of London.

Under the English mode of parliamentary government as it functioned for most of the Victorian era, a government ministry had to secure Treasury approval before its financial proposals, under specific heads, were submitted to the Commons. The minister might ultimately have to take his fight to the cabinet to secure funding for part or all of his programme. Some departments lay outside the cabinet, so their position was weak to start with. Even if the cabinet approved a department's proposals, they might run into a storm of parliamentary hostility that would cause them to be abandoned or at best postponed. Once voted, money could not be transferred from one head to another without Treasury sanction. And from 1866 if an annual appropriation was not spent in the financial year, the surplus had to be surrendered, and the item resubmitted the following year. On the other hand, if at any stage of the year a department seemed to be over-spending, the Treasury would insist that action be taken, either to arrest expenditure or to submit supplementary estimates to parliament, a proceeding likely to bring searing criticism.[3]

There were some objects of expenditure that were inherently unpopular: one was public building. The exceeding of architects' estimates in public works was proverbial. Anyway, government offices did not need architectural magnificence: they were only workshops. And in the orgy of architectural flavours that was the nineteenth century, any particular taste would be strongly criticized. So government's architectural proposals were always open to two lines of attack: financial and aesthetic.

A second unpopular object of expenditure was London. London was an amorphous mass. Although one in six of the population is said to have lived there at some stage in his or her lifetime, London, save for a self-interested body of 'City' men, evoked no civic pride. To the ordinary country voter the metropolis was still Cobbett's 'great wen', feeding on the country's lifeblood. For the 'country party' MP, expenditure on metropolitan improvements was strictly for Londoners to pay for.

London's problems were seldom among Victorian ministers' primary concerns. The classes from which Queen Victoria's ministers were drawn were largely insulated from the problems of the capital. What were unavoidable were public order concerns and public health concerns. But Sir Robert Peel's creation of the metropolitan police in 1829 really solved the public order problem. More serious and more immediate were health problems. From 1832 onwards the threat of a cholera epidemic hung over the capital. In 1848–9 there was a devastating outbreak that killed 14,000; in 1854 the morbus returned to kill another 10,675; yet another outbreak in 1866 killed some 5,000 in a mere three weeks.[4] A sense of self-preservation as well as public horror forced ministers to seek a remedy, but different opinions among the experts gave rise to differing proposals, and like the donkey between two bunches of carrots, government was paralysed.

Another problem of which ministers could not be entirely unaware was that of metropolitan traffic congestion. The Strand was for many years the only serious route between Westminster and the City. In the City, the area around the old Royal Exchange was notorious for its impermeability.[5] Whitehall itself, and its continuation Parliament Street (a Georgian attempt at traffic relief), formed a major thoroughfare, carrying traffic in two massive streams, to Victoria, and to the Embankment and Westminster Bridge (plate 48). And in the heart of the fashionable West End, the congestion of traffic at Hyde Park Corner was 'one of the sights of London'.[6]

Ministers, however, were not subjected to the pressure for the resolution of London's problems that we might expect today. London was not an entity, hardly even a concept. Two cities were there: the powerful self-governing City of London, the old square mile with its counting houses and commerce – a district of which the residential population was shrinking as its commercial wealth grew; westward lay the old court centre, Westminster, and its largely residential spawnings in the estates of the great landowners: the Grosvenors, Cavendishes, Portmans, Cadogans *et hoc omne genus*. Westminster had never possessed a real city government. Outside the square mile, in the ever-spreading suburbs, local government reposed largely in the hands of parish vestries, often self-perpetuating and even more often self-interested. Much power reposed also in the hands of the great landowners: the 2nd and 3rd Marquesses of Westminster exercised far greater control over the face

48 Administrative London in 1865, showing the Thames Embankment and controversial
potential sites for public buildings.

of the West End than did any minister or local government body.[7] And because of
the inadequacies of local government, inhabitants had formed groups to secure
statutory powers for local paving and lighting. In 1849 the *Spectator* observed that
London was 'a constellation or cluster of cities, each having its separate district and
conditions of existence – physical, moral and political ... nearly as diversely
marked and *caste* as so many distinct nationalities'.[8] A royal commission on the
City of London Corporation in 1853 remarked that London was really a province,
its inhabitants lacking the 'minute local knowledge and community of interest'
found commonly in towns.[9] Only in 1855 was the first rudimentary London-wide
authority set up – the Metropolitan Board of Works (MBW) – and then with a
strictly limited sanitary function.[10]

The mass of London's inhabitants could not bring pressure to bear in
Parliament because, even after the Great Reform Act of 1832 that enfranchised
many, they still possessed few representatives in the House of Commons – 18
members out of 658. The 1867 Conservative redistribution allowed London only 4
more seats. So until 1885 London's popular parliamentary voice was small,
though not often still. Even had it been louder, it is unlikely to have spoken out for
embellishment: the well-being of the populace was more important than an image
of metropolitan magnificence.

On the other hand, the City, the trading metropolis of the world,[11] the manager of the national debt, the source of credit, exercised great parliamentary influence; the Corporation was said to influence as many as a hundred members. 'The behaviour of Parliament towards the metropolis during the nineteenth century is difficult to explain except in terms of the lobbying activities of the public utility companies which plundered the consumer in the wealthiest city in Europe,' declared W.A. Robson.[12] While London lacked a government, the gas and water companies could mint money. A considerable number of members of the City Corporation sat in the Commons; other MPs were members of City livery companies, or were (increasingly as time went on) members of boards of financial or commercial companies in the City. The City did not hesitate to use this influence to block proposals for metropolitan government reform. Its success rested, in part, Mr Waller suggests, on the 'legendary gourmandizing and ceremonial' that 'had a place in the calendar of state ritual'. It was the Corporation that provided the most brilliant image of London, providing elaborate state dinners for the entertainment of foreign potentates.[13] The annual 9 November Guildhall dinner, to mark the installation of a new Lord Mayor, with a thousand guests, including the diplomatic corps and the leaders of society, was habitually the occasion of a major speech from the prime minister on the government's policy;[14] while the Lord Mayor customarily marked the end of the parliamentary session by a banquet to ministers – used by Peel in 1834 to launch his programme for the general election.[15] Such a platform was important to ministers in putting over their policies to a significant audience at a time when convention restricted their opportunities for extra-parliamentary speech-making. The endowments of the livery companies flourished, with concomitant benefits for members (often MPs) – 'For outside observers the most important were the feasts.'[16]

The City was, moreover, prepared to move with the times. Jews were admitted as aldermen, even lord mayors. Conferment of the honorary freedom of the City was a distinction that few would refuse, and it was even extended to women. The livery companies expanded their charitable benefactions, education – a traditional object – benefiting particularly, so warding off the threat of a statutory redistribution of their assets – proposed by Gladstone in 1873.[17] But the most important reason for the Corporation's survival was, as Waller puts it, that 'it had a corporate sense and was prepared to act ... There seemed none to match it elsewhere in London.'[18]

Thus, ministers often accepted the role of the City Corporation as the image of London. The public finances often required the City's cooperation; it was much more convenient, possibly advantageous, to go along with it; its cooperation brought advantages; and its parliamentary cohorts in mufti secured its safety.

But there were, as we have seen, problems about London life that would not go away. In view of the perils of a minister's seeking to pursue some remedy of his own, it was far safer to proceed by appointing a select committee to investigate the problem and propose such remedies as might be generally acceptable – but remedies to which the government was not initially committed and need not take up until it was safe to do so. Thus the problems of traffic and the planning of metropolitan roads, like the problems of public health – securing a clean water

supply, removing slums that were seen as the breeding grounds for disease, promoting better housing – could be referred to select committees, or, if the problem were sufficiently persistent and important, to a royal commission that could draw on a body of authoritive opinion beyond the confines of the Palace of Westminster.

But if these problems – traffic congestion, slum housing, epidemic disease and public order – closely inter-related and much discussed in the metropolitan press, could not be ignored by ministers, there were two major obstacles to government action: the cost, and deciding what action to take. The financial question was an even more serious obstacle than the technical question. The 'Metropolitan Improvements' of the Regency and reign of George IV had been costly. Costly public offices designed by Soane were denounced as hideous. Smirke's new British Museum progressed invisibly but expensively. The great work of Regent Street had by 1826 cost £1,709,042, against an original estimate of £600,000.[19] Regent's Park appeared a doubtfully successful investment.[20] All this work was associated with the government Offices of Works & Public Buildings and Woods & Forests, and their architect John Nash, who was also responsible for the rebuilding of Buckingham Palace, of which the cost had risen from a £250,000 estimate to £613,000, still incomplete, by 1831.[21] Essential as most of these works had been, and advantageous as they were in improving the image of London as one of the great European capitals, they had spawned a belief in the extravagant cost of public works, works associated with 'Old Corruption', extravagance that the reformers of 1832 were determined to arrest. The effect of these expensive building projects may be seen in *The Times*'s call for 'salutary control' of building expenditures, urging on ministers 'an inflexible and inexorable disregard of every proposition ... for indulging wild propensities to extravagance'[22] – as well as in the debates on the rebuilding of the Houses of Parliament after the disastrous fire of 16 October 1834.[23]

The era of cheap government associated with the Whig ministries of the 1830s was enforced by severe scrutiny of any public works proposals.[24] Dr Tyack has investigated the replanning of London's roads in the early Victorian period in his study of Sir James Pennethorne, for many years Surveyor to the Office of Woods and Works (1832–51), responsible for public buildings, the Crown estate, and any vaguely connected activity. Tyack sees the new wave of metropolitan improvements that swelled at the end of the 1830s as set in motion by 'a combination of outside pressure and growing professional expertise'.[25]

New sanitary ideas were fed into a succession of committees on metropolitan improvements.[26] Thus, the idea of resuming the improvement of London had already been extensively discussed when the Royal Exchange, at the very heart of the City's financial district, burnt down on the night of 10 February 1838, creating an opportunity for re-planning that location. The City was prepared to rebuild the Exchange on a larger scale – to provide for increased business activity created by the new facility of rail travel, rather than to improve London's image – but wanted parliament to pay for removing traffic bottlenecks. A committee was already examining proposals for road improvements: rather than recommending Pennethorne's full-scale northern West End-to-City relief road, it approved only a section from Piccadilly Circus to Long Acre. And the mean-

minded, penny-pinching attitude of the day was exemplified by the committee's insistence that embellishment was to be of 'subordinate importance'.[27] Little enthusiasm could be expected there for the City's request. Persuaded, however, that this was an opportunity that would not recur, the committee did approve it in principle, though at a cost less than the City had proposed; but it insisted that 'Notwithstanding the very extensive interests connected with the transactions which are conducted at the Royal Exchange, the burden of effecting any improvements incidental to the rebuilding of the edifice, ought not to be cast upon the resources of the Nation at large.'[28]

Here then was a dilemma. Those who wish the end must wish the means, but the committee was refusing the means. The escape lay in a traditional source of funds for London improvements, utilized ever since the rebuilding after the Great Fire of 1666: duties levied principally on coal brought into London, most recently authorized in 1831 for a series of years to build new approaches to the new London Bridge. With the consumption of coal in London increasing as the number of houses and workplaces increased, the revenue came to exceed the predetermined charge upon it. There would be a surplus left after the bridge-connected works were paid for, and that surplus could, the committee suggested, furnish the money for the Royal Exchange street improvements.[29] This proposal focused attention on the coal duties' surplus; the select committee revived in 1839 took a more prosperous view of street improvements to be effected by that means, and recommended four thoroughfares needed for traffic easing or health reasons as part of a future comprehensive improvements programme.[30] These improvements 'held out the hope of imposing a rational street pattern on central London.'[31] However, the £638,000 estimated cost was beyond the available resources, and the Treasury refused to raid national taxation to meet the deficit. Indeed, it had little choice, so strong was parliamentary hostility to diverting national taxes to London's local purposes.[32] The problem was referred back to the committee, which, ironically, consulted Richard Lambert Jones, the City's advocate in the Royal Exchange debate, who recommended that the width of the proposed streets be reduced by 15 ft to that of King William Street in the City (for which Jones's own City committee had been responsible), and that purchases of property for constructing the new streets be rigidly controlled, thereby sadly hampering the planning and building of the new streets.[33] Even so, the architect's estimate was exceeded and so the programme of public works was discredited. The root of the trouble here was the intractability of the system of compulsory purchase; those affected could refer the valuation of their properties to the decision of a jury; and juries tended to award affected businesses extravagant 'goodwill' sums.[34] Stories of extravagant claims and awards of course confirmed the general prejudice against meeting the costs of metropolitan improvements.

* * *

Another type of criticism, strengthened by the aesthetic debates of the nineteenth century about architectural style, was of the poor quality of buildings erected by public authorities. A leading article in *The Times* (15 February 1848) lamented the lack of splendid public buildings in London, with the exception of the new Palace

of Westminster – but even that great work came under attack for its mounting cost,[35] and, as taste changed, for its unfashionable style.

To overcome the confusion caused by the frequent changes of government and of policy at this period, several solutions were proposed. One was to create a loan fund (like a modern mortgage, the public charged with annual sums for interest and capital redemption), controlled by an all-party commission of knowledgeable men.[36] Another was to make the minister responsible a permanent appointment, or alternatively, to create a permanent public official with responsibility for such works such as that enjoyed by the aediles of the Roman Republic – a classical allusion familiar to a parliament largely classically educated. In May 1856 *The Times* called for the appointment of an aedile to do justice to 'the metropolis of the earth'.[37]

Official circles were fully conscious of the problem. Late in 1859 the Deputy Director of Works at the Admiralty suggested to the First Commissioner the setting up of an advisory council representing the Works, the Admiralty, the War Department and the professions. But the First Commissioner was not prepared to surrender his authority.[38] The Treasury, too, was looking into the problem, the financial secretary, Samuel Laing, MP, a once and future railway magnate, recommending a permanent head of the Office of Works under Treasury control.[39] Gladstone considered the question at the Exchequer, but first it was reviewed by a select committee investigating 'miscellaneous expenditure' in May and June 1860. Lord Llanover, a former First Commissioner as Sir Benjamin Hall, told the committee that 'there was nothing whatever political' in his department, and that it was therefore 'one of the greatest absurdities existing in the State' that the First Commissioner should be a political officer. The committee agreed, and recommended that, because of 'the evil arising from constant changes in the office of Chief Commissioner of Works', the post should be made permanent.[40]

It was true that public building matters were seldom resolved along party lines, but to argue that they were therefore 'non-political' was absurd. They were often among the most contentious issues before the House of Commons. Lord Stanley described the debate over the purchase of the 1862 International Exhibition building for a natural history museum as the stormiest he had ever experienced.[41] As a spending department, any public works department, however directed, must be subordinate to the Treasury, and dependant upon annual parliamentary votes of funding. A permanent commissioner would be no more able than a political commissioner to command funds, and for any spending department parliamentary representation was vital, as the Poor Law Board had learned in the 1830s.[42] It was inconceivable that, under the English system of government, the department and its responsible officer could be taken out of the normal political system.

Despite the committee's call for a permanent commissioner, such an appointment was never made. This was partly because Gladstone sought a different solution. When the Radical A.S. Ayrton criticized delay in settling the future of the Burlington House site – purchased by the government in 1853 as a home for the National Gallery – Gladstone blamed the 'total want of authority to direct and guide'. He denounced the prevailing parliamentary system: 'When anything was to be done they had to go from department to department – from

the Executive to the House of Commons, from the House of Commons to a Committee, from a Committee to a Commission, and from a Commission back to a Committee.'[43] Gladstone's unwritten agenda, as Professor Matthew has made clear, was to increase the authority of the executive government in the House of Commons.[44]

Nevertheless, the argument continued to be heard not infrequently. William Gregory argued for such an appointment in 1862: a man 'chosen for the excellence of his taste, or the correctness of his eye'.[45] This was quickly followed by a call for a royal commission on public buildings, proposed by Disraeli's 'Young England' friend Baillie Cochrane.[46] He argued that, though successive First Commissioners had for years past done their best for the improvement of the metropolis, the existing system was the chief obstacle to progress. He surveyed the history of government over several decades, showing how much had been spent and how unsatisfactory the results had been. He wanted a plan to meet the public needs which would 'by its unity and symmetry contribute to the beauty of the metropolis without causing an unreasonable outlay'. It was 'of the utmost importance' that London's public buildings 'should be such as reflected no discredit on the Government as caring less than did the authorities of Paris, Vienna, and Munich, that the splendour of the capital city should be commensurate with the importance of the nation.' A royal commission could select a site, hold a competition with cost limited, report on the plans; and the government could (as that other 'Young England' champion Manners had suggested)[47] raise a loan to be paid off over twenty-two years.[48] The great contractor Sir Morton Peto suggested placing all public works 'under the authority of some responsible Minister of the Crown'.[49]

Gladstone in a weighty speech now recurred to his desired solution: the mode of managing public works 'must be worked out in the regular, practical, and constitutional method to which we are accustomed; that is to say, in the daily and habitual relations between the executive Government and the House of Commons.' He implicitly attacked the constant intervention of select committees, insisting, 'The executive Government must take upon itself the management and settlement of these great questions. The Cabinet must give its judgment upon them, and the House of Commons must deal with them as questions upon which the Cabinet has pronounced its opinion.'[50] Baillie Cochrane's proposal was decisively rejected by 116 votes to 67, partly, a contemporary source declared, from fear that it might lead to the then First Commissioner's becoming permanent:[51] William Cowper was closely associated with Ruskin and the Gothic Revivalists.

* * *

In view of all the obstacles to brightening London's image, it is a marvel that anything at all was accomplished. Much of the credit for the erection of a number of grand public buildings worthy of a great metropolis must go to half a dozen men: the acknowledged aediles of imperial London. Five – Hall, Cowper, Manners, Shaw Lefevre and Akers Douglas – were junior ministers, one – Beresford Hope – a back-bencher.

Sir Benjamin Hall,[52] our first aedile, appointed in 1855, determined to leave his mark on London, but also to control what he saw as the extravagance of such public works as were already afoot (notably Sir Charles Barry's New Palace at Westminster). Hall took office at precisely the moment when Palmerston's government had decided that the pressures on such existing government offices (old houses) as the Foreign and War Offices had become intolerable. Hall's period in office was a watershed. It was he who created the Metropolitan Board of Works (MBW) as a sanitary authority for the whole metropolitan area, conducting London's main drainage.[53] The great issues of new public offices were also fought out under his administration. This latter tale has been told many times, most comprehensively by the present author.[54] Hall's international competition of 1856–7 for government offices, of which one component was a master plan (plate 49), produced grandiose palatial schemes that terrified MPs into a fit of economy (plates 50a and 50b): many MPs objected to architectural embellishment of workshops for clerks manufacturing government documents.

What Hall did was to turn the weapons of the philistines against themselves: by showing that his programme was economical (employing the select committee procedure to establish his case),[55] efficient both in means (public competition for the best design based on a brief supplied by the relevant ministries) and anti-monopolist (the architect appointed as a result of the foresaid competition). Hall's scorn for Pennethorne, who was in effect though not in name the Government Architect, ensured that the commission for whatever offices were built would go to a leading competitor. But his further personal contribution was terminated by the defeat of the government over foreign policy.

Two years of weak governments stiffened the sinews of independent-minded MPs and empowered committees. We may, however, propose Lord John Manners,[56] First Commissioner in the brief Conservative ministry of 1858–9, as the second of our aediles. Manners, a keen supporter of the Gothic Revival, proved to be a decision-taker, though he moved cautiously. Feeling the parliamentary pulse, and that of the architectural profession, he persuaded the prime minister to propose a committee to sift 'conflicting opinions and extensive evidence'.[57] This brought into play our back-bench polisher of London's image, the rich Alexander Beresford Hope,[58] an architectural amateur who owned a weighty weekly, the *Saturday Review*. He suggested that, as London already had two or three miles of parks, the finest river of any city in Europe (St Petersburg apart), and the noble parliamentary buildings 'precisely where its curvature enhances their architectural value', all that was needed 'to lay the foundation of a magnificent, reformed, artistic London' was to remove the 'dense mass of habitation' on either side of Whitehall between the Thames and the Park. The extension of the Parks and the reconstruction of the public offices could be combined 'with the most signal advantage to both', and so they must be unless London were 'to be for ever left the laughing-stock of the artistic world'.[59] Through his roles as a journalist, newspaper proprietor and architectural connoisseur he was able to stir up discussion 'out of doors' of the poor image cast by London in Europe, and as an MP, to make good use 'within doors' of the concern thus generated. Securing the chairmanship of Manners's committee, he persuaded it of the peculiar merits of George Gilbert Scott, third in the War Office

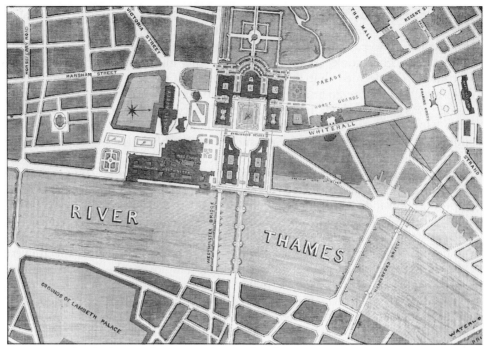

49 Master plan for layout of new government offices by Alphonse-Nicolas Crépinet (1826–92), awarded first prize in 1856–7 competition, but abandoned as a result of parliamentary hostility. [*Illustrated London News*].

competition (like him, an enthusiast for the revival of Gothic architecture) (plate 50b), ensuring his appointment to design the new government offices.[60] Although the famous 'Battle of the Styles' saw Palmerston (back in power) impose a classical palace on Whitehall (plate 51), in keeping with the other important buildings in the street, Scott retained his commission, a triumph for the concept of public competition.

Palmerston was a cultivated nobleman who was a firm believer in the classical tradition: he played a celebrated role in the contemporary 'Battle of the Styles', killing Scott's Gothic and Venetian–Byzantine Foreign Office designs stone dead.[61] He was aware of London's defects, which he ascribed basically to 'the great wealth and great population of the City': the wealth of the metropolis caused 'immense competition' for 'the smallest spaces of ground'.[62] In consequence, 'our streets are narrow, our open spaces few and small, our public buildings are not many.' It was this financial factor that induced Palmerston to throw his support behind Prince Albert's project to establish a range of museums and galleries at South Kensington, where the ground was 'infinitely cheaper'.[63]

The ground was cheaper, of course, because there was not the same demand for it as in the centre, where residential, commercial, industrial and governmental uses were competing against one another. When labour was ill paid, men walked to work and to their leisure occupations. There was no lack of parliamentary voices to urge that South Kensington was too far and too expensive for the working man and his family: the very class who would most benefit from the new

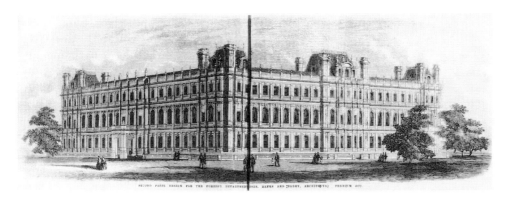

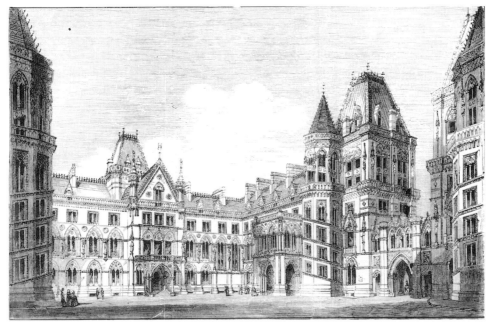

50 Prize-winning designs for the Foreign Office in the 1856–7 competition, abandoned after House of Commons' attacks on their palatial character, August 1857 [*Builder*]:

a. By R.R. Banks (1812–72) and Charles Barry jnr (1823–1900), 2nd prize. Because of the first prize winners' lack of experience, it was generally thought Banks & Barry would be given the commission.

b. By George Gilbert Scott (1811–78), 3rd prize. Praised by committee of 1858; in consequence Lord John Manners commissioned Scott to design the new government offices.

museums and galleries would find them inaccessible. Violent controversy over the siting of the natural history collections of the British Museum and the paintings of the National Gallery obliterated any serious consideration of these great buildings forming essential parts of a master plan for embellishing the metropolis.[64] Such museums as were ultimately located at South Kensington formed a sort of appendix to London, one that by the 1870s achieved a coherence and symmetry of its own, unhappily marred by subsequent exploitation of the site.[65]

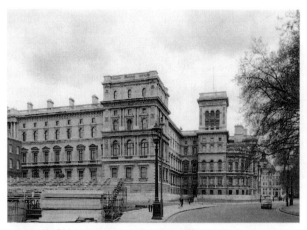

51 Park front, Foreign and India Offices, G.G. Scott, 1863–8. [Photo: M.H. Port]. Palmerston as prime minister insisted on a classical design, and Scott capitulated.

Although he announced no programme, and was regarded as a parliamentary lightweight, William Cowper's[66] relatively long tenure of the Works (1860–66) was of basic importance to the amelioration of London's image. He initiated the largest programme of government building since Nash's day: a new National Gallery, new Law Courts, museums at South Kensington, and the removal of the Royal Academy, the Learned Societies and London University to new buildings at Burlington House – though many of his projects were to be mauled in execution. He developed, too, Hall's method of selecting architects by competition, but preferred that form limited by invitation.[67] Each of these initiatives required careful preparation, although the needs had been admitted for decades. The financing of the New Law Courts was a masterpiece of Gladstonian ingenuity, but achieved only in 1865, after the chancellor had shot himself in the foot by his Treasury minute of 16 July 1861, causing first the postponement and then in 1862 the defeat of the necessary bill.[68] Similarly, the decision to erect a new National Gallery at Burlington House was decisively rejected by the Commons on 4 June 1864, so that the proposed sites of Gallery and Royal Academy had to be transposed.[69]

When the Conservatives returned to office in 1866, Lord John Manners inherited Cowper's projects. The great competitions for the new National Gallery and Law Courts turned out unfortunately because of the failure of the judges – mostly laymen, with an architect included as a boon to the profession. Manners brought the quarrelling to an end by commissioning Street to design the Law Courts and his rival Edward Barry the National Gallery (plate 52). Perhaps even more significant were his recommendations about completing the public offices. When Cowper had advised completing Scott's Foreign and India Offices block towards Whitehall, the Treasury had appointed a departmental committee to consider the whole question of official accommodation. In this move by the executive, we may see the hand of Gladstone. Manners now took over the chair. He appointed a sub-committee (Lord Devon, a minister, with Trevelyan and the chairman of the Board of Inland Revenue), which proposed completing Scott's block onto Whitehall, placing the naval and military departments in the adjacent southward area towards Great George Street, with Health and Education on the opposite, river, side of Parliament Street. Manners, however, in response to the views of the War Minister and the commander-in-chief, proposed a War Office next to the Horse Guards, displacing the Treasury and civil departments to the Great George Street site, while the Admiralty would stay where it was at the

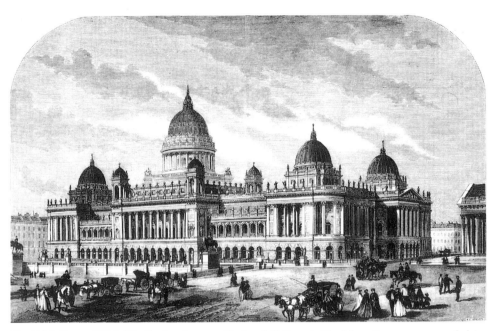

52 E.M. Barry (1830–80), Design for new National Gallery in Trafalgar Square, commended in 1866 limited competition. [*Builder*]. Barry was awarded the commission in 1867, but funds were never voted by Parliament.

northern end of Whitehall (plate 53). Thus, all the public offices would have been ranged in one magnificent complex between Whitehall and the Park. A widened Parliament Street would divide the Victoria-bound traffic from that bound for Westminster Bridge or the Embankment.[70] Unfortunately, that would have left the eastern side of Parliament Street, the key approach to the Palace of Westminster, as an untidy congeries of old buildings. Trevelyan suggested a nobler alternative: to place the War Office and Admiralty there, at the same time demolishing the Horse Guards to create a magnificent approach from the Park, and selling the old Admiralty, partly for first-class residences. But this would have been a very expensive operation, too bold a concept for a minority-party government, though Manners, having been to Paris, wrote to the prime minister, 'As F[irst] C[ommissioner] I do not think that I can ever hold up my head again having witnessed the contrast between the two Capitals.'[71] Instead, the cabinet endorsed Manners's proposals and legislation was prepared for purchasing the Great George Street block.

Thus matters stood when Gladstone became prime minister, in December 1868. Despite the call he had previously made for reform in the Office of Works, he did not instigate any revolutionary change. Instead he appointed a notable aesthete from the radical wing of the Liberal Party, Austen Henry Layard,[72] fourth of our aediles, a man with a definite programme of his own for a splendid line of public buildings on the new Thames Embankment. Even before he took up office, he was plotting to build the proposed new Royal Courts of Justice beside the river (plate 54). Upon this, everything hung. 'If that had been carried out London could really have been made one of the finest, if not the grandest capital in the world –

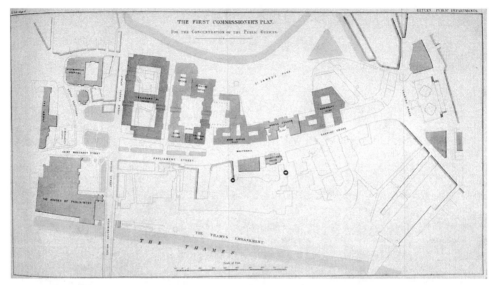

53 Lord John Manners's plan for layout of new government offices, 1868, ranged on the west side of Whitehall and Parliament Street. [*Parliamentary Papers*]

as innumerable improvements would have followed of necessity.'[73] But the opposition of the Lincoln's and Gray's Inn lawyers, the Law Society (all distant from the river), and economically minded MPs killed this noble project. There still remained the possibility of placing the new museum for Natural History on the Embankment, which many scientists preferred to the alternative site at South Kensington; a committee chaired by Layard's ally Lord Elcho, a back-bencher always very forward in questions of London improvement, had recommended the more central site.[74] But the hope of using land reclaimed from the Thames, which belonged to the Crown, was killed by a hostile motion in the Commons from W.H. Smith, Conservative member for Westminster, who insisted that the reclamation had been paid for by London's ratepayers (as part of the MBW's Thames Embankment works), and must be retained as recreational gardens.

Equally unsuccessful was Layard's attempt to establish an architectural advisor to the minister in the Office of Works – for which function he chose his friend James Fergusson, the architectural historian[75] – 'to advise the First Commissioner and to controul [*sic*] expenditure – not to make designs for important public buildings'.[76] Layard, already unhappy at the degree of Treasury control of the Office of Works, was effectively driven from office because he had authorized mosaic work in the Houses of Parliament before the Commons had voted the money, so provoking a tempest of criticism.[77] Fergusson also then resigned, and was replaced by a Royal Engineer lacking architectural experience.[78] The new minister himself, Acton Ayrton, was a Radical zealous for economy in public works – an anti-aedile if ever there were one – with a very utilitarian view of public architecture. He alienated all the architects then employed on great public buildings, who had achieved the positions through the several competitions of the 1860s, though most of his interventions had only limited success. Street, with Gladstone's sympathetic ear, was able to save the central hall of his Royal

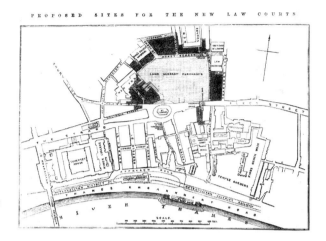

PROPOSED SITES FOR THE NEW LAW COURTS

54 Rival sites for the new Law Courts, 1868. [*Illustrated London News*]. The Carey Street site had already been purchased, but Layard fought unsuccessfully for an Embankment site; even the reduced 'Howard Street site' was rejected by the Commons.

Courts of Justice (plate 55a); and Waterhouse's entrance front towers at the Natural History Museum were reinstated to provide fire-fighting reservoirs. But Edward Barry's proposed rebuilding of the National Gallery in Trafalgar Square was abandoned in favour of piecemeal additions, and Scott's completion of the New Government Offices on Whitehall truncated of terminal towers.

The last great public building which the Gladstone administration had contemplated erecting was that new War Office originally decided upon in 1856, combined with a new Admiralty, which a cabinet committee had proposed placing on the Thames Embankment.[79] Smith's motion, referred to above, blocked this, being supported by Lord John Manners, who resented the change from his master plan of 1867. A modified proposal was subsequently postponed for want of finance.

The succeeding Conservative ministry, however, took up the question, driven by the insanitary condition of the War Office buildings in Pall Mall.[80] A choice of site now lay between Crown land that looked onto the Embankment Gardens (the so-called 'Fife House site'), and the area from Scott's great government offices block southwards to Great George Street, portions of which the government was buying as they came onto the market. But a bill in 1876 to expedite the purchase of the entire block was bitterly opposed by the Great George Street area residents, with every prospect of the scheme becoming unacceptably costly. Disraeli therefore referred the general issue of providing accommodation for the growing departments of administration to yet another committee; but, sitting late in the 1877 session, it did no more than present alternatives. One was essentially to employ the Fife House site; a second would range all the departments between Whitehall and the Park, opening the Mall to Charing Cross (a version of the Manners plan of 1868); and the third would have employed the whole Great George Street site, freeing the old Admiralty site for sale (see plates 48 and 53).[81] The permanent secretary of the Treasury threw his considerable weight against 'mixing up (further than be helpful) the question of new public offices and general metropolitan improvements', insisting that 'improvements' were the responsibility of London's local government.[82] The Treasury then prepared a new bill for purchasing the Great George Street site.

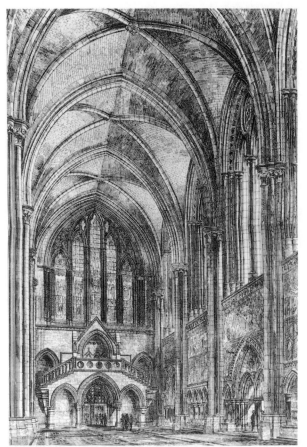

55a (left) G.E. Street (1824–81), Design for central hall in new Law Courts, Strand, 1873. [*Building News*]. The Commissioner of Works, Ayrton, and his officials tried to strike this out for economy's sake, but the Chancellor of the Exchequer thought the architect should not be 'compelled to make such reductions, which he so strongly deprecates'.

55b (bottom left) G.E. Street (1824–81), main entrance of new Law Courts, Strand, 1873–82, showing gable of central hall. [Photo: M.H. Port].

55c (bottom right) A. Waterhouse (1830–1905), entrance and towers, Natural History Musuem, South Kensington, 1873–80. [Photo: M.H. Port]. The Office of Works cut down the towers, but they were reinstated to carry water tanks at the insistence of the fire brigade.

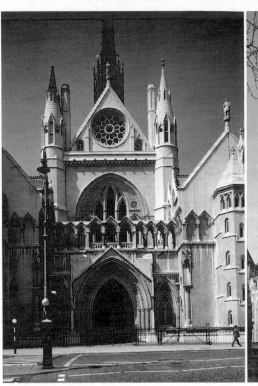

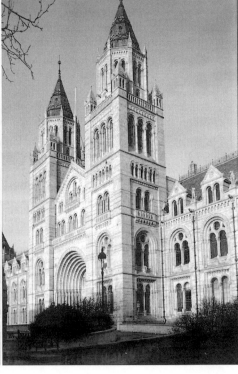

But a slump in the economy and costly colonial wars destroyed any prospect of funds becoming available.

Our fifth aedile was George Shaw Lefevre, (1831–1928) First Commissioner of Works in Gladstone's second administration, already known as founder of the Commons Preservation Society, instrumental in saving London's lungs. He rather apologetically published his somewhat unoriginal programme for improving London's image: 'the Government, within the limits which are possible to it, is doing its best.'[83] (Later, out of office, reviewing his achievements, he was more declaratory: London had 'more buildings of the highest importance than any other city in the world' save Rome; the government should carry out its works 'in the best possible manner' with a view to persuading London's citizens to play their part and 'creating a pride in our metropolis'.)[84] In 1882 he was proposing to sweep away Soane's Law Courts and rebuild the west front of Westminster Hall; improve Hyde Park Corner; build a new Admiralty and War Office; add a monumental hall to Westminster Abbey for commemorating the illustrious dead; enlarge the National Gallery; and restore parts of the Tower of London. Works 'of purely local interest' were up to the MBW.

The destruction of the old Law Courts exposed the soft stone of Westminster Hall's west side. Some expert opinion recommended reconstructing a lost building indicated only by its foundations; but William Morris's Society for the Protection of Ancient Buildings (SPAB) strongly objected to any medieval imitation. A committee provided a battlefield for the SPAB and other objectors, but Lefevre was able to ride over mutually hostile critics to carry out his intended 'restoration' designed by J.L. Pearson.[85]

The long-contemplated removal of partly superfluous modern buildings at the Tower of London raised precisely the same issues as the work at Westminster Hall. But the military, who controlled the Tower, insisted on accommodation in place of that demolished: if the new buildings were to be modern, it was 'scarcely worth while to remove the warehouses'.[86] Despite snarls from the SPAB and Treasury-imposed delay, Lefevre was able to resurrect supposed medieval work in the Ballium Wall and Lanthorn Tower.[87]

Another long-ventilated idea was that for an English Valhalla to relieve Westminster Abbey of its monumental burdens. But the cost of the necessary clearance would have been high and the 'economic tendencies' of the House of Commons in the late 1880s clearly precluded hope of any vote of public money. The Abbey becoming overcrowded with memorials, the Salisbury government in 1890 appointed a royal commission, which offered two costly and scarcely practicable schemes. Architects designed in vain. It was easier to prune the memorials already in the Abbey.[88]

Shaw Lefevre's works at Hyde Park Corner, a continuation of an old story, improved the traffic flow at the cost of distorting Burton's co-ordinated Hyde Park entrance screen and triumphal arch, and unbalancing the latter: that the arrangement was approved by a committee merely proved their architectural blindness. The much-needed additions to the National Gallery had the ironic effect of preserving the generally criticized Wilkins building. The new galleries, however, 'ornamented with the finest collection of marbles in London', as Lefevre thought, '... made the Gallery one of the best in Europe, and for the first time

worthy of the splendid collection of pictures.'[89] Others were not impressed by Algerian marble, and still less by the inconvenient layout, an inescapable consequence of the piecemeal character of the additions.

The scheme for building a new War Office and Admiralty on an enlarged site based on the old Admiralty looked more promising; it had the agreement of the ministers concerned. A committee approved, a bill passed, architects competed. Its history shows parliamentary government at work on London's image. A vast building costing more than £500,000, it would have had a dominating effect on Whitehall. Influential in choosing the winning entry (plate 56a), Lefevre was accused of ignoring good design for clever draughtsmanship. But MPs in the 1880s were woefully ignorant about architecture: an estimate was approved, the money voted; even a Conservative government in 1885–6 did not abandon the project. But after Gladstone's return to power, the penurious Conservative leader in the Commons, W.H. Smith, mentioned above as MP for Westminster, joined with the Liberal chancellor Sir William Harcourt, strongly opposed to the scheme, in a further committee (renewed in 1887, when the parties had again changed places) to condemn it, recommending instead a simple enlargement of the old Admiralty (plate 56b), and deferring a new War Office for several years to come.[90]

Shaw Lefevre's efforts to function as London's aedile thus ran into the usual problems, peculiarly heightened. Finance was the primary hurdle; but a higher and more obstructive series of hurdles was the need to submit ministerial initiatives time and again to the criticism of parliament. Economy-minded ministerial colleagues could exploit intricacies of procedure to negate projects already agreed upon. Victorian parliaments were inherently suspicious of proposals for public works, and MPs architecturally ignorant, and hence all too ready to respond to facile press criticism. In an era of cut-throat competition there were always writers in the architectural press ready to denounce any building proposal, and their comments were likely to be reflected in the periodicals or the daily press, itself thriving on controversy. Only a minister who knew clearly the style of building he wanted, with an ascendancy over the Commons and an indifference to the public prints, but a sense also of financial responsibility, could secure his object, as Palmerston did with the Foreign Office – with a design that 'might not be very magnificent or splendid, but it would be handsome enough for the purpose'.[91] Shaw Lefevre was assiduous but uninspiring; he did not command the support even of major colleagues; civil servants saw him as a third-rater.[92] His self-complacent posing 'as the architectural instructor of his generation' was denounced as the shallow pretensions of a meddler who 'has consistently bungled and spoiled everything that he has interfered with'.[93]

The failure of yet another parliamentary aedile provoked renewed calls for a better public works regime. A writer in *Murray's Magazine* in 1889 attacked the entrusting of public works in architecture to a party politician, instead of 'to a man or a committee of men selected and permanently entrusted with such matters on account of their special knowledge and qualifications'.[94] H.H. Statham, 'conductor' of the influential *Builder* weekly, had in 1882 forecast Lefevre's failure, attacking Works' architecture as 'draughtsman's architecture', the permanent head of the Office was a mere 'man of business', the First

Commissioner a party politician: the opinion of neither on architectural questions of any value whatever. 'It remains to be seen,' he remarked,

> whether educated public opinion will not demand the appointment of a permanent and specially qualified 'Minister of Public Works' – whose jurisdiction should be independent of political changes – or at least of a permanent architectural adviser of the highest class; or whether we are to continue indefinitely a system such as would not be tolerated in any other first-class city in Europe.[95]

Fourteen years later, he was lamenting that, the Houses of Parliament apart, 'our successive governments, Liberal and Conservative alike, seem to have been seized with an inexpugnable spirit of pettiness and economy in regard to all other buildings required for State administration.'

Once again, it was a fallacious solution that was being advocated. Statham seemed unconscious that the economical spirit of government that he had identified was a dark cloud hanging over any aedile however well qualified. The First Commissionership, he insisted, 'ought to be a permanent one, independent of political changes, and conferred on a man of special and recognized ability' in architectural matters. Similarly, select committees should be supplemented, as in France, by 'a certain proportion of architects and artists, competent to instruct the political members ... on subjects of which they are usually ignorant, though not aware that they are so.' Competitions, too, should be judged by a jury 'largely composed of persons who are really competent to form a judgement on architectural designs'[96] – all good ideas, but of small significance to an aesthetically blind rate-paying electorate and its representatives. At the time of the Diamond Jubilee, Statham reflected on the image of London as a capital city, one regrettably 'almost entirely devoid of the qualities of spaciousness and stateliness', improvements carried out piecemeal, but more often deferred indefinitely: 'anything which concerns the beauty and amenity of London may wait till the Greek Kalends.' Among other instances, he cited the neglect of the South Kensington Museum, 'rich with the spoils of ancient and Renaissance art', for which an 'admirable design' had been selected by competition, 'which cannot be carried out because the Government ... cannot spare the money. It might surely be worth consideration,' he concluded, 'whether it really pays a country to allow, for mere motives of financial economy, the continuance of what is almost a national disgrace, or must appear so to those foreign visitors who may come from a country in which there is any regard for art.'[97] But could public opinion be sufficiently aroused?

Responsive as *cognoscenti* might be to such pleas, the electorate was unmoved and Parliament declined to surrender its nominal control. Agitation in the periodicals died away under the calming influence of the policies of our last aedile, Aretas Akers-Douglas,[98] First Commissioner in Salisbury's third ministry (1895–1902), former Tory whip, a skilful, experienced politician accustomed to work behind the scenes, and of the new permanent secretary of the Office of Works, Reginald Brett (from 1899 Lord Esher), himself a saponaceous political manipulator. Their very considerable achievements in London rested on the

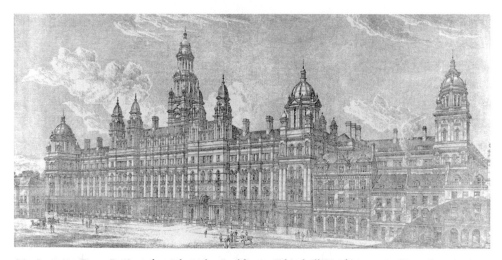

56 Leeming Bros. Designs for Admiralty Buildings, Whitehall [*Parliamentary Papers*]:
a. (above) Whitehall front. Revision as instructed by Commissioner of Works, of winning two-tier competition design of 1882–3 for new Admiralty.
b. (opposite) Design for extension only to existing building, as required by committee of 1887, seen from Horse Guards Parade.

foundation of solving the perennial financial problem. This was possible not merely because of a general improvement in the economy, but also specifically because the death duties introduced by the Liberals in 1894 were proving remarkably productive – so much so that the Conservative chancellor would not abolish them. The resultant annual surpluses gave the Salisbury ministry room to manoeuvre: instead of using surpluses in the traditional way to reduce the national debt, they were appropriated for specific purposes, initially for defence. Akers-Douglas was able for the first time to obtain a major appropriation for a public buildings programme thus secured from the perils of annual votes in the Commons. Even more remarkable was the detail of the Public Buildings Expenses Act of 1898, by which the money not immediately needed was to be invested in government stock and the interest applied to the purposes of the Act. Akers-Douglas brushed aside criticism of such a new method of finance. There was, it was generally agreed, a somewhat more relaxed atmosphere about use of public money at this time. Even the more financially austere Liberals followed the same principle in the 1908 Act providing for the completion of Akers-Douglas's works.[99]

Thus, it was at last possible for a comprehensive range of public buildings to be undertaken in London in the certainty that an agreed design would be carried out. Furthermore, Akers-Douglas abandoned the competition system for obtaining designs that had proved so constantly controversial. Instead, after careful inquiry, he selected an architect from a list submitted by the Royal Institute of British Architects (RIBA). He gave us the Great George Street government offices (now the Treasury) overlooking Parliament Square (plate 57a), and the huge War Office in Whitehall (plate 57b), the Admiralty front on Horse Guards Parade – three vital portions of Westminster – and Aston Webb's

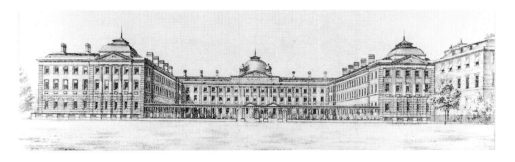

transmutation of the South Kensington Museum into the Victoria and Albert Museum (plate 57c). To all these was added in 1903 the north front of the British Museum: it was a range of noble buildings of which any capital may be proud. London could at last contemplate its public face without blushing.

There remained, however, a lack in London of those noble axial vistas which gave grandeur to Continental capitals. One long-suggested improvement, the opening of a processional way from Buckingham Palace to Charing Cross was realized as the nation's memorial to Queen Victoria, thanks to the alacrity of Viscount Esher, in 1903–11, with a *place* at one end and a triumphal arch at the other. At the same time the rebuilding of one of the capital's principal streets, Regent Street, the pearl necklace of Nash's metropolitan improvements in the Regency era, became an object as the Crown leases fell in. Here the situation was quite different from that in Whitehall or South Kensington. The Crown was landlord, a government department admittedly in charge but acting strictly as custodian of the sovereign's estate, and as a revenue-producing landowner less subject to parliamentary interference than works paid for by taxation. In Regent Street, it proved to be the shopkeepers who called the tune, as Professor Saint points out. It was they, rather than the landlord or 'idealists for improving London', who clamoured for rebuilding.[100] Nash's architecture was held in disfavour, and the fashionable shopkeepers wanted larger, more imposing shops. The Treasury interfered to insist upon appointing a committee of architects, who recommended Richard Norman Shaw as architect for redeveloping the crucial Quadrant sector. His designs failed because of the hostility of the shopkeepers: 'the concerted, democratic action of lessees was a new and bewildering phenomenon.'[101] More committees were appointed, the press and MPs took up the question, and little was done around Piccadilly Circus until 1923, when most of the leases had fallen in, and Sir Reginald Blomfield's respectable designs were executed. Meanwhile, the rebuilding in Portland stone of the more northerly extent of the street had proceeded largely to designs of *c*. 1910–12, approved by the Woods and Forests, uniform within the successive blocks.[102] By June 1927 the rebuilding was sufficiently complete for a royal opening of 'The First Street in Europe' – as the Regent Street tradesmen called it. 'Calm magnificence' was its character, thought the *Daily News*.[103]

The difficulty, however, of sustaining such a public works arrangement as Akers Douglas had devised in a parliamentary system was soon highlighted. When the architects of the new War Office and the Great George Street Offices (William Young and J.M. Brydon) died in 1900 and 1901 respectively, their works were

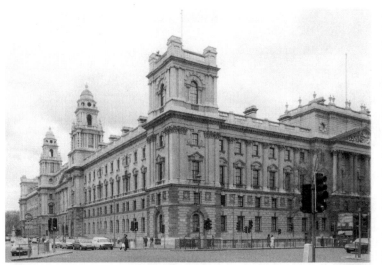

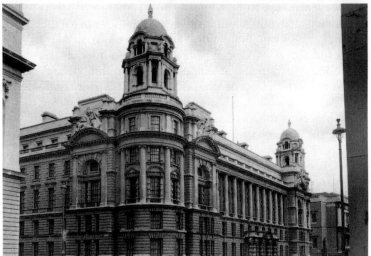

57 Public works executed under Akers-Douglas's 1898 Act providing long-term funding: a. (top) J.M. Brydon (1840–1901): public offices, Great George Street, 1900–15, executed by Sir Henry Tanner of the Office of Works. [Photo: M.H. Port]. b. (middle) W. Young (1843–1900): War Office, Whitehall, 1900–06, executed by C. Young and Sir John Taylor. [Photo: M.H. Port]. c. (bottom) Aston Webb (1849–1930): Victoria & Albert Museum, South Kensington. [*Architectural Review*].

brought to completion largely by Office of Works' architects, who also executed some lesser government buildings in the 1900s. This gave rise to complaints in the deprived architectural profession, supported by Liberal MPs who objected to an apparent official monopoly. These views found an object in the need for new offices for the London County Council (LCC). This more powerful and effective successor to the Metropolitan Board of Works, established in 1889, seemed at last to be looking to improve London's image: led by Shaw Lefevre in a new aedilic role, it undertook in 1899 a vast road improvement scheme between Holborn and the Strand, and in 1900 invited eight architects to submit elevations for the new half-moon at the Strand end. When the LCC contemplated building new offices on a prominent site on the South Bank of the Thames, almost opposite the Houses of Parliament, 'There was a strong external lobby for a competition, mainly among RIBA members, who tended to view public architects as mere incompetent technicians ... and ... undercutting independent architects' fees at the taxpayers' expense.'[104] The County Hall competition of 1907 was won by the sort of unknown talent traditionally supposed to be discovered by this procedure. It was however not until 1910 that a 'long and many-faceted revision' was completed, and a design approved by the County Council. Nevertheless, when it came to launching vast new offices for the Board of Trade, the LCC competition's apparent success and loud Commons' voices urging competition for public offices carried the day with Earl Beauchamp, then First Commissioner, against the recommendations of his own officials.[105] A two-tier competition was announced in September 1913, but when the final result was announced in 1915, the victor was a rifleman serving in France.

For the Great War had broken out. During the next three decades ministers and parliament alike had little concern with London's image.[106]

<div align="right">

M.H. Port
Queen Mary & Westfield College, University of London

</div>

Notes

I am deeply grateful to Victor Belcher for reading a draft of this chapter.
(Place of publication is London unless otherwise stated.)

1 *Fortnightly Review*, vol. 72, (1899), p. 523.

2 Sir J.H. Briggs (ed. Lady Briggs), *Naval Administrations 1827 to 1892: the experience of 65 years* (1897), p. 163. (Briggs was chief clerk of the Admiralty.) I am grateful to Professor Paul Smith for this reference.

3 See H. Roseveare, *The Treasury* (1969), pp. 199–202; H. Parris, *Constitutional Bureaucracy* (1969), pp. 253–5; M. Wright, *Treasury Control of the Civil Service 1854–1874* (Oxford, 1969), chap. 15 – somewhat contrary to the run of Dr Wright's conclusions, the Treasury did exercise control over the Office of Works.

4 N. Longmate, *King Cholera* (1966), pp. 95–6, 168ff.

5 *Parliamentary Papers* (hereafter PP) 1837–8 (661) XVI.

6 According to Disraeli, Lord Redesdale, *Memories* (1915), vol. 2, pp. 694–5.

7 *Survey of London*, XXXIX, *The Grosvenor Estate in Mayfair* (1977), pp. 48–66.

8 Cited, in K. Young and P.L. Garside, *Metropolitan London* (1982), p. 20.

9 Cited in P.J. Waller, *Town, City and Nation. England 1850–1914* (Oxford & New York, 1983), p. 58.

10 See D. Owen, *The Government of Victorian London 1855–1889* (Cambridge, Mass., and London, 1982), chaps 2 and 3.

11 Henry Thornton's expression, 1802, cited

D. Kynaston, *The City of London*, vol. 1 (1994), p. 9.

12 W.A. Robson, *The Government and Misgovernment of London* (1939), p. 156.

13 For the visit of the Sultan of Turkey in July 1867, a huge and gorgeously decorated reception hall costing £6,000 was built on to the Guildhall, and 3,000 persons were invited – *The Times*, 4 July, p. 9; 19 July, p. 9; 23 July, p. 11. The Viceroy of Egypt, too, received a Guildhall dinner at this period.

14 Disraeli in particular using the occasion adeptly, see W.F. Monypenny and G.E. Buckle, *Life of Benjamin Disraeli* (1929), vol. 2, pp. 691, 888, 965, 1064, 1262, 1373. Gladstone, who introduced speech–making all over the country, used the City only occasionally, perhaps because the 'relationship between the City and Gladstone had long been difficult' (Kynaston, *City*, op. cit. [note 11], vol. 1, p. 371). See J. Morley, *Life of William Ewart Gladstone* (1903), Chronology.

15 N. Gash, *Sir Robert Peel* (1972), p. 98.

16 I. Doolittle, *The Mercers' Company 1579–1959* (1994), p. 183.

17 J.F.B. Firth, *Reform of London Government and of the City Guilds* (1888), II. For reform of the City's parochial charities, see V. Belcher, *The City Parochial Foundation 1891–1991* (Aldershot, 1991), part 1.

18 Waller, op. cit. (note 9), p. 57. For City action affecting parliamentary proceedings, see *Saturday Review*, 31 March 1883, p. 391, cited in Young and Garside, op. cit. (note 8), p. 48 (see also 49–51); Firth, *Reform of London Government*, op. cit. (note 17), chap.1.

19 J. Summerson, *Life and Work of John Nash, Architect (1980)*, pp. 87–8. It was true that Parliament had only voted £600,000 of the total, and that there was an income offset of £173,354, but the aura of extravagance hung undispersably over the great street.

20 *5th Report of Commissioners of Woods & Forests*, 1826. The assured income of £15,000 p. a. was only a third of that Nash had promised them in 1811, A. Saunders, *Regent's Park* (Newton Abbot, 1971), p. 102.

21 Summerson, *Nash*, op. cit. (note 19), p. 182.

22 *The Times*, 6 January 1830.

23 M.H. Port (ed.), *Houses of Parliament* (New Haven & London, 1976), pp. 20–4.

24 See J.M. Crook and M.H. Port, *History of the King's Works, VI, 1782–1851* (1973), pp. 204–6, 209–10; 'Watchman', *Builder*, 26 January 1850, p. 39, referred to the constant 'begrudging on the part of the Legislature the sums needed' for erecting public works.

25 G. Tyack, *Sir James Pennethorne and the making of Victorian London* (Cambridge, 1992), p. 45.

26 *PP* 1836 (517) XX, 1837–8 (418) XVI, 1839 (136) XIII, 1840 (410) XII.

27 Cited, Tyack, op. cit. (note 25), p. 47.

28 *PP* 1837–38 (418) XVI, p. 5, cited in A. Saunders (ed.), *The Royal Exchange*, 1997, p. 281.

29 This provoked a row between the City and the Treasury, because the former feared that the Treasury might impose extravagant plans; see Saunders, ibid., pp. 280–2.

30 *PP* 1839 (136) XIII.

31 Tyack, op. cit. (note 25), p. 54.

32 'the strongest objection exists on the part of the House of Commons to give anything towards metropolitan improvements at the present moment' – John Locke, MP, *PP* 1861 (372) VIII, *Second report of s.c. on Metropolis Local Taxation*, q. 3587. Cf. *The Times*, 27 May 1856, leader: 'The English despise their city, and it returns their scowl.'

33 *PP* 1840 (410) XII. See Tyack, op. cit. (note 25), pp. 54–66.

34 See *Third Report of s.c. on Metropolitan Local Government*, *PP* 1867 (301) XII, q. 152; *Report of s.c. on the Artizans' Dwellings Act*, *PP* 1882 (235) VII, qq. 528, 529, 584.

35 Lord Elcho, leading a deputation to the prime minister, remarked that he 'knew the patience of the House of Commons had been worn out by the enormous expenditure' on the Houses of Parliament, *Builder*, 6 August 1859.

36 *Builder*, 2 Febuary 1850, p. 52; 26 October 1850, p. 505; 19 March 1853, p. 181. The appointment of a commission of five wise men had been recommended by a select committee as far back as 1828 – *PP* 1828 (446) IV. The loan idea, without the commission, was urged by Lord John Manners as First Commissioner, memo. on Public Offices, 9 April 1858, Derby MS 161/7 (formerly in the care of Lord Blake, The Queen's Coll., Oxford).

37 *The Times*, 27 May 1856.

38 W.H. White, *Architecture and Public Buildings* (1884), 165ff.; *PP* 1868–69 (387) X, *2nd Report of s.c. on Hungerford Bridge ... Viaduct*, q. 3448.

39 M.H. Port, *Imperial London* (New Haven and London, 1995), p. 62.

40 *PP* 1863 (483) IX, *Report of s.c. on Miscellaneous Expenditure*, iv, qq. 1365–6. The existing duties of the First Commissioner should be executed by another minister in the Commons.

41 J. Vincent (ed.), *Disraeli, Derby and the Conservative Party. Journals and Memoirs of Edward Henry, Lord Stanley, 1849–1869* (Hassocks, 1978), p. 199.

42 See H. Parris, *Constitutional Bureaucracy* (1969), p. 90.

43 *3rd series, Parliamentary Debates* (hereafter *3PD*), 160, 1360 (16 August 1860).

44 H.C.G. Matthew, 'Disraeli, Gladstone and the Politics of mid-Victorian Budgets', *Historical Journal* 1979, pp. 615 ff., esp. 632–3, 637.

45 *3PD*, *165*, 1781–2 (18 March 1862).

46 *3PD*, *166*, 1040–48 (29 April 1862). When he died, Baillie Cochrane was described as 'one of the few men in either House of Parliament who had real interest in ... architecture, more especially in regard to ... public improvements in London', *Builder*, 22 February 1890, p. 130.

47 See n. 37, above.

48 *3PD 166*, 1047–8.

49 ibid., 1060.

50 ibid., 1064.

51 *Fraser's Magazine*, vol. 69 (February 1864), p. 182.

52 1802–67. Welsh landowner, Liberal MP 1831–59 (representing St Marylebone from 1837); created bart. 1838, Baron Llanover 1859. President Board of Health 1854–5, First Commissioner of Works 1855–8.

53 See D. Owen, *Government of Victorian London*, op. cit (note 10), p. 31–8.

54 Port, *Imperial London*, op. cit. (note 39), chaps 13–15.

55 *PP* 1856 (368) XIV, *Report of s.c. on Public Offices*. Hall himself was chairman, and members included Edward Cardwell (who as President of the Board of Trade 1852–5 knew about the inadequacy of public offices), R.S. Holford, who built the grandest private house in London, Dorchester House, the great connoisseur William Stirling (later Stirling–Maxwell), and Disraeli and his friend Lord John Manners – both known to be sympathetic to new offices, and as Opposition front-benchers, the indicators of opinion to the five Conservative back-benchers on the committee of 15 members. The only witnesses were H.A. Hunt, Hall's nominee as Surveyor to the Office of Works, and Sir Charles Trevelyan, permanent secretary of the Treasury, co-author of the 1854 report on the Civil Service, which had set out the economical case for building new public offices.

56 1818–1906. Active in Cambridge Camden Soc.; Grand Tour 1839–40; Conservative MP 1841–7 (member of 'Young England' and figured in Disraeli's *Coningsby*), 1850–88; succeeded brother as Duke of Rutland 1888. First Commissioner of Works 1852, 1858–9, 1866–8.

57 Memo. of 9 April 1858, Derby Papers 161/7.

58 1820–87. Youngest son of Thomas Hope, collector and writer on architecture. Conservative MP 1841–52, 1857–9, 1865–d. A patron of the Gothic Revival; co-proprietor, *Saturday Review* from 1855; President RIBA 1865–8.

59 [A.J.B. Beresford Hope], 'Shall we save London', *Saturday Review*, 4 October 1856, p. 500; A.J.B. Beresford Hope, *Public Offices and Metropolitan Improvements* (1857), pp. 4–5.

60 *PP* 1857–8 (417) xi, *Report of s.c. on Foreign Office Reconstruction*. This committee, chaired by Hope, included Sir B. Hall, Lord John Manners, Lord Elcho, William Stirling, and the architect of the Royal Exchange, William Tite. Hall, as Liberal front-bencher, would have set the tone for his party colleagues.

61 See Port, *Imperial London*, op. cit. (note 39), chap. 13.

62 For the Coventry Street–Long Acre improvement, the ground had cost £119,000 an acre.

63 *3PD*, *171*, 903–6 (15 June 1863).

64 See *Survey of London XXXVIII (1975), The Museums Area of South Kensington and Westminster, passim*.

65 ibid.

66 1811–88. 2nd son of 5th Earl Cowper and his wife Emily (sister of Lord Melbourne, and mistress and later wife of Lord Palmerston, who made William Cowper his heir; he then took additional name of Temple). Liberal MP 1835–80; President Board of Health 1855–8; First Commissioner 1860–66. Created Baron Mount-Temple 1880.

67 See Port, *Imperial London*, op. cit. (note 39), p. 175. So delicate was the Law Courts matter that all planning was handed over to a commission appointed by Act, thereby entailing much confusion.

68 P. Guedalla (ed.), *The Palmerston Papers: Gladstone and Palmerston ... correspondence ... 1851–1865* (1928), no. 137, Gladstone to Palmerston, 19 July 1861. See D.B. Brownlee, *The Law Courts. The Architecture of George Edmund Street* (Cambridge, Mass., and London, 1984), pp. 70–6.

69 Port, *Imperial London*, op. cit. (note 39), pp. 90–2.

70 *PP* 1867–8 (281) LVIII, [Treasury] *Commission to inquire into ... the Accommodation of Public Departments*.

71 Derby Papers 161/8, 3 September 1867.

72 1817–94. Liberal MP 1852–7, 1860–9; under-secretary, Foreign Affairs, 1853, 1861–6; First Commissioner December 1868–October 1869; diplomatist 1869–80. GCB 1878. Excavated Nimrud (believed to be Nineveh) and published account; collector and writer on pictorial art.

73 British Library (henceforth BL), Add. MS 38949, ff. 7–9, and 25–8, Layard to William Gregory, 20 August 1868 and 5 March 1870. See also Layard's remarks to the RIBA, November 1868, RIBA *Sessional Papers*, 1868–69, pp. 11–12.

74 *PP* 1868–9 (200) and (387), X, *First and Second Reports of s.c. ... on Hungerford Bridge ... Viaduct*.

75 Who himself had in 1849 published *Observations on the British Museum, National Gallery, and National Record Office, with suggestions for their improvement* – in fact, for a comprehensive re-organization and new building.

76 BL, Add MS 38949, f. 28, 6 April 1870.
77 *3PD*, 197, 1431–45, 8 July 1869. See M.H. Port, 'A Contrast in Styles at the Office of Works', *Historical Journal*, 27 (1984), p. 160. Layard was also unjustly accused of having a financial interest in the mosaic commission.
78 See Port, *Imperial London*, op. cit. (note 39), p. 66.
79 BL, Add. MS 44421, ff. 9–14, Layard to Gladstone, 3 June 1869.
80 Port, *Imperial London*, op. cit. (note 39), p. 27.
81 PP 1877 ((312) XV, *Report of s.c. on ... Public Offices and Buildings (Metropolis)*.
82 PRO, T.1/7632B/18736, no.11736, 8 November 1877.
83 G. Shaw Lefevre, 'Public Works in London', *Nineteenth Century*, 1882, pp. 667–86.
84 G. Shaw Lefevre, 'Public Buildings in London', *Nineteenth Century*, 1888, p. 718.
85 PP 1884–5 (166) XIII, *Report of s.c. on Westminster Hall Restoration*. See Port, *Imperial London*, op. cit. (note ??), 237–9, and C. Miele, 'The Battle for Westminster Hall', *Architectural History*, 41 (1998), pp. 220–44.
86 G. Shaw Lefevre, *Nineteenth Century*, 1888, p. 708.
87 See PRO Work 14/1/15.
88 PP 1890–91 [C.6228, C.6398], *First and Final Reports ... into the present Want of Space for Monuments in Westminster Abbey*. See F. Barker and R. Hyde, *London as it might have been* (1982), pp. 150–3.
89 G. Shaw Lefevre, *Nineteenth Century*, op. cit. (note 84), p. 710.
90 PP 1882 (253) XII, *Report of s.c. on Public Offices Site Bill*; 1887 (184) VII, *Report of s.c. on the Admiralty and War Office (Sites)*; BL, Add. MS 44153, ff. 226–7, Lefevre to Gladstone, 20 May 1886.
91 Quoted, H.H. Statham, 'The Proposed New Government Offices', *Fortnightly Review*, 66 (1896), p. 884.
92 D. Brooks, *The Destruction of Lord Rosebery* (1987), p. 262.
93 'Mr Shaw-Lefevre as an Aedile', *Murray's Magazine*, vol. 5, (1889), pp. 82–4.
94 ibid., pp. 68–84.
95 'How our Public Improvements are carried out', *Fortnightly Review*, 38 (1882), p. 816.
96 'The Proposed New Government Offices', *Fortnightly Review*, 66 (1896), p. 893.
97 H.H. Statham, 'London as a Jubilee City', *National Review*, 29 (1897), pp. 594–603.
98 1851–1926. Conservative MP 1880–1911; Treasury secretary 1885–6, 1886–92; Opposition chief whip 1892–5; First Commissioner 1895–1902; Home Secretary 1902–05. Created Viscount Chilston 1911.
99 See Port, *Imperial London*, op. cit. (note 39), pp. 158–60.
100 A. Saint, *Richard Norman Shaw* (New Haven and London, 1976), p. 374. See also H. Hobhouse, *A History of Regent Street* (1975), chap. 4.
101 Saint, *Shaw*, ibid., p. 386.
102 See H. Hobhouse, *Regent Street*, op. cit. (note 100), pp. 122–6.
103 ibid., p. 135.
104 *Survey of London*, monograph 17, *County Hall* (1991), p. 17.
105 See Port, *Imperial London*, op. cit. (note 39), p. 194.
106 See *5PD* 435, 1603 ff., 28 March 1947; PP 1946–7 (100) IX, 245–327, *Report of s.c. on Public Offices (Sites) Bill*.

Rebuilding 'The Heart of the Empire': bank headquarters in the City of London, 1919–1939

Iain S. Black

The Bank, then, is no ordinary cross-roads; it is the hub of Empire. That Empire is not primarily one of the sword ... it is the greatest Empire of Commerce the world has ever seen. (A. Valance, *The Centre of the World*, 1935)

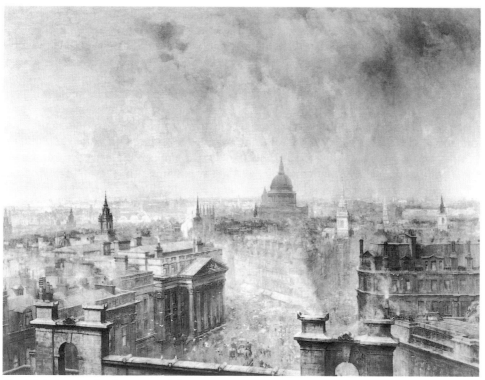

58 Niels M. Lund, *The Heart of the Empire*, 1904. By kind permission of the Guildhall Art Gallery.

Between 1919 and 1939 the landscape of the City of London's central financial district underwent a sustained transformation, as the Bank of England and other major banking institutions rebuilt their headquarters in the heart of the City.

Surprisingly, given the immense historical importance of the City in English cultural identity and economic life, this transformation of its built environment has received remarkably little attention. By contrast, the City of London has long held a prominent place in accounts of the political economy of the British Empire. In *Industry and Empire*, a classic study of the dialectic between British industrialization and imperial expansion, Eric Hobsbawm pointed explicitly to the intricate web of interconnections established between the City, the empire and the wider world in the nineteenth and twentieth centuries.[1] In similar vein, studies in financial history, such as de Cecco's *Money and Empire*, have also drawn attention to the ways in which Britain's imperial power translated into a global financial hegemony centred on the City.[2] More recently Cain and Hopkins, in their wide-ranging two-volume historiography entitled *British Imperialism*, draw upon their earlier work on gentlemanly capitalism and empire to give the City a central place in their examination of the British imperial experience.[3] Yet despite this continuing critique of the City's political-economic role in empire, we still know remarkably little about how its landscape was shaped by its place in the wider imperial project. Unsurprisingly perhaps, the City most often depicted in these economic and financial histories is an abstract space of flows: as a clearing house for the world economy and pivot for the global circulation of sterling. Yet the City was also a built environment – a distinctive landscape – of great complexity.

The starting point for several recent accounts of the City as an imperial landscape is Niels Lund's 1904 painting *The Heart of the Empire* (plate 58). The painting is now well known, largely because of the series of architectural controversies surrounding the redevelopment of Bank Junction in the 1980s.[4] For this paper, however, its interest lies more in its portrait of a decidedly nineteenth-century world. Within thirty-five years the landscape in the foreground of the painting, centred on the public space between the Bank of England, the Royal Exchange and the Mansion House, was rapidly transformed as the City's major banks rebuilt their headquarters on a scale and in a style which challenged the predominantly Victorian townscape captured by Lund. This paper presents a detailed reading of this rebuilding of 'The Heart of the Empire' between 1919 and 1939, comprising three main sections: firstly, it examines the formative role of Lund's painting in several recent accounts in cultural geography which discuss the City as an imperial and post-imperial landscape, paying close attention to the consequences of its adoption as the paradigmatic representation of the City of empire; secondly, the changing City/ empire nexus is explored between the later nineteenth-century and the interwar years, indicating how the political-economic context for the production and reproduction of the City's landscape was itself temporally unstable; thirdly, it presents a series of deep descriptive analyses of the key rebuilding projects completed at the heart of empire between the wars, emphasizing their production within a distinctive late-imperial discourse of finance and empire.

Lund and *The Heart of the Empire*

In *The Heart of the Empire* Lund articulates a vision of the City as a key site of Britain's imperial power in the later nineteenth century (plate 58). Looking down

from a viewpoint on the Royal Exchange, the painting captures a scene of concentrated activity, framed by the monumental architecture of the Mansion House, the Bank of England and, in the middle distance, the dome of St Paul's Cathedral. This is a landscape of power, the monumental buildings signifying the City's historic role as a world centre of finance and trade. The view then stretches away to the horizon suggesting the vastness of the imperial metropolis, and contrasting the teeming activity of the centre with the diffuse networks of commerce and exchange which made that power possible. Lund's vision of the imperial City also links past and present, populating an historic built environment shaped by the rebuilding of London after the Great Fire and remodelled in incremental fashion over the eighteenth and nineteenth centuries, with the dynamism of trade and commerce at the dawn of the twentieth century. This is very much a vision *from* the heart of empire too: purchased for Lord Mayor Sir William Treloar and later donated to the Corporation of London, the painting was locked into an inner circle where City authority and its representation seamlessly merged.[5]

Lund's painting resurfaced in the 1980s as a rallying point for conservationist interests in the protracted battle over the redevelopment of Bank Junction.[6] The triangular group of Victorian commercial buildings in the centre of the picture, providing a visual link between St Paul's and the commercial heart of the City, had been under threat since the early 1960s. Such redevelopment proposals intensified in the 1980s with two major public inquiries, one centred on a modernist tower proposed by Mies van der Rohe; the other concerning a postmodernist scheme by James Stirling.[7] In opposing the incursion of modern or postmodern styles into the City's historic core, *The Heart of the Empire* was used by conservationists as a medium through which to argue for the preservation of a special landscape redolent of the City's historic centrality within its former empire. Ironically, as Jacobs has shown, Lund's vision also became a central point of reference for the developer, Lord Palumbo, who 'was driven by his desire to see a quality building of its time at the heart of a City which he, as much as his opponents, viewed as central to the memory of the grand and sure days of the City of empire.'[8] In similar fashion, Lund's vision has proved remarkably formative in shaping much recent critical writing on the City as an imperial and post-imperial landscape. In what follows, I want to draw attention to three recent essays in cultural geography which, in varying degrees, turn on the imperial vision articulated by Lund.[9]

In the first chapter of *Fields of Vision*, Stephen Daniels explores the changing role of St Paul's Cathedral in visions of the City, nation and empire, locating the cathedral at a number of key moments between the seventeenth and the late twentieth centuries.[10] *The Heart of the Empire* symbolizes one such key moment, representing the characteristic image of the City's imperial centrality and picturing the symbolic exchange between God and Mammon centred on St Paul's. In contrast to the classical Georgian vision of the City represented by Canaletto, Lund captures 'the more gothic, dynamic image of the Victorian city, smoking with power'; a power, furthermore, seen as the 'natural' outcome of British supremacy in the political economy of imperial expansion.'[11] Indeed, according to Daniels, the very title of Lund's painting 'alludes to contemporary geo-political

theories of imperial destiny', situating London as 'the "heart" of the imperial organism'.[12] Yet discussion of the relationships between the City and the empire is closely focused on the period between 1870 and 1914, which saw the 'ascendancy of London as a self-consciously financial, imperial and regal capital'.[13] Within this context *The Heart of the Empire* is peculiarly formative in framing a vision of the imperial City, one both rooted in and reflective of the nineteenth-century liberal world economy. This characterization of the City/empire nexus at the *fin de siècle* is deepened by Daniels's seeming identification of the end of empire – or, at least, the end of its register in the metropolis – with World War I. Indeed, the extensive rebuilding of Bank Junction in the interwar years, a rebuilding indelibly marked by a powerful late-imperial context, finds no place in Daniels's essay as he moves swiftly in but a single paragraph from the high imperialism of late Victorian and Edwardian London to the aftermath of World War II.[14]

The space of Bank Junction as the heart of empire also receives close attention in Jane Jacobs's recent book *Edge of Empire*, as part of a wider argument on the 'encounter between the space of the contemporary city and recent theorisations of colonialism and post-colonialism'.[15] In the context of the City of London, the recent planning disputes over the redevelopment of Bank Junction provide 'a means of exploring the circulation of imperial sensibilities in this more uncertain post-imperial present'.[16] Lund's depiction of an energized space of imperial power in *The Heart of the Empire* plays a key role in her account, indicating that 'then, as now, the intersection was a symbolic site of a Britain made great by its global reach' and is central to establishing the claim that this very site today is 'an imperial space in a post-imperial age'.[17] Lund's painting was of vital importance in organizing the conservationist interest against proposed redevelopment, by visualizing the 'memory of a time when the City of London felt secure as the centre of a global empire'.[18] However, though Jacobs clearly demonstrates the importance of *The Heart of the Empire* as a conservationist icon shaping contemporary planning discourse, her uncritical attachment to the nineteenth-century vision of the imperial City articulated by Lund obscures the important late-imperial reconstruction of Bank Junction in the three decades after Lund's painting. In consequence, the elision of the late nineteenth and late twentieth centuries achieved by Jacobs's reading of Lund, weakens her attempt to tackle the City as 'an imperial space in a post-imperial age'. Furthermore, the conservationists' emphasis upon townscape discussed by Jacobs, framed in part by the seeming unity imparted to the 'heart of empire' by Lund, also obscures the important ways in which particular buildings and institutions *within* that townscape have specific stories to tell of the complex relations between City and empire. Thus, while Jacobs raises fundamental questions about the role of empire in the constitution and identity of the City, both past and present, her commitment to a particular nineteenth-century vision of British imperialism at the heart of empire provides only a partial reading of the site.

Finally, a recent paper by Felix Driver and David Gilbert entitled 'Heart of Empire?', also raises important issues concerning the interpretation of the City as an imperial landscape.[19] In a wide-ranging and perceptive account, they contextualize the difficulties of reading the imperial city by seeking to explore 'the ways in which the global processes of imperialism were absorbed and re-

presented in the urban context'.[20] This emphasis on the urban is significant, uniting themes of the city and the empire often treated separately. Indeed, despite significant insights into the imperial experience afforded by recent post-colonial literature, a fundamental problem remains in that it 'has yet to explore the diverse relationships between imperial culture and the production, consumption, and representation of urban space.'[21] Driver and Gilbert argue further that post-colonial theories run the risk of generalizing the diverse historico-geographical experience of different imperial cultures, suggesting that 'any account of the culture of imperial urbanism must therefore pay due attention to the particularities of time and place.'[22] This can be extended from the macro-scale of different imperial systems to a recognition that imperial cities themselves may have many different 'centres of empire' which can be interpreted in very different ways. Although the general themes developed in the paper are extremely helpful in rethinking the complex and differentiated nature of imperial London, some considerable difficulties of interpretation nonetheless remain. In particular, there are substantial problems with their characterization of the City as a central site of empire 'where a different kind of imperial power made its mark on the landscape'.[23] Pointing to the fact that though much is now known about the economics of the City's role in the empire, they claim that 'we know rather less about the empire's role in shaping the landscape, architecture, and use of the City as a space.'[24] Whilst the latter may be true, accounts of the economic and financial roles of the City within the empire scarcely constitute a unitary discourse, and Driver and Gilbert risk seriously underestimating the range of competing views on the City as the financial heart of empire. This is significant, because the historical dynamic of the City/empire nexus is important in interpreting the changing nature of the City's landscape at different moments in the trajectory of British imperialism.

The Heart of the Empire is central to their account of the City as an imperial landscape, providing 'a liberal and characteristically British vision of the imperial capital as the centre of world trade and exchange'.[25] The City as a site of empire is thus clearly rooted in a later nineteenth-century landscape, where 'a few of the new offices were in a neoclassical style, but others made reference not to imperial Rome but to the trading empire of Renaissance Venice.'[26] This judgement seriously underplays the comprehensive rebuilding of the City's central financial district between the 1830s and the 1880s, which though scarcely reflecting the formal British imperial project, was nonetheless widely influenced by Roman imperial precedent.[27] Further difficulties are raised by the claim that although 'the influence of the imperial project on the design and ornamentation of the City's buildings was perhaps muted and ambiguous, the City was also a key central space in which imperial ceremony and performance took place.'[28] The latter point is well made, and Driver and Gilbert draw our attention to the variety of important ways in which the City became energized through ceremonial processions, royal celebrations and spontaneous displays of patriotic fervour. Yet the exclusive identification of the imperial City with the vision framed by Lund obscures the rebuilding of Bank Junction in the interwar years, a rebuilding that explicitly articulated a late-imperial vision of finance and empire embedded within the City's built environment.

City and Empire

In the readings of the City as an imperial landscape discussed above, the precise nature of the economic and financial links between the City and the empire are rarely, if ever, considered. Yet such links are of vital consequence in developing an interpretation of the City's landscape. There are dangers, too, in accepting uncritically the implicit link between City and empire conventionally read into Lund's painting *The Heart of the Empire*. Porter, in an important paper on London and the British Empire between 1815 and 1914, characterizes the conventional wisdom of those years as 'the age of the Pax Britannica, Britain's imperial century ... London's century as a city of finance, [and] principal motor of a global economy'.[29] Yet, he argues, recent work has begun to redefine this conventional view. The financial network linking the City and the empire was only slowly assembled, in piecemeal fashion, during the nineteenth century, where 'London's unchallenged role at the heart of even an imperial financial system was both less assured and more short-lived than is often implied by the hyperbole of British global dominance.'[30] Over the nineteenth century there was a continuing divergence between Britain's formal empire and the wider economic space of the emerging world economy where, in a variety of informal ways, the City began to assert its dominance after 1870. Ingham suggests that Britain's commitment to free trade and a liberal market ideology, combined with the pursuit of peace under the Pax Britannica and the maintenance of the stability of the pound sterling as the world's currency, were all of greater long-term significance than empire to the City's rise to international dominance in the nineteenth century.[31] This is not to suggest that imperial finance and trade had no role in shaping the fortunes of the nineteenth-century City, of course, but to warn against reducing explanations of the City's dominance of world finance and commerce to a purely imperial discourse.

World War I shattered the liberal world economy upon which much of the City's nineteenth-century dominance had been based.[32] The war devastated international trade and recovery was slow and incomplete throughout the 1920s, when British policy aimed, without much success, to re-establish the pre-1913 world economic order. By contrast, Cain and Hopkins highlight the increasing importance of empire trade to Britain in the interwar years.[33] Following the Wall Street Crash of 1929 and the ensuing world depression, Britain created an imperial preference system for intra-imperial trade, centred particularly upon the white colonies. This retreat into protectionism initially struck at the heart of the City's traditional cosmopolitanism, where the principles of free trade and sound money had always worked to ensure its continuing success. But the world had changed. Cain and Hopkins note how in the 1920s 'most United States business was permanently lost [and] confidence in London was never quite the same again.'[34] Competition from New York, and later Paris, as rival international financial centres began for the first time to be keenly felt. Britain's determination in 1925 to return to the gold standard at the pre-war parity was seen as vital to London's postwar rehabilitation as the world's financial centre. However, despite strenuous efforts, the strain on sterling could not hold and in September 1931 the gold standard was abandoned, proving 'a defeat for the City, for gentlemanly

capitalism and for cosmopolitanism'.[35] With the dream of a return to the pre-1913 world economy in tatters, the City retreated into empire, where the development of the Sterling Area 'offered the City of London an international standing and influence which must have seemed unattainable in the desperate days of 1931.'[36]

The Sterling Area comprised a wide range of countries that conducted most of their trade in sterling, fixed their currencies against the pound and held sterling reserves, often in London, as so-called 'sterling balances'. Though many non-empire countries, including some smaller European states, were included, the core of the Sterling Area was the British Empire. Its creation was undoubtedly a piece of crisis management following the breakdown of the gold standard in 1931, but it allowed the City to maintain an impressive degree of world financial power. Indeed, Cain and Hopkins argue that 'although Britain suffered in the world slump that began in 1929, she was far less affected than her rivals, including the United States, whose global economic influence shrank rapidly. Indeed, it is important to remember that Britain was the only truly world power of consequence in the 1930s.'[37] Financial relations between the City and the empire reached new levels of importance as the Bank of England unceasingly pursued central bank co-operation with the Dominions, reinforcing 'export-oriented, London-facing trading and financial interests in the Dominions and other satellites', creating 'a latter-day expression of financial imperialism [through] the maintenance and extension of London's influence and control'.[38]

The City captured in Lund's *The Heart of the Empire* had a more ambiguous and uncertain relationship with the formal British Empire than is perhaps commonly thought. While empire clearly provided an important context for the reproduction of the City's commercial and financial power, it was only one such context and not necessarily always the most important. In the interwar years, by contrast, the links between the City and the empire became progressively stronger as the collapse of the liberal world economy forced the City to look elsewhere for its survival. As Ingham has argued, 'given the world depression, the City retreated into the security of the Empire in which it found a ready-made banking network in which the use of sterling had a political basis.'[39] The Sterling Area, which arose out of the sterling crisis of 1931, provided this vital late-imperial context for the reproduction of the City as an international financial centre. This late-imperial context was given concrete expression in the built environment too during the rebuilding of the City's central financial district in the interwar years.

Rebuilding 'The Heart of the Empire'

Between 1919 and 1939 four of the 'Big Six' British clearing banks, namely Lloyds Bank, the Midland Bank, the National Provincial Bank and the Westminster Bank, together with the Bank of England, rebuilt their principal offices in the heart of the City. Aside from the Bank of England, the country's central bank, the underlying reason for this generalized rebuilding was the great expansion in size of the leading British clearing banks, following several decades of intensive merger and acquisition activity. With their newly extended branch networks and increased concentration of capital and business, a greatly expanded head-office

staff was required to run these immensely powerful examples of new corporate capital. Collectively, these new head office buildings erected in the interwar years transformed the nineteenth-century landscape captured in Lund's celebrated painting *The Heart of the Empire* (see plate 58). The scale and extent of this building activity captured the attention of critics in the popular and specialist press alike. Writing in the *Banker* in 1929, C.H. Reilly, Professor of Architecture at the University of Liverpool and a leading critic of bank architecture in the 1920s and 1930s, remarked how 'it is a fine antidote to the depression of closed factories and mills in the North of England to visit the heart of the City and to see on all hands great buildings rising phoenix-like above their lesser neighbours. It is an extraordinary moment really in the architectural history of English banking.'[40] A correspondent in the *Evening News* claimed how 'truly the face of London changes. You can see the drastic process at the Mansion House centre ... all this activity of reconstruction and expansion, you perceive, is for the great business of banking [but] what would happen to the banks and their new monster headquarters in the City if we went back to the old plan of hiding our savings in the mattress?'[41]

By the early 1930s the general impact of what the *Evening News* correspondent called the 'Battle of the Bankers' Palaces' was becoming clear.[42] Despite the fact that each rebuilding project was an individual undertaking, thought out and executed without any necessary relation to the whole and without any official plan imposing some overall coherence, the resulting landscape possessed considerable unity of purpose and expression. The London Building Act, which limited each façade to a height of eighty feet, with a further two storeys set back, clearly played a part in this by promoting a certain harmony in scale. The architects too were clearly sensitive to context in designing with reference to their immediate surroundings, if only to overcome the vexed problem of ancient rights to light which set further limits on each scheme. But was there something deeper at work that, perhaps less formally, encouraged the architects involved towards a more generalized set of aesthetic responses to their individual design problems? Professor A.E. Richardson, writing in 1932 on 'the financial palaces of modern London', clearly thought so:

> London reflects its ancient splendours in its newer architecture, as if
> reluctant to forget. Herein is the explanation of design tradition which
> from the building of the first Bank of England down to the present day
> has determined what architects call 'Bank character'. The greatness of the
> Empire, the ramifications of finance, the resources of commerce, severally
> and collectively, provide the impulses which really decide the grandiose
> style for modern London.[43]

Here Richardson suggests important ways to approach the City as an imperial landscape. In contrast to the formally planned spaces of royal and political power in Westminster, remodelled in the later nineteenth century to reflect a self-conscious image of British imperial supremacy, the City lacked such clearly articulated geometries of power.[44] Yet the rebuilding of the heart of the City in the interwar years was explicitly constituted within a late-imperial discourse of

finance and empire, where the influence of the wider imperial project, though less palpable, was nonetheless present. The pound sterling, in its capacity to circulate widely throughout the world and integrate diverse cultural and economic spaces under a common British monetary authority, was the imperial currency *par excellence*.[45] This was an empire of money that went far beyond the confines of the formal British empire, of course, and as sites for the production and circulation of money and credit, the new bank headquarters drew upon the classical language of architecture, notably that of imperial Rome, to claim legitimacy and authority for their banking activities. Alongside such echoes of a glorious imperial past, more proximate links between the City and the empire were evident, as some of Britain's leading imperial architects became involved in the design of these new bank headquarters. Herbert Baker and Edwin Lutyens, for example, were active in imperial Delhi at the same time as working on key architectural projects in the heart of the City, to which they brought not only their direct experience of working in these different arenas, but also a wider vision of Britain's imperial role.[46] As Stoler and Cooper have noted, recognition of 'the circuits of ideas and people, colonizers and colonized, within and among empires' is crucial to capturing much of the dynamics of imperial experience that is lost in the fixed categories and more stable imaginings of a dominant metropolitan–colonial axis.[47] To recover the particular imperial contexts surrounding the rebuilding of the heart of empire, a detailed look at the key architectural projects is needed.

Lloyds Bank rebuilt their headquarters between 1926 and 1931, on a fine site close to the Bank of England, Royal Exchange and Mansion House with frontages to both Cornhill and Lombard Street. By securing the freeholds of a series of properties between Change Alley and the blocks immediately west of Pope's Head Alley, a coherent and relatively uniform site was gained (see plate 59). Following a limited competition, Sir John Burnett & Partners, together with Campbell Jones, Sons & Smithers, were chosen jointly to design the building.[48] Booker notes how 'the problem for Lloyds was that the frontage which carried the address was in prestigious but very narrow Lombard Street, while the one in less fashionable Cornhill was by far the more visible.'[49] The solution adopted a strong classical design in which the two frontages, though generally similar in scale and disposition, carried decoration reflecting the differing character of their respective streets: the façade to Cornhill, facing towards the Royal Exchange, possessed round fluted columns (plate 60), whilst that to Lombard Street was given pilasters, reflecting its narrower, more domestic quality. Reilly, in several critical commentaries upon the new building repeatedly drew attention to its imposing and dignified appearance. Despite the 'galaxy of authors', he argued, the architects have produced 'an entirely unified scheme … the same monumental feeling and character pervade the whole. The great scale is maintained. The palace or temple character … prevails at any rate wherever the public sees the building.'[50] The local character of Bank Junction strongly influenced the achieved design. Burnett had recently been responsible for a more explicitly modern commercial architecture in his designs for Adelaide House in the City and Vigo House in Regent Street. For the Lloyds headquarters he drew upon his earlier design for the north front of the British Museum, perhaps suggested, according to

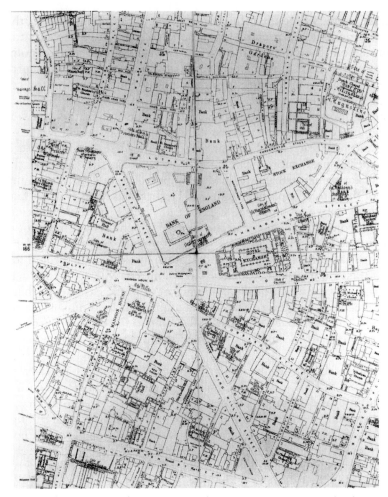

59 Bank Junction in the 1930s. O.S. Sheet VII. 66, 1937–38. By kind
permission of the Guildhall Library, Corporation of London.

Reilly, 'by the Roman columnar buildings in the immediate neighbourhood, such
as the Exchange and the Mansion House'.[51] The Cornhill front was particularly
impressive, appearing much larger than its immediate neighbours, though in fact
of the same height due to the regulations of the London Building Act. Booker
remarks how it 'stood up well against the Royal Exchange, across the street, and
controlled the Cornhill perspective from the Bank intersection.'[52] The presence of
the building gained much from the fine adjustment of its parts, with the inset
columns starting high above the ground and running through three storeys in the
centre of the front. The air of proud disdain and/monumental aloofness conveyed
by these façades led Reilly to judge them 'notable additions to the architecture of
the City [both] masculine and unaffected'.[53]

 The temple-like character of the banking hall was no less impressive (plate
61). Contemporary American models clearly influenced the architects here and

the emphasis on monumental public space contrasted sharply with the heavily populated bank interiors more typical of the City.[54] The marble Ionic columns marking the interface between public and private space within the banking hall, underlined the Graeco-Roman decorative scheme preferred by the bank's directors. The Lloyds site, possessing a greater uniformity than was usual in the City, contributed much to the success of the scheme, overcoming the irregularity of plan that was 'the chief difficulty our bank architects have in making monumental piles to vie with those of New York'.[55] Here Reilly underlines how the ever-present threat of competition with New York could take an architectural as well as financial form. The dominant architectural discourse here emphasized the themes of solidity, stability and security that had long been traditional elements of bank building: monumental classical design to impress the depositing public.[56] Stylistic innovation was grounded in learning from the American experience

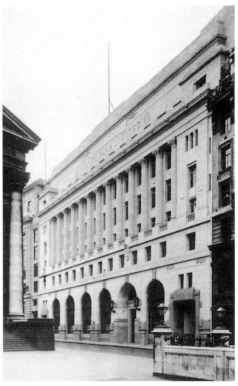

60 Lloyds Bank, Lombard Street. The Cornhill façade and the Royal Exchange in the 1930s. Lloyds Bank Collection. Reproduced courtesy of Lloyds Bank plc.

rather than any particular imperial vision. Nonetheless, the new headquarters took its place within the heart of empire. The context was important. The architects' response to the monumental architecture of Bank Junction, both past and present, gave a unity to the great rebuilding of the central City of which this new bank was a part. In its design and ornamentation this was truly a bank on an imperial scale, reflecting in its architectural form its place within the wider empire of money itself.

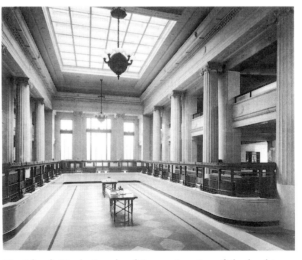

61 Lloyds Bank, Lombard Street. Interior of the banking hall in the 1930s. Lloyds Bank Collection. Reproduced courtesy of Lloyds Bank plc.

137

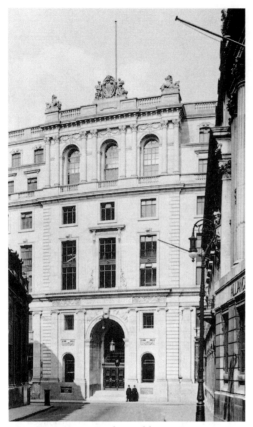

62 Westminster Bank, Lothbury. Entrance block seen from Bartholomew Lane in the 1930s. Natwest Group Collection. Reproduced courtesy of Natwest Group plc.

The new Lloyds headquarters can usefully be compared with the rebuilding of the Westminster Bank head office, where a more explicit articulation of imperial classical style was evident. From the later 1830s, the Westminster Bank had occupied premises designed by the celebrated C.R. Cockerell on a prime site in Lothbury, just opposite the north-east corner of the Bank of England.[57] By the early 1920s, though, the building was deemed too small for modern requirements and the bank began an extended rebuilding programme lasting until 1932. The existing site was expanded eastwards along Lothbury to Angel Court and west to Tokenhouse Yard (see plate 59). Following a limited competition Arthur Davis, of the well-known architectural firm of Mewès and Davis, was selected to design the bank's new headquarters. Davis had trained at the Ecole des Beaux-Arts in Paris and was much influenced by European architectural tradition.[58]

Between 1901 and 1906 he worked with his French partner Charles Mewès on two outstanding London hotels, the Carlton and the Ritz, before beginning his first major commercial work, the Morning Post Building in the Strand. Prior to World War I, Davis built a series of European branches for the Westminster Bank, before returning to England to design the Cunard Building on the Liverpool waterfront just before war broke out. Apart from the Westminster's Lothbury headquarters, Davis was very active elsewhere in the City in the 1920s, building two further branches for the bank in Threadneedle Street and Old Broad Street, and renovating 23 Great Winchester Street for Morgan Grenfell. In the later 1920s he built 52–68 Bishopsgate for the Hudson Bay Company, before 'his last commercial building ... Cunard's London headquarters at 88 Leadenhall Street, completed in 1932'.[59]

Plate 62 shows a view of the Lothbury façade shortly after the new bank was completed. Davis selected an Italianate High Renaissance theme, the main feature of which was the central pavilion facing down Bartholomew Lane. By placing the main entrance asymmetrically in this way, with an open street opposite, Davis was able to go up without the customary setback at that point, untroubled by any claims to ancient lights. Rising boldly, with a fine triumphal arch composition

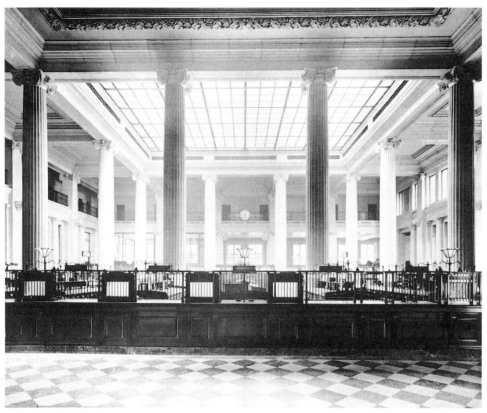

63 Westminster Bank, Lothbury. Interior of the banking hall in the 1930s. Natwest Group Collection. Reproduced courtesy of Natwest Group plc.

against the sky, the entrance block gave the bank an imposing air fully in keeping with its place at the heart of empire. *The Financial Times* drew attention to the use of symbolic sculpture atop the entrance block, where 'an escutcheon bearing the arms of the bank is surmounted by a mural crown and supported by the figures of Mercury and Ceres, representing Commerce and Agriculture, while on either wing are marine horses, suggesting overseas trade.'[60] However, though the asymmetrical treatment of the entrance was the key to the success of the whole scheme, it was the great entrance doorway that captured the imagination. Reilly, writing in the *Banker* in 1931, noted how:

> [this] great doorway ... must be the finest entrance to any building in the City of London. Here is classical detail in all its richness used by a master of it ... to find an equal to this doorway one would have to go to Italy from whence it springs [for] if anywhere it is right to-day to return to what Piranesi called in giving a title to his great volume of etchings, 'The Magnificence of Rome', it is right in the headquarters of a great bank ... Roman splendour on this scale and with this elegance produces a romantic feeling one did not realize it still had the power to do.[61]

Others saw in it a riposte to encroaching modernism. J.R. Leathart, writing in the *Architects' Journal*, remarked how with 'a lofty and slightly supercilious air it gently chides the impatience of the younger school in its effort to kick overboard the paraphernalia of the orders and orthodoxy', calmly insisting 'that chastity and correctitude are architectural shibboleths of the traditional school ... not to be broken down by the assaults of the restless youngsters who despise architecture when it is draped on steel bones.'[62]

The banking hall was no less impressive (plate 63). The central space was, in fact, occupied by the clerks and tellers, reversing the rapidly emerging convention for reserving the central area for the public. The boundary between public and private space was marked by a series of Ionic columns in cream Subiaco marble, each over thirty-five feet high. Entering the banking hall a contemporary critic suggested 'one feels one is walking through some old Roman Imperial palace; but the palace of an Emperor, if such existed, with a real sense of refinement and taste.'[63] The concern with refinement and the use of high-quality materials was also evident in the bank's chief private rooms, completed as early as 1924 in the Angel Court section of the new headquarters.[64] In a retrospective account of Davis's work for the Westminster Bank in Lothbury and Threadneedle Street, Reilly claimed they 'are indeed echoes not only of other times, but ... of other countries as well.'[65] In the interwar years the Westminster Bank was one of the chief agents for correspondent banks in the dominions, colonies and overseas, bringing the centralized financial expertise of the London money market to places as diverse as South Africa, India and the Far East. For the bank's new headquarters in Lothbury, Davis drew substantially upon Roman imperial precedent, erecting a monument befitting the bank's place opposite the Bank of England at the heart of empire. This was as much about the glorification of money as any particularities of imperial destiny, of course, but money was one of the undisputed pillars of empire.

Since 1898 the Midland Bank's head office had been in the former headquarters of the City Bank in Threadneedle Street, with which it had merged in that year.[66] By the end of World War I, however, new premises were badly needed as the business of the bank continued to expand.[67] The Midland had become the largest bank in the British Empire, and indeed the world, in 1919.[68] It was no surprise that it should become centrally involved in the rebuilding of the City's central financial district in the 1920s and 1930s. The site for the new headquarters resulted from yet another amalgamation, when in 1918 the Midland joined with the London Joint Stock Bank, whose substantial head-office property lay in Princes Street, opposite the Bank of England. Green notes how, 'the Joint Stock Bank had also acquired property behind Princes Street, including the old Poultry Chapel', thus giving the Midland a frontage in Poultry too.[69] Further acquisition extended this frontage to include the entire area between Grocers' Hall Court and St Mildred's Court (see plate 59). Despite its complexity, the site was clearly of great symbolic as well as monetary value, allowing the bank to be opposite the Bank of England at the very heart of empire.

The bank chose Sir Edwin Lutyens to design their new headquarters, in cooperation with the architectural firm of Gotch and Saunders. Lutyens was a close friend of the bank's chairman Sir Reginald McKenna and had designed his

140

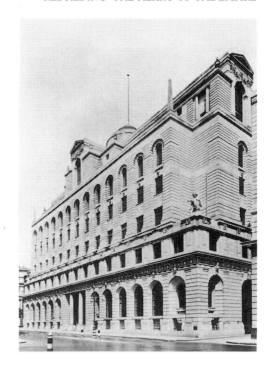

64 Midland Bank, Poultry. Principal front
to Poultry in the 1930s. Midland Bank
Collection. Reproduced courtesy of HSBC
Group plc.

London house in Westminster between 1911 and 1913.[70] Through his friendship
with McKenna, Lutyens began a long relationship with the Midland Bank in the
early 1920s, designing a new branch in Piccadilly between 1921 and 1925. In 1924
he began work on the new head office, a project that was to last until 1939. He
also designed two further important Midland branches: Leadenhall Street between
1928 and 1931 and King Street, Manchester, between 1928 and 1935.[71] One of the
most celebrated of all English architects, his inventive and original style evolved
from a love of rural vernacular, to a wholehearted embrace of the classical
tradition eminently suited to his own vision of Britain's imperial destiny.[72]
Imperial Delhi, designed in conjunction with Sir Herbert Baker, may be reckoned
as Lutyens's finest hour. Nonetheless, in his designs for Britannic House in
Finsbury Circus for the Anglo-Persian Oil Company and the Midland Bank in
Poultry, Lutyens left outstanding examples of an architecture imperial in scale,
style and intent, rooted in the metropolitan heart of empire.

Plate 64 shows the Poultry façade shortly after its completion in 1939. The
building was a unique addition to the City's architecture. Drawing upon a deep
understanding of the classical tradition it was, however, no slavish copy of a Roman
prototype, but a highly original interpretation of that most basic of architectural
forms: the wall. Christopher Hussey, Lutyens's biographer, notes how the Poultry
front represented Sir Edwin's 'transition from Classical to Elemental architecture
taking place: the most ancient Order, the very conception of Wall, dissolving and
being reconstituted before our eyes'.[73] Butler, in *The Lutyens Memorial* called it
'architectural sculpture', noting that the building was 'a palace of Finance as much
as the Viceroy's House was the palace of a King's representative. Both, in their
degree, are more splendid than they need to be for their purpose.'[74]

141

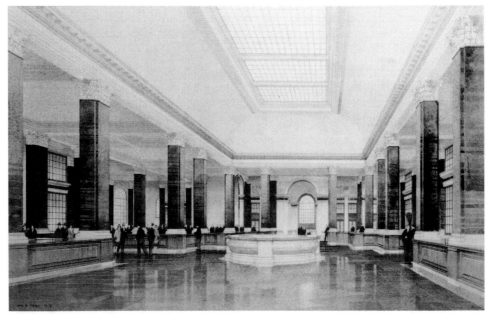

65 Midland Bank, Poultry. Perspective drawing of the banking hall by Cyril Farey, 1927.
Midland Bank Collection. Reproduced courtesy of HSBC Group plc.

The banking hall also demonstrated Lutyens's distinctive approach to design
(plate 65). The irregularity of the site, with entrances on two important
thoroughfares set at awkward angles, presented a complex architectural problem.
Only by orienting two distinct banking halls on a circular light well placed at the
centre of the scheme could an overall harmony be achieved.[75] Reilly, writing in the
Banker in 1931, remarked:

> [walking] through the great banking hall with its array of magnificent green
> columns and pilasters in verdite – that brilliant stone found in Northern
> Rhodesia [it is notable how] the architects, out of a typically irregular
> English town site, have produced order and even grandeur but without
> that overpowering temple-like magnificence which is so striking a feature of
> the great American banks. Indeed, there is something very English and,
> to English eyes, very charming about the dignity of this great interior
> combined with its obvious efficiency. There is richness, indeed, but without
> excess of ornament, nobility without any trace of swagger.[76]

Such disciplined, ordered simplicity lay at the heart of Lutyens's architectural
practice. Whether designing the plan for Imperial Delhi or the headquarters of a
great company in the City of London, he always revelled in the big scheme.

In the later 1920s the National Provincial Bank decided to rebuild the old
Union Bank head office at number one Princes Street. It had acquired the site
following a merger with the Union of London and Smiths Bank in 1918.[77]
Although the headquarters of the merged bank remained housed in Gibson's
Victorian masterpiece in Bishopsgate, head office of the National Provincial Bank

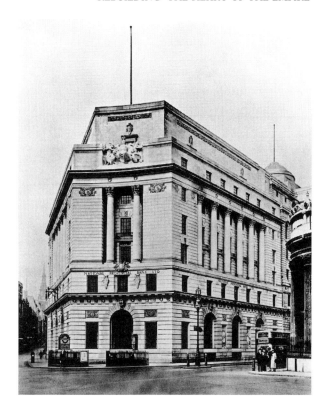

66 National Provincial Bank, Princes Street in the 1930s. Natwest Group Collection. Reproduced courtesy of Natwest Group plc.

since 1866, the bank no doubt felt it necessary to signal its expanded financial power by rebuilding Princes Street as its principal office, in a manner in keeping with the other head office rebuilding in the immediate vicinity.[78] The site, at the junction of Princes Street and Mansion House Street, with views over the Bank, the Royal Exchange and the Mansion House, was widely recognized as special, the *Evening News* noting that 'it has been called the best in the Empire' (see plate 59).[79] The bank chose Sir Edwin Cooper to design the new office, which was completed between 1928 and 1931 (plate 66). Cooper was no less an architect of empire than Lutyens or Baker, though his major contributions were to be found in the heart of the metropolis rather than in more distant lands. Responsible for the Port of London Authority Building in Trinity Square, for which he was knighted, and the new building for Lloyds of London in Leadenhall Street, Cooper was an architect with remarkable consistency of view.[80] An appreciation by A.E. Richardson in the *Builder* remarked that:

> The work of Sir Edwin Cooper represents one of the most interesting contributions made to English architecture during the past quarter of a century ... no other living architect has had such opportunities to add to the dignity of the metropolis ... Sir Edwin Cooper views the City as the centre of the Empire, and he indulges his taste for symbolism because he feels that the riches that are seaborne should find some conventional echo in the buildings which he has designed.[81]

143

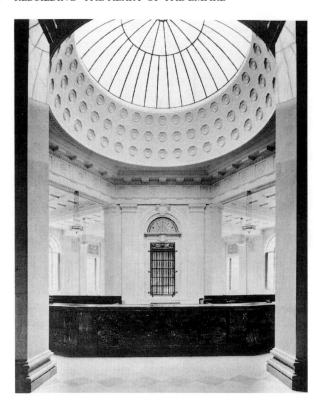

67 National Provincial Bank,
Princes Street. Interior of the
banking hall in the 1930s.
Natwest Group Collection.
Reproduced courtesy of Natwest
Group plc.

Here Richardson suggests some of the complex ways in which 'visions of empire' could be articulated in architectural form. In his design for the National Provincial office, Cooper was concerned to reflect the role of the City as the pivot of imperial finance and trade, where money was 'the chief part of the circulating capital of a vast Empire'.[82] For Richardson, it was Cooper's use of the maritime theme which was the key to successful architectural expression: 'viewed from the corner of Lombard Street the new National Provincial Bank stands bluff bowed, suggesting a mighty ship at anchor. The receding lines are shiplike. The sculptural interest at the angle suggests the figurehead, the embellishments are symbolical.'[83] The statuary on the splay at the top of the building, designed by the sculptor Ernest Gillick, comprised Britannia seated in a central position, with on either side a female figure representing Higher and Lower Mathematics; additional figures on either side represented Mercury and Truth.[84] Plate 67 shows the banking hall, capped by a dome coffered in the style of the Pantheon, in a muted ivory with creamy Subiaco marble wall surfaces blending with the plaster ceiling. Bronze statues stood in niches on either side of the approach to the main staircase, representing Integrity and Prosperity, copies of the stone figures on the front walls. The selection of ornament and the richness of detail suggested, to a contemporary critic, 'the quality of an etching by Piranesi [with] historical detail ... recast, modified and changed, until all parts have become related'.[85] However, it was a notice in the *Architects' Journal* that perhaps best caught the mood:

Sir Edwin Cooper's great building in the City for the National Provincial Bank falls into its general place in the group of great banks round the Bank of England with admirable general effect. In this architecturally top-hatted neighbourhood its clothes are well cut in the best San Michele manner, though a few of the buttons look to me a little worried by minute chasing and carving. It is interesting when in the neighbourhood to walk up St Mildred's Court and compare the detail of the work of the two Sir Edwin's where they abut. One learns a good deal by doing so, as one could at Delhi in similar places where one Sir Edwin is reputed to have said he had met his Bakerloo.[86]

The largest and most contentious rebuilding project of the interwar years – not only in the City, but in London more generally – was that of the Bank of England. The question of rebuilding the Bank was first raised in earnest in 1916 when the pressure of financing World War I meant that the National Debt had broken out of its century-old limits, creating a substantial increase in the Bank's workload.[87] However, further consideration was postponed until after the war, when in May 1920 a special committee was formed to plan the great project of rebuilding.[88] In 1921 the Bank's directors approached Herbert Baker to design a new building on the present Threadneedle Street site (see plate 59), though preserving as much of Sir John Soane's existing building as possible.[89] By the 1920s Baker had become Britain's most prolific imperial architect. In the early 1900s he developed close links with South Africa, building Government House and Union Buildings in Pretoria between 1905 and 1913. From 1912 onwards he worked closely with Lutyens on the planning of Imperial Delhi, being responsible for the Secretariat Buildings there. Irving notes how 'no architect of any era had done so much important work throughout the British Empire. Baker was supremely happy in his generation, to use Wren's much earlier phrase: his personality, ideas and art coincided to an uncommon degree with the needs and aspirations of his clients.'[90] In the interwar years Baker also contributed substantially to the shaping of late-imperial London, building India House in 1925 and South Africa House in 1930. It is within this consistent imperial vision that Baker's design for the new Bank of England must be placed.

From the outset Baker faced an immensely complex architectural problem concerning not only what the new Bank might look like, but whether it should be rebuilt at all.[91] The existing building, inimitably that of Sir John Soane, had achieved the status of a national monument. The *Architects' Journal* noted how 'Soane's masterpiece is an integral part of the City; it is impossible to conceive the City without the Bank as the Bank without the City. Perhaps, without exaggeration, it may be said that it stands for far more than the City; that its low impressive walls of solid masonry symbolize the integrity of the British Empire.'[92] Baker clearly recognized the specific imperial context within which he was working, signalling in his first report to the Bank's Rebuilding Committee his desire to design a building 'which might contain the elements of architectural dignity commensurate with the Bank's position and destiny in the City and the Empire'.[93] Given the delicacy of the issue at hand, the Bank's directors' released Baker's plans for public scrutiny in the middle of 1922. These were, in fact, very

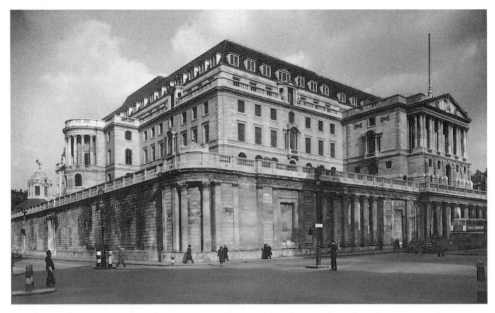

68 Bank of England, Threadneedle Street. View of façades to Threadneedle Street and Princes Street in 1938. Bank of England Collection. Reproduced by kind permission of the Governor and Company of the Bank of England, London.

close to the final achieved design (plate 68). That the Bank, ostensibly a private institution, had gone public in this way was picked up immediately by the journal *Country Life*:

> [the] issue to the Press of Mr Herbert Baker's scheme for rebuilding is surely something of a portent ... it means that the Court of Directors, eminent people in the City of London, see that their business is also other people's business; that they are the trustees for the amenities of the heart of the Empire ... [indeed] time was when the first notice of such a change in the aspect of the City would have been the rattling down of Soane's great wall ... for the Bank's directors have no statutory or customary duty to the public.[94]

Opposition to the planned rebuilding crystallized around the Trustees of the Soane Museum, who claimed that Soane's building should be considered an historical monument, that at the very least the façades to the streets should be kept intact and, if possible, the remarkable domical banking halls too.[95] Criticisms were also raised of Baker's suggested portico for the Threadneedle Street façade.[96] Baker was clearly mindful of his enormous historic responsibility in designing the new Bank and, though it proved impossible to save Soane's banking halls, the curtain wall, though modified in places was kept generally intact. The idea for a portico had been criticized for introducing a strong vertical theme to Soane's predominantly horizontal lines. Clearly, though, the new building erected within Soane's walls had changed the fundamental geometry of his design. Baker explained the portico thus:

146

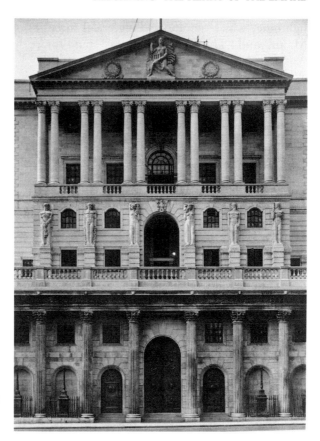

69 Bank of England,
Threadneedle Street. The new
portico and bronze doors at the
Threadneedle Street entrance.
Bank of England Collection.
Reproduced by kind permission of
the Governor and Company of
the Bank of England, London.

'it has a higher meaning [forming] the architectural connexion between the old low façade and the new high building ... raised behind it.'[97] Crucial to that link was a series of new sculptures designed by Charles Wheeler, and strategically placed to connect Soane's original columns with the coupled ones Baker designed to support the new pediment (plate 69). It was at such points, where Baker attempted to fuse the old building with the new, that contemporary architectural criticism was most emphatic. Reilly highlighted the mismatch between Baker's architecture, containing 'the lighter notes of Wren and the Georgian architects' and 'the deep-toned base of early nineteenth-century men ... like Soane [who] knew the full strength of Roman architecture'.[98] Baker's attachment to the work of Wren no doubt stemmed, in part, from his wider imperial imagination. In his memoir, he explicitly characterizes Wren as the leading architect of England 'while the Empire was in the making'.[99]

Plate 69 also shows Wheeler's design for the bronze doors at the Threadneedle Street entrance. The details here indicate the clear sense that both he and Baker had of the place of the Bank in an imperial world economy. This was no simple mapping of the Bank within a definitive imperial space though, the designs revealing a relationship between the Bank, the City and the world economy mediated through a wider empire of money. The left-hand door symbolized the foundation of the Bank, featuring a sailing ship of the period of William III, whilst the right-hand door stood for reconstruction, carrying the hand of Zeus grasping

147

lightning, which symbolized electrical force. Further, 'the constellation of "Ursa Major" and "The Southern Cross" stand for both sides of the world, implying the world-wide extent of the Bank's operations.'[100] The configuration wrought by Wheeler suggested strongly the idea of the place of the Bank at the centre of the world. As guardian of the pound sterling and pivot of the imperial space economy, the Bank embodied the power of one of the world's leading currencies at the heart of empire. The process of time–space compression reordering this imperial monetary space, from sea power to electronic communication, was also symbolized. Similar themes were elaborated on the two side doors flanking the main entrance, where 'beneath the paws of the lions on the right are shown three piles of coins [which] appear to be intentionally shaped like the Greek "omphaloi", the allegory presumably represents the monetary centre of the world.'[101] In this, as in many other aspects of the Bank's complex iconographical scheme, Baker and his collaborators followed the general instruction that 'any decoration should not be for the mere sake of ornament, but should have some special significance to the work and ideals of the Bank.'[102] The scale and style of its new building, as much as its continuing importance as the pivot of imperial finance, denoted its special place within the rebuilding of 'The Heart of the Empire'.

A landscape of power?

In 1927 Reilly had remarked that in the designs for their new headquarters, the banks 'are creating the palace architecture of our time'.[103] By 1939, with the great rebuilding of the heart of the City largely complete, a monumental palatial landscape had indeed been created.[104] In one sense this was simply architecture in the service of Mammon; a commercial landscape exceptional in scale, perhaps, but aesthetically part of a long tradition of banks drawing upon the classical language of architecture to establish their identity and underline their stability and security. Yet this was a special place. In the interwar years, perhaps more so than in the later nineteenth-century vision of *The Heart of the Empire*, the City was a key site of British imperial power. The landscape created by the rebuilding of the City in the 1920s and 1930s was an imperial landscape too. This was not the triumphal imperial architecture of Westminster or Whitehall, where the geometries of power were laid out in the landscape for all to see.[105] The City was a private landscape of capital, not a formally planned imperial space consciously modelled to reflect an official view of Britain's imperial destiny. Recovering the imperial visions embedded within the City's new landscape presents, therefore, a complex task requiring sensitivity to the intersection between the architectural discourse of money power and the series of imaginative geographies of empire articulated by the architects involved. In the new headquarters buildings for Lloyds and the Westminster Bank, the architectural response to the wider context of the heart of empire was largely implicit. Critics drew attention to the imperial scale of their architecture and the echoes of a Roman Imperial past that their designs elicited. Drawing upon European traditions of imperial style, together with more recent American influences in

the temple-like banking halls, they sought a new aesthetic of money power befitting their place at the monetary hub of empire. The designs for the Midland Bank and the National Provincial, as with that for the new Bank of England, reflected in different ways an explicit imperial vision. Sir Edwin Cooper's National Provincial office was part of his wide-ranging contribution to the shaping of late-imperial London, in which he consciously sought to express through architecture the place and purpose of the City within the empire. For Sir Edwin Lutyens and Sir Herbert Baker, their work in the City in the 1920s and 1930s was part of a widespread and continuing contribution to imperial building, at both the metropolitan heart of empire and in the dominions and colonies overseas. As leading figures in the circuit of architects and architecture that centred on late-imperial London, they articulated a vision of Britain's imperial destiny rooted in classical style.

The characterization of this period of interwar rebuilding in the City as *late-imperial* is significant. It was evident that despite the rearguard action fought by the City in the 1920s and 1930s, the world would never be quite the same again. Indeed, by World War II the limits to British imperial power were obvious. It is possible, therefore, to see this new landscape created at the heart of empire as reflecting an absence of power, rather than the late nineteenth-century confidence captured by Lund. This is not to say that architects like Baker or Lutyens saw it that way. Baker's memoir published in 1944 is replete with the confident imperial vision of late-Victorian and Edwardian Britain.[106] But the circumstances surrounding the conception of their great rebuilding projects in the City, like their work together at Imperial Delhi, were radically changed by the time of their completion in the later 1930s. There is a sense in which these great stone palaces of finance represented the end of an era rather than its continuation. Such uncertainties can be read in the changing views of the noted architectural critic C.H. Reilly. Exasperated by Baker's attempts to marry the lighter classicism of Wren with Soane's existing strong Graeco-Roman wall at the Bank of England, he commented 'the frankest and most honest solution might well have been to erect behind the Soane walls, and without any connecting links with them, a tall, plain modern structure in steel and stone, which would be truthfully of our time.'[107] The apparent duplicity of hanging ornamented stone façades onto a steel frame was a persistent concern for Reilly. In 1927 the model for Lutyens's new Midland Bank head office was displayed at the Royal Academy. Reilly wrote enthusiastically that it showed 'a monumental pile of building of great and genuine originality ... there is something significant about the relation of the masses of the building ... which is of the essence of great architecture.'[108] Yet, on the bank's completion in 1939, Reilly worried about the fact that it took 'no account in its expression of the steel which holds it up ... a monumental building appearing to be built in stone in the solidest possible manner ... is merely hung on to steel girders and stanchions like so much sugar-icing.'[109] Reilly, and other architectural commentators in the 1920s and 1930s, recognized that radically different solutions were shaping the financial landscape of London's great competitor New York, where an explicitly modern architecture clearly reflected the new form of steel construction employed.[110] By contrast, the late-imperial rebuilding of the City of London seemed to reflect the uncertainties of empire in its very fabric. And yet this late-imperial landscape lives

149

on. Today the great 'bankers' palaces' at the heart of the City continue to provide echoes of empire in a post-imperial world.

Iain S. Black
King's College London

Notes

The research for this paper was conducted as part of a Nuffield Foundation project entitled 'Rebuilding *The Heart of the Empire*: Financial Headquarters in the City of London, 1919–1939'. I would like to thank the Foundation for its generous support. I would also like to thank the following individuals and institutions who allowed access to their archives and offered much help and advice: Mr Henry Gillett, Ms Sarah Millard and the Bank of England; Dr John Booker and Lloyds Bank plc; Ms Fiona Maccoll, Ms Susan Snell and the Natwest Group plc; Mr Edwin Green, Ms Sara Kinsey and the HSBC Group plc. I am grateful too for the advice and helpful comment received on earlier versions of this paper given at conferences and seminars at the Royal College of Art, Royal Holloway, Cambridge, Coventry and Connecticut College.

1 E.J. Hobsbawm, *Industry and Empire*, Harmondsworth, 1968.
2 M. de Cecco, *Money and Empire*, Oxford, 1974.
3 P.J. Cain and A.G. Hopkins, *British Imperialism: Innovation and Expansion 1688–1914*, London, 1993; P.J. Cain and A.G. Hopkins, *British Imperialism: Crisis and Deconstruction 1914–1990*, London, 1993. See also L.E. Davis and R.A. Huttenback, *Mammon and the Pursuit of Empire: The Economics of Imperialism*, Cambridge, 1986; and P.J. Cain, *Economic Foundations of British Overseas Expansion, 1815–1914*, London, 1980.
4 See J.M. Jacobs, 'Negotiating the Heart: Place and Identity in the Postimperial City', in *Edge of Empire: Postcolonialism and the City*, London, 1996, pp. 38–69.
5 See S. Daniels, *Fields of Vision: Landscape Imagery and National Identity in England and the United States*, Cambridge, 1994, p. 31.
6 Jacobs, op. cit. (note 4).
7 ibid.
8 ibid., p. 58.
9 See also N.J. Thrift, *Spatial Formations*, London, 1996, p. 236, where he notes how 'the City's role in the British Empire [was] conventionally symbolized by Niels Lund's picture *The Heart of the Empire*.'
10 S. Daniels, 'The Prince of Wales and the Shadow of St Paul's', in *Fields of Vision*, op. cit. (note 5), pp. 11–42.
11 ibid., p. 15.
12 ibid., p. 31.
13 ibid., p. 29.
14 See ibid., p. 32.
15 Jacobs, op. cit. (note 4), p. 1.
16 ibid., p. 40.
17 ibid., p. 38.
18 ibid., p. 53.
19 F. Driver and D. Gilbert, 'Heart of Empire?

Landscape, Space and Performance in Imperial London', in *Environment and Planning D: Society and Space*, vol. 16, 1998, pp. 11–28.
20 ibid., p. 12.
21 ibid., p. 14.
22 ibid.
23 ibid., p. 18.
24 ibid.
25 ibid., p. 21.
26 ibid., p. 18.
27 See, for example, I.S. Black, 'Symbolic Capital: the London and Westminster Bank Headquarters, 1836–38', in *Landscape Research*, vol. 21, no. 1, 1996, pp. 55–72; and I.S. Black, 'Spaces of Capital: Bank Office Building in the City of London, 1830–1870', in *Journal of Historical Geography* (forthcoming).
28 Driver and Gilbert, op. cit. (note 19), p. 18.
29 A.N. Porter, 'London and the British Empire: c. 1815–1914', in *Cities of Finance*, H. Diederiks and D. Reeder (eds), Amsterdam, 1996, p. 53. See also R.C. Michie, *The City of London: Continuity and Change, 1850–1990*, London, 1992; and the essays in S.D. Chapman, *Merchant Enterprise in Britain: From the Industrial Revolution to World War I*, Cambridge, 1992.
30 Porter, ibid., p. 54.
31 G. Ingham, 'The Emergence and Consolidation of City Dominance 1815–90', in *Capitalism Divided? The City and Industry in British Social Development*, London, 1984, pp. 96–127.
32 See Cain and Hopkins, *British Imperialism: Crisis and Deconstruction*, op. cit. (note 3), pp. 11–105.
33 ibid.
34 ibid., p. 42.
35 ibid., p. 75.
36 ibid., p. 93.
37 ibid., p. 6.
38 ibid., p. 92.

39 Ingham, op. cit. (note 31), p. 200.
40 C.H. Reilly, 'The New Lloyds Bank Headquarters', in *The Banker*, vol. 10, 1929, p. 68.
41 'Change at the Bank', *Evening News*, 6 October 1928.
42 ibid.
43 A.E. Richardson, 'National Provincial Bank, Princes Street', in *The Banker*, vol. 22, 1932, pp. 84–6.
44 Driver and Gilbert, op. cit. (note 19), pp. 16–19. See also M.H. Port, *Imperial London: Civil Government Building in London 1851–1915*, New Haven and London, 1995.
45 R. Roberts and D. Kynaston (eds), *The Bank of England: Money, Power and Influence 1694–1994*, Oxford, 1995.
46 R.G. Irving, *Indian Summer: Lutyens, Baker, and Imperial Delhi*, New Haven and London, 1981.
47 L. Stoler and F. Cooper, 'Between Metropole and Colony: Rethinking a Research Agenda', in F. Cooper and L. Stoler (eds), *Tensions of Empire: Colonial Cultures in a Bourgeois World*, Berkeley, 1997, p. 34. See also the arguments in M. Crinson, *Empire Building: Orientalism and Victorian Architecture*, London, 1996.
48 C.H. Reilly, 'The New Headquarters of Lloyds Bank', in *The Banker*, vol. 3, 1927, pp. 202–208. For further discussion of the rebuilding, including details of site assembly, see J.R. Winton, *Lloyds Bank 1918–1969*, Oxford, 1982, pp. 51–7.
49 J. Booker, *Temples of Mammon: The Architecture of Banking*, Edinburgh, 1990, p. 234.
50 Reilly, 'The New Headquarters', op. cit. (note 48), p. 203.
51 ibid., p. 204.
52 Booker, op. cit. (note 49), p. 234.
53 Reilly, 'The New Headquarters', op. cit. (note 48), pp. 205–207.
54 On North American bank design, see *Money Matters: A Critical Look at Bank Architecture*, New York, 1990.
55 Reilly, 'The New Lloyds Bank Headquarters', op. cit. (note 40), p. 72.
56 See C.H. Reilly, 'Lloyds Bank New Headquarters', *The Banker*, vol. 15, 1930, pp. 113–29.
57 Black, 'Symbolic Capital', op. cit. (note 27).
58 Biographical details on Arthur Davis are drawn from *The Morning Post Building*, London, 1978.
59 ibid.
60 'Architecture Today: Rebuilding the City', in *The Financial Times*, 8 May 1931.
61 C.H. Reilly, 'Some Westminster Bank Branches', in *The Banker*, vols 17–18, 1931, pp. 306–310.
62 J.R. Leathart, 'Westminster Bank Limited:

Offices in Lothbury, E.C.', in *Architects' Journal*, 17 June 1931, p. 847.
63 C.H. Reilly, 'The New Headquarters of the Westminster Bank', in *The Banker*, vol. 10, 1929, p. 186.
64 For a detailed account, see 'The Head Offices of the Westminster Bank, London', in *The Architectural Review*, vol. 56, September 1924.
65 C.H. Reilly, 'Bank Buildings of Merit: VI Westminster Bank', in *The Banker*, vol. 62, 1942, p. 48.
66 See A.R. Holmes and E. Green, *Midland: 150 Years of Banking Business*, London 1986, pp. 96–7.
67 See E. Green, *Buildings for Bankers: Sir Edwin Lutyens and the Midland Bank, 1921–1939*, London: privately printed, 1980, p. 10.
68 Holmes and Green, op. cit. (note 66), p. 150. See also 'A Great Bank', in *Bankers' Magazine*, vol. 132, July 1931, pp. 50–83.
69 Green, *Buildings for Bankers*, op. cit. (note 67), p. 10.
70 ibid., p. 5.
71 ibid., p. 3.
72 Irving, *Indian Summer*, op. cit. (note 46), pp. 168–70.
73 Quoted in Green, *Buildings for Bankers*, op. cit. (note 67), p. 15.
74 A.S.G. Butler, *The Lutyens Memorial. The Architecture of Sir Edwin Lutyens. Vol III*, London, 1950, pp. 26–7.
75 See 'The Midland Bank Headquarters', in *The Builder*, 17 April 1931, pp. 720–1.
76 C.H. Reilly, 'The Midland Bank Headquarters', in *The Banker*, vols. 17–18, 1931, pp. 253–4.
77 See R. Reed, *National Westminster Bank: A Short History*, London: privately printed, 1983, pp. 20–4.
78 On Gibson's National Provincial Bank headquarters, see I.S. Black, 'Bankers, architects and the design of financial headquarters in the mid-Victorian City of London', in *The Hidden Iceberg of Architectural History*, C. Cunningham and J. Anderson (eds), Annual Symposium Papers: Society of Architectural Historians of Great Britain, 1998, pp. 45–58.
79 'Making way for an eight-storey skyscraper', *Evening News*, 21 September 1928.
80 See 'Presentation of the Royal Gold Medal to Sir Edwin Cooper', in *Journal of the Royal Institute of British Architects*, vol. 38 (third series), no. 9, March 1931, pp. 279–91.
81 A.E. Richardson, 'The Work of Sir Edwin Cooper, A.R.A., An Appreciation', in *The Builder*, 6 March 1931.
82 A.E. Richardson, 'The National Provincial Bank, Princes Street and Mansion House Street, London', in *Architectural Review*, April 1932, p. 3.
83 Richardson, 'National Provincial Bank', op. cit. (note 43), p. 86.
84 'N.P. Bank's New Building, The Statuary',

Financial News, 14 March 1932.

85 Richardson, 'National Provincial Bank', op. cit. (note 43), p. 89.

86 'National Provincial Bank', *Architects' Journal*, 11 January 1933.

87 See R.S. Sayers, *The Bank of England 1891–1944*, vol. 3, Cambridge, 1976, pp. 338–42.

88 ibid.

89 On the choice of Baker as architect, see N. Jackson, *F.W. Troup, Architect 1859–1941*, London, 1985, p. 55.

90 Irving, op. cit. (note 46), pp. 275–6.

91 For a detailed account of the Bank's rebuilding, see I.S. Black, 'Imperial visions: rebuilding the Bank of England, 1919–1939', in *Imperial Cities: Landscape, Display and Identity*, F. Driver and D. Gilbert (eds), Manchester, 1999, pp. 96–113.

92 'The Question of the Bank of England', in *Architects' Journal*, vol. 56, 1922, pp. 173–4.

93 Quoted in Sayers, op. cit. (note 87), p. 339.

94 'The Public and Modern Buildings', in *Country Life*, 29 July 1922.

95 Jackson, op. cit. (note 89), p. 61.

96 'The Bank of England. Soane's Design in Danger', in *The Times*, 25 July 1923.

97 'The Bank of England. Answer to the Soane Trustees', in *The Times*, 27 July 1923.

98 C.H. Reilly, 'The Emergence of the New Bank of England', in *The Banker*, vols. 17–18, 1931, p. 98.

99 H. Baker, *Architecture and Personalities*, London, 1944, p. 221.

100 'Bank of England's New Building. Artistic Designs for Doors', *The Financial Times*, 3 March 1931.

101 'Bank of England Rebuilding. New Doors and Sculptures', in *Financial News*, 3 March 1931.

102 Baker, op. cit. (note 99), p. 124.

103 Reilly, 'The New Headquarters', op. cit. (note 48), p. 203.

104 The last rebuilding project to be completed was the Bank of England, where finishing work ran on until mid-1942. See Sayers, op. cit. (note 87), p. 342.

105 See Port, op. cit. (note 44).

106 Baker, op. cit. (note 99).

107 Reilly, 'New Bank of England', op. cit. (note 98), p. 95.

108 C.H. Reilly, 'Bank Architecture at the Royal Academy', in *The Banker*, vol. 3, 1927, p. 498.

109 C.H. Reilly, 'The Midland Bank Headquarters', in *The Banker*, vols 49–50, 1939, pp. 369–70.

110 See, for example, C. Willis, *Form Follows Finance: Skyscrapers and Skylines in New York and Chicago*, Princeton, 1995.

Benjamin's Paris, Freud's Rome: whose London?

Adrian Rifkin

> Unreal City, ...
>
> Under the brown fog of a winter dawn
> A crowd flowed across London Bridge, so many,
> I had not thought death had undone so many.[1]

[At the Wheel]
Surely every man who has driven through the fog with eyes that ache and imagine phantoms at each cross-road will be glad to raise his hat to the bulky figure behind the wheel of a London omnibus as he steers his living cargo to safety with no thought of praise – because it's all in a day's work?

Under the Dome
I was cheered to find that St. Paul's looked quite firm and permanent when I walked up Ludgate hill the other morning. How deceptive are the works of man! Who would have guessed that this mountain was feeling its age a bit, moving ever so slightly under the weight of its Dome.[2]

This essay sets out to read cinematic, theoretical and psychoanalytic texts that either directly concern the city or which are articulated via an imagery of the urban; and to do this through a consideration of the phantasmatic forms of the particular city that they relate. In such a short piece I will inevitably engage in very little close reading, and restrict myself rather to a more general framing of or mapping of the conditions for such a reading. I will assume the elements of my title, the particular relationship between Sigmund Freud and Rome on the one hand and Walter Benjamin and Paris on the other, as a cultural given. But this is clearly a functional simplification which, I believe, stands up to examination, for all that Benjamin wrote of many cities, and Freud's love of Italy was infinitely more expansive than his infatuation with Rome.

Indeed, it is a commonplace of the history of psychoanalysis that Sigmund Freud was so inspired by Italy and its great cities, Naples, Milan, Venice and Rome, that we have to think of his excitement as a fundamental and necessary condition for the invention of the 'talking cure' and its vast theoretical elaboration by him. As Antonietta and Gérard Haddad have recently written, '[P]sychonanalysis and Italy reveal themselves ... to be narrowly interwoven. Freud elaborated his work in a ceaseless to and fro between Vienna and Italy. *He*

went there more than twenty times.'[3] Rome he was to visit in 1901, only after he had completed *The Interpretation of Dreams* (1900), a journey which he related to the conclusion of this great period of work. And while the voyage onward to Pompeii was to provide him with a primary image or metaphor of the larva-covered strata of lost experience, Rome is to reappear in strength in *Civilisation and its Discontents* (1919) as one crucial stage in his attempt to develop a viable metaphorics for the human mind. Yet already in *The Interpretation of Dreams* Freud has written of the importance of his frustration in never having been to the city, and he has already outlined the beginnings of this later metaphor: '[day-time phantasies] stand in much the same relation to the childhood memories from which they are derived as do some Baroque palaces of Rome to the ancient ruins whose pavements and columns have provided the material for more recent structures.'[4]

In *Civilisation* . . . this becomes a more layered exploration in the unfolding of two possible metaphors: first, if crocodiles persist as a living reminder of the earliest stages of animal development, then second, the ruins of Rome might likewise suppose the continuous existence of materials that, once brought into being, persist for evermore. But such lost or partial materials are significantly visible only as they conjuncturally and momentarily appear as the meaning of otherwise-determined conscious representations. Freud's purpose in trawling these comparisons is to find an adequate image for the persistence of pre-oedipal elements of the human subject, which, as they sometimes surface and force their pre-linguistic figure into the conscious mind, give rise to the 'oceanic' feeling, the sense of a profound and inexplicable sense of the unity of the being and the world – that is to say, the delusion of religion. In effect, after jettisonning the image of the saurian leftover that is the crocodile, he also turns against his Roman metaphor, renouncing it as having any substantial value for a mapping of the human mind. But he does this on the rather literal grounds that edifices cannot physically exist in all their various forms and successive rebuildings from early to late Roman, from early Christian to Baroque:

> There is clearly no point in spinning our phantasy any further, for it leads
> to things that are unimaginable and even absurd. If we want to represent
> historical sequence in spatial terms we can do it only by juxtaposition in
> space: the same space cannot have two different contents. Our attempt
> seems to be an idle game. It has only one justification. It shows us how far
> we are from mastering the characterstics of mental life by representing
> them in pictorial terms. (p. 258)

Yet 'clarity' is hardly the point of Freud's own phantasmatic excursus into this metaphor, and precisely what the three pages preceding his withdrawal have left us with is a powerful way of daydreaming the mind as city and the city as if it were the mind. That Freud retracts his image in the name of reason should not hide from us the passage through his thinking of those great representations of the city as human subject which go back to Charles Baudelaire and Edgar Allen Poe, and which Benjamin was to take up as offering a possible access to the future-perfect tense of capitalism in its origins in the *Passagen-Werke*. In an important

sense Benjamin's whole obsession with Paris might be understood as a Freudian gesture in the spirit of *Civilisation and its Discontents*, but one that he was neither able nor willing to forclose; what he once described to Gershon Scholem as a matter of a few months' visit to deal with Paris turned into the sojourn that we know. Benjamin's entrapment by Paris has in effect left us with *its* figure as that of the lost futurity of capital, in the economic sense of the word and, at the same time, as the presiding substratum of cityness in general as a mental percept. For what is now nigh on some forty years of urban theory and history writing Benjamin's vision has interacted with a variety of literary or art-historical narratives of cultural modernity as quintessentially French and Parisian in such a way as to make it difficult to name other modernities which invite our empathy with capital. Benjamin and historical ruin stand in for each other in his writing and its historical after-life, and in so doing elide the ur-being of cities, or capitals, that are not Paris, either in their own substantive history or as an alternative modality of historical process.

But to understand this is to begin to approach the figural problem of London, which is the focus of my essay. Not surprisingly, the narratives which London incites often seem not quite to belong to the name 'London', but rather to have come to it. In part this must be because, at a certain point in the histories of its becoming a figure for modernity – and I am addressing myself here only to modern London – it loses itself to a number of external discourses. One of the most striking examples of this is precisely the phenomenom of the Benjaminian construction of the modern city as the Paris of Baudelaire – but as a city which always and already includes London. For while the Benjamininan vector of urban modernity is worked through an archive of exemplary density, and of essentially Parisian texts, objects and images, it can be argued that it hangs together around a London motif – that of the 'man in the crowd'. This transposition of Edgar Allen Poe's *imagined* London into one of Baudelaire's representations of the city adheres the crazy, mannered figure of an English obsessionality, hardly able to cope with the flux and motion of street life in which it must exist, to that of the *flâneur* who above all deals with shock aesthetically. In effect, London is parisianized by this gesture, processed into a protocol that brings it into theory through the borrowed clothing of Parisian modernity. Thus, the distinction between London and Paris which Benjamin suggests we make through that between Poe's relatively neutral 'man in the crowd' and Baudelaire's deeply complicit *flâneur* is not only lost in the historiography of cities, but is provoked in Benjamin's text itself, in his repetitious return to the latter of these two figures; which may itself just be thought of as an illicit and negative effect of London, transmitted to him via Poe or Dickens.[5]

It is not surprising then if, in comparison to Paris, London comes to be celebrated as an unsatisfactory city. Major representations of London, from the writing of Edgar Allen Poe or Charles Dickens to the films of Patrick Keillor, make this clear enough – as do substantial attempts at physical re-planning from John Nash to Patrick Abercrombie. While Poe's London is as mysterious as his Paris – and he knew neither city – it is probably something more of a nightmare, more shocking in the physical sense of the word, less available for the kind of rapt *dénouement* that may conclude one of Dupin's Parisian thrillers. Dickens's London is too well known and the debates around it too intense for me to engage

with them at any length here – though I will have to return to David Lean's film of *Great Expectations* (1947). However, I should say that I take the side of those who argue that Dickens is out to produce or to invent London rather than to record it or tell stories about it. London is not so much a metaphor for the convoluted and impenetrable complexities of social and legal relations of his novels, such as *Bleak House*, as the object to be invented through them, a mise-en-scène held together, after or around the effects of narrative. So Dickens expresses not so much a fear of the great miasmic city as a desire for such a fear to be real, present in narrative, and giving an emotional form to the narrative that London might otherwise destroy and strip of any meaning.[6]

Patrick Keiller, in his film *London* (1994), is wholly undecided between an archaeology or recovery of the past and the projection of an imaginary historical unity onto the present, in his attempt to decide what it is that the city might still be. If his essentially literary-historical view of the city as having already been told now requires him to re-tell it in recognizable form if he is to save it from oblivion, then his attempt trips over itself in the most current possible present, that of the giant Brent Cross shopping centre; it is here that he finds Walter Benjamin being read, in a commodity space beyond redemption, rather than in the nineteenth-century moment when the 'hollowing out' of the human subject by empathy for the commodity was still an impulse of poetics. In the end *London* turns to the family structures and working life of the more recently immigrant strata of the population to project a phantasm of primordial community, effectively and critically blocking the notion that the city was ever truly present as available for recognition, other than as the projection of some desire that London cannot satisfy.

The space between Dickens and Keiller might then be thought of as one of the iterative enactment of the swing between an exteriority or strangeness that is felt as if within and from without the city subject. London is turned into narrative on an uneasy borderline between the terms 'other-to-oneself' and 'other-as-oneself', an indeterminacy which itself produces an unsatisfactoriness or a frustration registered as much in Eliot's poetics in my opening quotations as in H.V. Morton's prosaics.

It is interesting here to take a London book of 1935 written by the French literary commentator Louis Cohen-Portheim, *The Spirit of London*, and to tease out other traces of this trope, or negative oceanic feeling, if I might here play with Freud's orderings of mental formation.[7] In his preface to the book Raymond Mortimer hails the recently deceased Portheim as a true European, one '[e]qually at home on the Zattere and the Kurfürstendamm, in the rue de Lappe and in Islington' (Portheim, p. vi), a characterization which places him, after his long experience of the city, in an unusual position to apprehend it both from within and without. And, indeed, this double aperception is precisely Portheim's strategic particularity, a recognizing of a specific urban density which is not quite adequate to cathexis in the absence of activation by some kind of Other. At one point, in a strange presaging of Patrick Keiller's flatness and let-down tone, he writes that '[Y]ou only have to cross Piccadilly to leave Mayfair for St James's, and you will come to a London where time has stood still, though it is not quite easy to say exactly when it decided to do that' (ibid., p. 17). The witticism chimes with his assertion that

[F]ew cities have a greater number of interesting and notable streets than London, and certainly none has a greater number of monotonous and featureless ones. It is the only great capital built on the system of the small one-family house; and that is why, when you get away from the central parts, you find acres of streets of undistinguished little houses ... (ibid., p. 33).

This is to say that even in its central dynamic, London might be as entropic as in its purely residential areas; and if the town within a town that is St James, (the exclusively male sociability that characterizes it is unchanged since the eighteenth century, despite its outward trappings), this does not strike his reader as much more attractive than the 'acres' of the 'undistinguished'. Petticoat Lane on the contrary is '[n]ot only alive, but teeming, swarming, screeching, and bellowing on its market-day'. This '[m]ost picturesque ghetto of western Europe ...' is '[p]ossibly the most surprising of the countless and ever-varied London districts, a few of which I have here described' (ibid., p. 32).

Portheim discloses what we would now call London's hybridity as its access to some kind of affective plenitude and he goes on to argue that, if there is no English equivalent '[f]or the French *se promener dans la rue*', then '[t]he East End does "promenade" all the same ...' Even if the '[j]oy and gaiety' of East End roads may depend as much on a lack of home comfort as love of the street, then nonetheless it is the Jews of Whitechapel who have reinvented the '*Corso*' – '[I] know of nothing quite like it in the more purely English parts of popular London, yet I have observed it in some big provincial cities of the North of England.' (ibid., p. 35) Something of this foreignness or hybridity also holds for him in Tottenham Court Road, the 'most Parisian' of London Streets, but in the writing of a London chronicler like H.V. Morton the same phenomenom is abject and disgusting, though its vitality nonetheless forces itself upon him. For Morton, Petticoat Lane is a repulsive melting pot of vile oriental stereotypes, strange combinations – '[t]he eyes of Ruth ... with the larynx of Bill Sykes [*sic*] ...', while Limehouse's Chinese population, which Portheim finds 'disappointing' – they wear European dress – he can assimilate into a generalized quaintness of ethnically different people wrapped up in their own little lives.[8] Clearly it is important to note that with both these writers the figures of ethnic and class difference are written across each other, and that this is not simply a matter of the trope of slumming. Rather, it registers a deeply problematic disparity between modes of access to the city; in which, obviously enough, money plays a distinct and divisive role. This is revealed in the way in which money is handled, expressing either the libidinous variety of the other even in the tiny transactions of Petticoat Lane, or the vacuous rigour of formal wealth in clubland – the street market on the one hand, St James's on the other.

'The Waste Land' resumes this figural complexity in its swinging between populist vernacular and symbolist poesis, the formal beauty of the City and the unfathomable wealth of otherness as a slippage of money's glamour: 'Phlebas the Phoenician, a fortnight dead,/ Forgot the cry of gulls, and the deep sea swell/ And the profit and the loss.'

So, framed like this, and eighty years after it was written, T.S. Eliot's repeated

linking of the words 'unreal' and 'London' in 'The Waste Land' is an almost unremarkable introduction to that city or to its heartland, the City, whose image as a space of churches and of finance, a palimpsest of world trade and poetic resources, is a structure of the poem. The juxtaposition is perhaps overly accurate and too readily acceptable to need much commentary, even though Eliot disturbs his conjugation in putting 'unreal' now before and now after 'London'. Here, on line 70, it comes before; but on line 376 it arrives at the end of a short list of other cities, so that the two syllables of 'London' fall directly on its three – 'unreal' – in such a way as to emphasize the specificity of their relation, despite the immediate precedence of Jerusalem, Athens, Alexandria and Vienna. But even today anyone of a literary bent who rides the number 253 bus from Aldgate right round East and North and back down to Euston will tend to agree with Eliot, whether because they will then witness such a superfetation of realities as to defy any resolution into a unified concept of the city as a functioning symbolic system; or, at a less theoretical level, because London's unending transformation of visual densities and social differences makes Los Angeles seem simply pastoral. London remains confounding and unsatisfactory. If, in Jacques Lacan's terms, the real is the excluded residuum of the production of the symbolic, the outside to all those discourses which constitute us as a subject, what we see from the 253 will deconstitute us as psychotic, were we for one moment to identify with it as reality.[9] 'Unreal city' ... is a good fiction for an alibi, even as Eliot's rhetoric conjures a powerful presence, an excess of effect which registers the choric being of the real and the object of desire.

It echoes down in different kinds of culture. We find it right at the beginning of the Ealing comedy film *The Lavender Hill Mob* (1951), for example. The title sequence frames a series of tight, claustrophobic shots of the Royal Exchange, Mansion House and the Bank of England, sharply lighted with deep black and white contrast and a long depth of focus, so that the buildings butt up airlessly against each other, squeezing out the sky, constricting the circulation of the traffic, the taxis and the buses. Gazing at the heart of Britain and its power of finance feels stifling, like seeing through a prison's bars. From the title we cut to a sunny tropical terrace, languidly rhythmic music, a parrot on its perch in profile against the sunlit wall. In the blazing luxury of a South American club-restaurant the hero, Mr Holland (Alec Guinness), begins to narrate his great theft of the Bank of England's gold to a civil-servant type who will turn out to be his captor. As he speaks of his ambition to have a life of ease, to escape from his being '... merely ... uh ... merely a nonentity amongst those thousands who flock every morning into the city ...', the screen is filled with Eliot's image, the 'undone' thousands of the living dead who stream across the bridge, compressed into a single body, a hypertrophic common identity as the slaves of capital, wrapped in unremitting grey, a moral fog; and then, swiftly, the scene cuts back to light clothes and flowing gestures, the easy sexuality of the Latin phantasy. The possession of money is broken from the prison house of the city; it is magically desublimated through its perversion to a sign of polymorphous pleasures that exceed its rigorous grid of its streets and columns. Holland hands out cheques and banknotes, a tip to the waiter, a present to his girlfriend and charitable contributions with a freedom that defies the constraints of dead and accumulated capital.[10]

H.V. Morton's rather bland, self-assured and anecdotal *flâneries* were some of the most successful and popular depictions of London in the period between the wars. Yet at first sight, so satisfied with their post-Baudelairean or Poe-esque elaboration of banal and reactionary urban stereotypes, they nonetheless offer some unsettling metonyms. Between the ending of his section on bus transport and the beginning of his pages on St Paul's, Morton slips between three figures of mountainous convexity; the hat, the driver and the Dome. At the same time passage between the two episodes amounts to a contradiction or a reversal of metaphoric sense, which should lead us to suspect that we cannot take the superficial effect of one convex alongside the other as an elegant and controlled figurative slippage. Rather, all three have turned up there to stand in for something else, perhaps the real *London* which is the title and subject of his book. While the first two convexes emerge as an affirmation of certainty despite, and therefore because of, the surrounding fog, which they overcome, the third is deceptive in its stillness. Time is eating away at the cathedral, through the very agency of its surmounting symbol – in a happily inverted premonition of the lightweight millennium dome of Greenwich today, unsurely anchored in its bed of noxious slime and an infill-rubble. So if the strange, slow, dark journey of the bus is a triumph over the time that space becomes in fog, St Paul's hints rather at time's eventual triumph over the very possibility of finding an adequate symbol of London. Absurdly, of course; given that eight years after this edition of Morton's book the Dome alone would still be there, to stand in for the lost fabric of bombed-out London after World War II (plate 70).

In one of the very few location scenes in David Lean's film of Dickens's *Great Expectations* the protagonist, Pip, journeys up to London taking the viewer across a schematic yet picturesque map of the road, countryside and towns that frame his approach to the city; but as he opens his eyes to the promised land itself, we see the great Dome in a carefully angled shot of St Paul's that evades surrounding chaos.[11] There it is, still floating above the City, even if the price of its representation is the exclusion of its circumstances – an exclusion naturalized by the *mise-en-scène* of Dickens's epoch, the peeling façades of the sets of Little Britain, seedy legal offices, cavernous courtrooms and an execution yard. All of which, in effect, in their volumetric intricacies, rhymings and contradictions, surround its simplistic convexity with the web of their spatial complexities. And it is here, in the densities of what might have been a nostalgic figuration, that the hidden narratives and geographies of Dickens's story entrain with them a process of overdetermining decay that also corrodes the fullness and stability of the image of the Dome. If Pip's new life really begins with the coach driver's utterance 'London!' and the camera's gesture to St Paul's, its disruption through the uncertainties and perversions of law, criminality, money and love has already been seeded in the alien mists of the Essex marshes. It will be the gloomy forces of a powerful outsiderness that are to make (non)sense of Pip's intentions in his story, of his overconfident assumption of a narrative that is not the one he is really living out; it will be these forces that allow London to signify, to be of the order of the *signifiant*.

It is now clear enough that this theme of outside-ness will echo throughout my essay, and that I am concerned primarily with the repetitions of the figure of

159

70 St Paul's seen amongst the ruins of the city. Private collection.

exteriority in the topography of London stories. For it does indeed appear to be a structuring trope for a range of discourses from the guidebook to urban theory and from the detective novel to light, cinematic comedy. So while outside-ness is at once abject and all powerful in both the novel and the film of *Great Expectations*, there subverting London's integrity through playing it out across a world map of subterranean criminality and legal manipulation, it may also take on the forms of comedy or parodic horseplay, masquerading the uncanny as a matter of harmless entertainment. And this combination of the elements of a winsome narcissism that identifies itself in quite specific stereotypes with a range

of cinematic conventions and histories begins to condense into something that we might call a London symbolic.

It is the need to frame this notion and to pick out something of its complex desiring structures that leads me to the writing of Jacques Lacan. In the fifth volume of his seminars, *Les formations de l'inconscient*, Lacan writes of the beginnings of meaning in the following terms, which might provide us with at least a useful analogy for the fairly simple combination of basic elements that we have begun to observe in poetic and filmic scenarios of London. Writing of the 'ultra-precocious' introduction of the maternal object into the process of symbolization, he says:

> Dites-le-vous bien – dès que l'enfant commence simplement à pouvoir opposer deux phonèmes, ce sont déjà deux vocables. Et avec deux, celui qui les prononce et celui auquel ils sont adressés, c'est-à-dire l'objet, sa mère, il y a déjà quatre éléments, ce qui est assez pour contenir virtuellement en soi toute la combinatoire d'où va surgir l'organisation du signifiant.[12]

The point appears, deceptively of course, to be quite a simple one; Lacan is arguing for a starting point, or a moment of reduction to the minimal elements of what may then become an infinite complexity. Yet even within the schematically reduced relation of 'four elements' there is the already ongoing process of the symbolizing of the maternal object via the phallus or the name of the father on the one hand, and the production of need through the sign of desire on the other. In effect the coexistence of need and desire as if need were an autonomous force in the realization of the subject, taken with the disappearance of the object behind the signifier, is deeply puzzling. It is a configuration that shuffles and unsettles any certainty about what is in and outside the subject, and it is this sense of a radical puzzlement that I want to bring to London.

How, for example, might our awareness of such a puzzlement enable us even just to set out on a description of the shot from *The Ladykillers* (1955) in plate 71, rather in the same spirit as we might risk getting on the number 253 bus? The scene, from near the beginning of the film, shows Mrs Wilberforce, the Lady of the title, receiving her new lodger, 'Professor Marcus', who is to use her lopsided, bomb-damaged house, the perfect relic of a lost Victorian and colonial London, as the base for his magnificent and perfect crime, the robbery of £60,000. We could begin quite literally by saying that there are three elements in the first instance – the Professor, Mrs Wilberforce and a Parrot. We, the viewer, must be the fourth, and enter into subjecthood through the combinations of ourselves with these. Mrs Wilberforce certainly represents the past of London, a London that has survived the transformation of modernity and the disfiguration of the war, a city which maintains a fierce autonomy and a sense of being for itself. For fierce and persistent Mrs Wilberforce truly is: a baby screams as she cooes into its pram; the police shrink evasively as she enters their station to explain that her friend Amelia did *not* see a space ship the previous week; her neighbours and shop-keepers greet her with respect (plate 72). But it is also important that, though a widow, she is not a mother. On the contrary, as her role evolves, both through the narrative of her relations with the criminals whose plans she unintentionally confutes, and her

71 *Ladykillers*, Mrs Wilberforce declines Professor Marcus's offer of advance rent. British Film Institute Stills.

relentless control of the street, or her disregard for any use of the streets other than her own, it becomes clear that she functions as the Law. It is Mrs Wilberforce who determines the borderlines between dream and non-dream, appearances and signs, sense and chaos. If she does stand in for London, then London's nostalgia is a trap – a trap laid to lure the desire for the mother, to snare it in the phallic system which alone will give it meaning. In *The Lavender Hill Mob*, too, Holland's landlady plays out the same ambivalence; old, frail, dotty, charming, she wastes his time of dreaming, plotting, scheming his crime in having him read American thriller fiction to her.

In this speculative scenario the Professor and the Parrot enjoy a complex significance. We have already seen that in *The Lavender Hill Mob* a parrot figures as the first sign of an exotic antinomy to London. Here, in *The Ladykillers*, it is both deep inside and from outside London at one and the same time (plate 73). A relic from colonial adventure, the pet of Mrs Wilberforce's late husband, it both functions as an unconscious natural force that subverts and diverts the conscious, intentionally directed actions of the characters as they chase it over the roofs in one scene, and as a model for the repetitious function of the film itself in its repetition of the thriller genre. For if, at a superficial glance, it looks as if there are three parrots in the shot, then the Professor himself is first sighted as a repetition of an image from German expressionist cinema. It is as Mrs Wilberforce asks the

162

72 *Ladykillers*, Mrs Wilberforce explains Amelia's dream to the Police. British Film Institute Stills.

shopkeeper in whose window she has posted her advert for a lodger if there have been enquiries that we see his hat reflected in the glass, dark in a sudden rainstorm, a reminder of Fritz Lang's *M*, followed by a sequence of shots in which the hat circles round her house as we see her pottering inside. Subjected to this threatening gaze, she eventually produces it as nothing more than the effect of her own being, a partial subject of her primitive rootedness at the origins of signification, just after the effacement of the maternal object.

This play between, and form of, narrative given from outside London and the particularity of the London which it renders visible and which, in turn, perverts it, is again a central figure of *The Lavender Hill Mob*. As we have seen, it invades the cosy nostalgia of the living room as Holland reads to his landlady, exciting her with the thriller's kitschily erotic dangers. And when Holland and his accomplice-to-be in crime, Pendlebury, go late at night to check up the latter's safe in his souvenir factory, they are surprised by a petty criminal whose shadow looms over them in a dramatic parody of Murnau's *Nosferatu* at the point when the vampire mounts the staircase to take his victim. Of course in London this expressionist terror turns to bathos, and there is no victim. But in its harmonizing of the criminal narrative with a kind of Dickensian eccentricity and chaos, we are left with the frustrating sense that London is both never quite enough and yet infinitely absorbent. If, indeed, in *The Lavender Hill Mob*, it is to be the casting of stolen gold as souvenir Eiffel

163

73 *Ladykillers*, Parrot food and the prescence of the pre-conscious. British Film Institute Stills.

Towers that produces both a figure for and means of escape from London, there is no eventual density of otherness that can disperse its power. At the end of the film we realize that Holland is handcuffed to his interlocutor and that London's most direly bland stereotype has come to claim him back.

To return, then, to my quotation from Lacan, we can begin to trace an outline of London as a specific urban figure, one that strains against Freud's Rome in the strangeness of its registers of presence. It would have been easy to go for London as the *petit objet à*, to think of London as desire's irremediably unfulfillable character. Rather I have wanted to suggest that London, more often than not, in Eliot or Portheim, Morton or Ealing Comedy, figures the difficulty of an obsessional and neurotic desire to see it as our object rather than to accept how or that we are its subjects. A process of signification congeals around a set of stereotypes that include the reader or the viewer, but which, in their very inadequacy, imperially recruit otherness to give them substance, only then to outlive narrative form, which is itself the gift of otherness. A few moments before the shot in plate 71 Mrs Wilberforce has left the hall of her house to fetch the Professor a set of keys. As she turns from him and walks through a door, her voice remains at the same level of loudness, it is left suspended in our hearing, along with the sound of parrots, railway trains and all the other aural paraphernalia of

the film, even as she disappears. This suspense both splits the sign in an uncanny substitution of one of its parts for the whole and suggests that the whole is ever present, even at the moment of its disappearance. At the same time it reminds us that the film begins with Mrs Wilberforce recounting Amelia's dream, which she attributes to her friend's dozing off as she listens to the radio, to a children's progamme on visitors from space. The outside, immaterial voice of radio too is a condition of narrative, dreaming or awake.

I want to argue that of all cities, it is London that is marked by this frustrating yet alluring lack of plenitude's illusion, and that in his elaboration of the formation of the unconscious, it is Lacan who can help us to live with this. At the same time, the city is Mrs Wilberforce's, she wins out, like the true religion, the law of the father disguised in the trappings of a phantasmatic and deceptive motherliness. At the end of the film the stolen loot, all £60,000 of it, reverts to her, and she will spend it on a new umbrella, give it to the beggar, as libidinous in her own way as Holland in South America.

Ironically, if Lacan can be our guide in this, then we must admit that London defeats us rather as he thought that Rome defeated reason. In a recent article in the French journal *Lignes* Jacqueline Risset recounts a drive around the eternal city with the great analyst–philosopher:

> It was during the Easter days, and the great, white silent limousine which had been put at the disposition of the *savant* by his friend the ambassador … [a]dvanced slowly through the almost empty streets of the baroque centre. And Jacques Lacan, looking upon the domes, suddenly said in a sweet and melancholy voice: *'they are going to win …'* Then, after a contemplative silence, and still in the same sweet voice, he added: *'They have gratifications to offer; we have none …'*[13]

Can it be that seen from the bumpy, almost dangerous time-warp of the number 253 bus, London too will win, in all its terrible refusal?

Adrian Rifkin
Middlesex University

Notes

This essay might be thought of as my own contribution to the course 'Cities and Film' which I taught over a period of five years to both BA and MA students in the Department of Fine Art and Centre for Cultural Studies at the University of Leeds. I owe a debt of gratitude to all those whose discussion stimulated my own desire to write this. In respect of the specific preparation of the piece my thanks go to Frank Mort and David Oppedisano for their critique and help.

References to the films in this article are all drawn from the standard video editions and bibliographies, including original film reviews, and other subsequent commentaries are all downloaded from the database at the British Film Institute library. The most important single study of *The Ladykillers* for what follows is Philip Kemp, *Lethal Innocence: the Cinema of Alexander Mackendrick*, London: Methuen, 1991. Kemp makes some interesting points concerning the film as Mrs Wilberforce's dream. For a 'realist' and nostalgic tracing of the settings for this film see Gavin Stamp, 'Dreams and nightmares of a changing city', in *The Times Saturday Review*, 31 November 1990, p. 22. The problem of location, set and the representability of London is a fascinating question in all the films I discuss here, and continues to be up to Michelangelo

Antonioni's *Blow Up* (1969), for example. Interestingly enough, in the postwar period the single film with what appears to be the most numerous outside locations and actual interiors is Jules Dassin's thriller *Night and the City* (1950), and it is worth wondering about what it meant to come to London from the outside with a project in mind – that of exploring greed and money in San Francisco, London and Marseille. In all Dassin has 54 locations and 14 interiors.

For a broad summary of London films, see http://www.uk.imbd.com.

1 T.S. Eliot, 'The Waste Land', in *Collected Poems 1901–1935*, London: Faber and Faber, 1937, p. 63, line 60.
2 H.V. Morton, *The Heart of London*, London(1925), nineteenth edition, 1937, pp. 25–7.
3 Antonietta and Gérard Haddad, *Freud en Italie. Psychanalyse du voyage*, Paris: Pluriel, 1995.
4 Sigmund Freud, *The Interpretation of Dreams*, trans. by James Strachey, ed. James Strachey and Alan Tyson, London: Penguin, volume edited by Angela Richards, 1975, p. 633.
5 See Walter Benjamin, *Charles Baudelaire, a Lyric Poet in the Era of High Capitalism*, London: NLB, 1973, pp. 48–54 for this discussion. Benjamin also sets out to distinguish London and Berlin through the difference between Poe's man in the crowd and E.T.A. Hoffmann's man 'at his corner window' (p. 48). But the attentive reader of this chapter, 'The Paris of the Second Empire in Baudelaire', will surely see that the dynamic of Benjamin's attraction to Paris in the swinging of his text is in excess of the logic of his comparisons so that Poe's man or Dickens's wanderings in effect serve as an empty *différand* from Paris rather than as substantially other kinds of trope.
6 A current and highly sophisticated account of these problematics is to be found in Julian Wolfreys, *Writing London. The Trace of the Urban Text from Blake to Dickens*, London: Macmillan, 1998.
7 Louis Cohen-Portheim, *The Spirit of London, with a Preface by Raymond Mortimer*, London: Batsford, 1935.
8 H.V. Morton, *The Heart of London*, op. cit.
(note 2), 'Oriental', pp. 11–15, and *The Nights of London*, London: Methuen, 1926, 'The Chinese New Year', pp. 124–8.
9 For a detailed summary of the possible use of the terms real, imaginary, symbolic etc., see both Elisabeth Roudinesco and Michel Plon, *Dictionnaire de la psychoanalyse*, Paris: Fayard, 1997, and J. Laplanche and J.B. Pontalis, *Vocabulaire de la psychoanalyse*, sous la direction de Daniel Lagache, Paris: P.U.F., 1967.
10 See the remarkable essay on *The Lavender Hill Mob* by Richard Hornsey, forthcoming in *Art History*, for an account of the gay perversion of gold into a gay sexual expenditure and its symbolizing in this film.
11 See *Ourselves in Wartime*, London: Odhams, n.d., and Colin Sorensen, *London on Film, 100 years of filmmaking in London*, foreword by Lord Attenborough, London: Museum of London, 1996, p. 121.
12 'Tell this to yourself as soon as the child simply begins to be able to oppose two phonemes, these are already two words. And with two, s/he who utters them, and that to which they are addressed, that is to say the object, the mother, there are already four elements, which is enough in itself to hold virtually all the combinatory [forms] from which the organisation of the signifier will arise.' Jacques Lacan, *Le séminaire livre v. Les formations de l'inconscient*, texte établi par Jacques-Alain Miller, Paris: Seuil, 1998, p. 222.
13 Jacqueline Risset, 'Triste fin de siècle', in *Lignes*, no. 35, octobre 1998 (Paris: Hazan), pp. 28–32.

Abstracts

Aestheticizing the Ancestral City: antiquarianism, topography and the representation of London in the long eighteenth century

Lucy Peltz – *Assistant Curator of Paintings, Prints and Drawings at the Museum of London. She has recently published a volume of essays on antiquarianism entitled* **Producing the Past: Aspects of Antiquarian Culture and Practice, 1700–1850** *(Aldershot, 1999). She works on the production, consumption and customization of print in the eighteenth and nineteenth centuries and is currently preparing a monograph on extra-illustration for which she holds a Paul Mellon Centre Post-Doctoral Fellowship.*

To assert its distinction, modernity has always looked backwards as well as forwards. During the eighteenth century London underwent a steady process of transformation as numerous ancient buildings were demolished in the name of urban improvements. As these modernizations went forward a concomitant rise of antiquarian sentiment prompted a plethora of engraved representations which aimed to keep the past in view. This essay considers the evolution, dissemination and reception of such cumulative antiquarian representations from the nostalgia for Hollar's bird's-eye view of pre-Fire London to the moral judgements implied in John Thomas Smith's later etchings of dilapidated and impoverished sites of antiquity. By charting the changing aesthetics and interests of this genre, this essay discusses the ambiguous relationship between the publishing of anti-quarian representations and the status and preservation of the sites that they depicted. It also asks whether the circulation of such representations helped to ground urban identity at a time when the city was in a constant and disorienting state of change.

Peripheral Visions: alternative aspects and rural presences in mid-eighteenth-century London

Elizabeth McKellar – *Lecturer in History of Art at Birkbeck College, University of London. She is a specialist on late seventeenth- and eighteenth-century English architecture with a particular interest in London's urban culture. Her book* **The birth of modern London: the development and design of the city 1660–1720** *was published by Manchester University Press in 1999 and she is co-editor with Barbara Arciszewska of a forthcoming collection of essays entitled* **Re-constructing British Classicism: New Approaches in Eighteenth-century Architecture.**

This essay moves beyond the traditional concentration on the formation of polite identities in the classical townscape of the West End to offer an alternative vision of London constituted of multiple, distinct environments. Using the examples of the spa resorts at Hampstead and Islington, it argues that we need to extend our notion of the

'urban' in this period to include these semi-rural locations. Through an analysis of textual and visual sources it presents the city as a complex and heterogenous landscape incorporating an 'edge' in which cosy suburban villages and farms were intermixed with industrial enterprises, shanty settlements and out-of-town leisure developments. Far from being marginal the periphery played a significant role in town life, and London in this period can be seen as the prototype of the fractured modern connurbation.

'Beastly Sights': the treatment of animals as a moral theme in representations of London c. 1820–1850

Diana Donald – *Professor of the History of Art at Manchester Metropolitan University. She is the author of* **The Age of Caricature: Satirical Prints in the Reign of George** III *[1996], and co-author of* **Gillray Observed: The Earliest Account of his Caricatures in 'London und Paris'** *[1999]. She is now working on a book on animal imagery in British art c.1750–1850.*

The huge growth of London in the first half of the nineteenth century projected the city's financial and cultural dominance; but celebrations of 'improvement' coexisted with unease over the social effects of laissez-faire capitalism. Thus, the ubiquitous exploitation of animals in London, a direct effect of commercial competition and intensive building, acquired great symbolic force in the imagery of illustration. While efforts to end cruelty to animals apparently testified to the humane and civilizing impulses of the time, their relative failure suggested a fundamental barbarity in capitalism itself, in its heartless commodification of both men and animals.

Conflicting impressions of human–animal relationships in nineteenth-century London are exemplified through a range of publications, from the *Illustrated London News* to George Cruikshank's books and the journals of the anti-cruelty groups themselves. Animals and their treatment could evoke, at one extreme, the vital energy and aggressively competitive spirit of the capital, at the other its endemic cruelty and alienation from nature and God. The varying conventions of pictorial representation are shown to have had a crucial role in these constructs, particularly in the underlying imagined antithesis between 'city' and 'country'.

London Bridge and its Symbolic Identity in the Regency Metropolis: the dialectic of civic and national pride

Dana Arnold – *Professor of the History of Design at the University of Southampton. Her recent publications include* **The Georgian Villa** *(1996) and* **The Georgian Country House: Architecture, landscape and society** *(1998). She is the author of* **Re-presenting the Metropolis: Architecture, urban experience and social life in London 1800–1840** *to be published by Scolar Press in 2000.*

This essay positions the rebuilding of London Bridge within the framework of the emerging early nineteenth-century metropolis. Improvements in planning, the definition of the city's perimeters and entrance points and the erection of monuments to nation and state were all part of the creation of an urban identity in which London Bridge played a significant and distinctive role. The balance of power between a national government interested in urban development and an established authority within the City of London creates a dialectic around the issues of civic and national pride. The discrete identity of London Bridge as the entranceway into the City was appropriated and revised to help to

create an image of a modern metropolis which encompassed not just the City but also the City of Westminster and the Borough of Southwark. As such, London Bridge became part of the infrastructure which attempted to give coherence to the fractured streetplan of the capital but its dis-location from the Metropolitan Improvements also expressed its local significance. A consideration of London Bridge in these contexts establishes its symbolic identity in Regency London. But it also raises interesting questions about the relationship between the symbolic and functional roles of buildings. A bridge can be a monument, a signifier of social or political preeminence, a national symbol or just a stretch of road that happens to pass over water. In this way London Bridge can be viewed as a matrix through which fundamental aspects of urban identity can be explored.

Government and the Metropolitan Image: ministers, parliament and the concept of a capital city, 1840–1915

M.H. Port – Emeritus Professor of Modern History, Queen Mary & Westfield College, University of London. He was co-founder (1975) and subsequently editor of the London Journal*. He is a council member of the London Topographical and London Record Societies, and a member of the Buildings Sub-committee of the Victorian Society. He has published extensively on public buildings in London, including* The History of the King's Works, VI, 1782–1851 *(co-author, HMSO, 1973) and* Imperial London *(Yale University Press, 1995).*

The two basic obstacles to reconstructing Victorian London as a magnificent capital were its lack of effective local government, and the prevailing system of parliamentary government.

Fear of disease forced ministers to act on sanitary issues, but they were reluctant to outface those interests that resisted, on one hand, interference with the peculiar powers of the City of London, and on the other opposed spending any part of national taxation on London. Even necessary improvements in government buildings were attacked as misuse of public money.

Improvements in London's image achieved in the Victorian era were largely the work of a handful of junior ministers influenced by developments in other European capitals, especially Paris. Only at the end of the nineteenth century was a means devised of safeguarding improvement schemes from capricious undermining.

Rebuilding 'The Heart of the Empire': bank headquarters in the City of London, 1919–1939

Iain S. Black – Lecturer in Human Geography at King's College London. He has written on the economic, social and architectural transformation of the City of London in the eighteenth and nineteenth centuries. He has recently completed a Nuffield Foundation project entitled 'Rebuilding The Heart of the Empire: Financial Headquarters in the City of London, 1919–1939*'.*

Between 1919 and 1939 the landscape of the City of London's central financial district underwent a sustained transformation as the Bank of England and other major financial institutions rebuilt their headquarters in the heart of the City. Indeed, by the mid-1930s the landscape captured in the foreground of Niels Lund's celebrated painting *The Heart of the Empire* had radically changed. Surprisingly, given the immense historical important of the City in English cultural identity and economic life, this transformation of its built environment has received remarkably little attention. This paper presents a detailed

169

evaluation of this changing landscape of finance within a conceptual framework that emphasizes important relationships between money, architecture and social power. Working through a series of 'deep' descriptions of the key rebuilding projects involved, the paper highlights how late-imperial visions of finance and empire provided an unique cultural and ideological context for this new palatial landscape of finance.

Benjamin's Paris, Freud's Rome: whose London?

Adrian Rifkin – *Professor of Visual Culture and Media at Middlesex University. His book* **Ingres Then, and Now** *will be published by Routledge early in 2000.*

This article sets out to consider the ways in which specific cities and particular bodies of theory come to belong to each other through the interaction of complex processes of urban development on the one hand and the institutional life of theories on the other. If Paris belongs to Walter Benjamin and Rome belongs to Sigmund Freud, to whom are we to attribute London? Arguing that London is an essentially unsatisfactory and even frustrating linguistic structure, which, in Lacanian terms, masquerades the phallus in the guise of the invisible maternal object, I propose that London belongs to Jacques Lacan; or that if it does not go to Lacan, then its presiding figure is Mrs Wilberforce, the leading character of the Ealing Comedy *The Ladykillers*, not because of the maternal comfort which she appears to offer, but for her uncodable authority that entraps us in our own desire for a satisfactory figure of the city.

Index